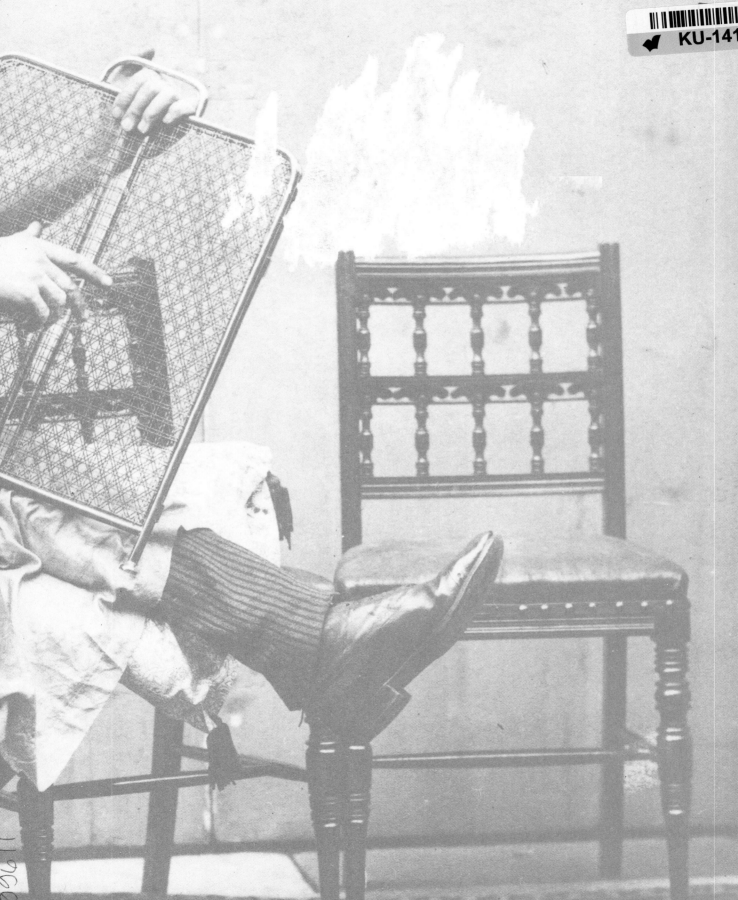

THE ARTIST'S
MODEL

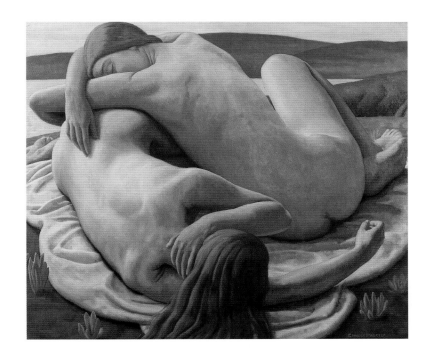

FROM ETTY TO SPENCER

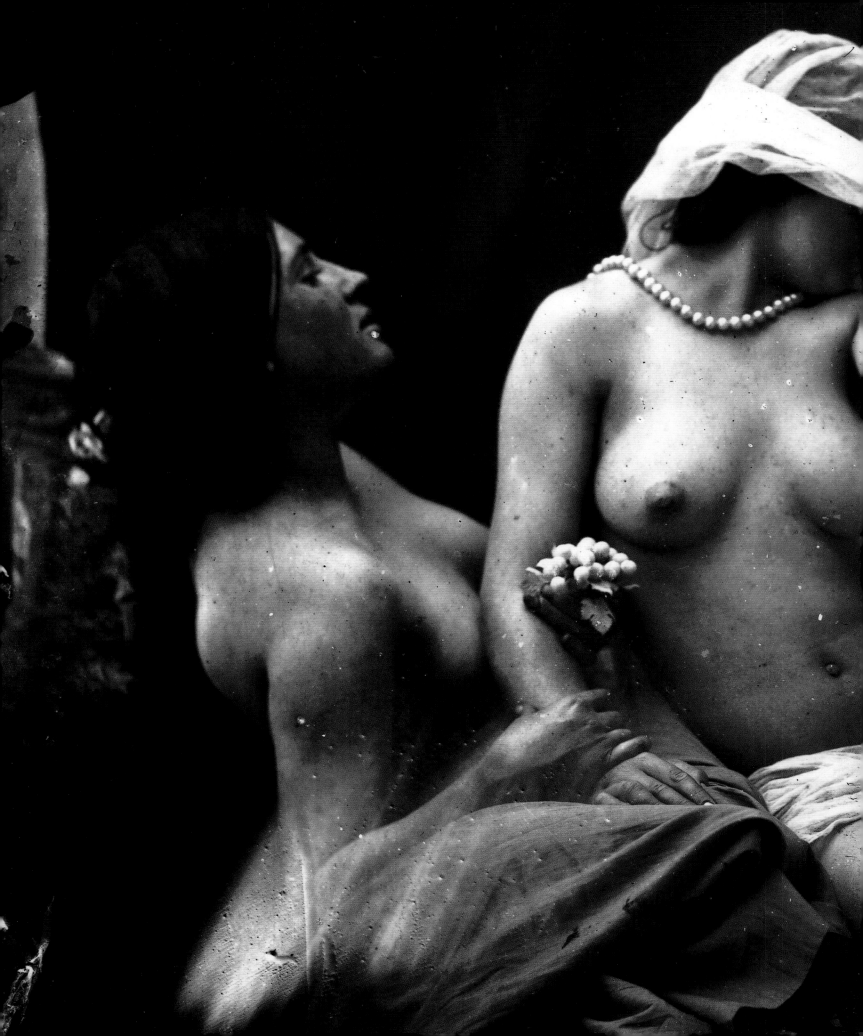

THE ARTIST'S
MODEL

FROM ETTY TO SPENCER

MARTIN POSTLE

WILLIAM VAUGHAN

MERRELL HOLBERTON

PUBLISHERS LONDON

This book has been produced to accompany an exhibition held in 1999 at

York City Art Gallery, 29 May 1999 – 11 July

Kenwood, London, 23 July 1999 – 26 September

Djanogly Art Gallery, University of Nottingham, 16 October 1999 – 12 December

The exhibition has been generously sponsored by Spink-Leger Pictures

SPINK-LEGER
PICTURES

The authors would particularly like to acknowledge the help they have received from the following in their enquiries and research: Emma Chambers, Marguerite Evans, Anthony Griffiths, David Fraser Jenkins, Ian Jenkins, Robin Hamlyn, Geoff Hassell, Rupert Maas, Clare McGraed, Shirley Nicholson, Richard Ormond, Regine Page, Aeli Roberts, Nick Savage, William Schupbach, Kim Sloan, Reena Suleman, Robert Upstone, Helen Valentine and Sally Woodcock.

First published in 1999 by Merrell Holberton Publishers Ltd
Distributed in the USA and Canada by Rizzoli International Publications, Inc.
through St Martin's Press, 175 Fifth Avenue, New York, New York 10010

British Library Cataloguing in Publication Data
Postle, Martin
 The artist's model: from Etty to Spencer
 1. Artists' models
 2. Art, Modern – 19th century
 3. Art, Modern – 20th century
 I.Title II.Vaughan, William, 1943-
 704.9'42

ISBN 1 85894 084 2 (hardback)
ISBN 1 85894 091 5 (paperback)

Produced by Merrell Holberton Publishers Ltd
Willcox House, 42 Southwark Street, London SE1 1UN

Designed by Matthew Hervey
Printed and bound in Italy

Front jacket/cover: John Gerald Hookham, *Seated female nude, Slade School of Art* (cat. 38)
Back jacket/cover: Augustus John, *Male nude* (cat. 29)
Half title: Ernest Procter, *The Day's End* (cat. 117)
Full title: Oscar Gustav Rejlander, Study for *The Two Ways of Life* (cat. 94)

Contents

Foreword

The Artist's Model: From Etty to Spencer is the sequel to the highly successful exhibition *The Artist's Model: Its Role in British Art from Lely to Etty* held at the University Art Gallery, Nottingham, and Kenwood in 1991. The previous exhibition met with outstanding critical acclaim and was one of the most popular ever to be held at Kenwood, the catalogue selling out before the close of the exhibition. Its successor is the result of a further collaboration between Nottingham (now the Djanogly Art Gallery) and Kenwood, this time with York City Art Gallery as a third partner: the York showing will mark the 150th anniversary of William Etty's death in that city.

We have been exceedingly fortunate in benefiting from the expertise of the exhibition's curators and catalogue authors Dr Martin Postle, Senior Curator of British Art at the Tate Gallery, London, and Professor William Vaughan, Professor of the History of Art at Birkbeck College, University of London. Martin Postle was co-curator of the 1991 exhibition, thus providing an important element of curatorial continuity between the two shows.

In mounting this exhibition the organizers and the curators have incurred numerous, and substantial, debts. It is a particular pleasure to acknowledge the support of the many lenders, both public and private, who without exception have made their works available for all three showing places. We are deeply grateful to them. Equally we thank Spink-Leger Pictures, without whose generous sponsorship the exhibition could not have taken place: we especially appreciate the interest that Lowell Libson has taken in our project.

The Paul Mellon Centre for Studies in British Art has not only supported the catalogue for this exhibition but has also enabled us to reprint the catalogue of the 1991 show. The transport has been carried out by Oxford Exhibition Services, whose involvement and co-operation have gone far beyond the call of duty.

We thank our publishers Merrell Holberton for producing the handsome catalogue to the exhibition and David Bickerstaff for his elegant design of the publicity material.

Much of the practical burden of organizing the exhibition has been cheerfully shouldered by Cathy Power and Chris Higgs at English Heritage and by Tracey Isgar at Nottingham, all of whom deserve special mention. Thanks are also due to Lara Goodband and Terry Jones at York, and Julia Findlater, Tori Petfield and Jeremy Richards at English Heritage.

Exploration of the theme of *The Artist's Model: From Etty to Spencer* has revealed a rich seam in the history of British art. We are confident that there will much to engage and be enjoyed by our visitors in York, London and Nottingham.

Richard Green
Curator
York City Art Gallery

Malcolm Cooper
Deputy Director, London Region
English Heritage

Joanne Wright
Director
Djanogly Art Gallery

Introduction

This exhibition is the successor to *The Artist's Model: Its Role in British Art From Lely to Etty*, held in 1991. It takes the story forward, looking at the way the model was used by artists in Britain from the early Victorian period to the Second World War. During these hundred or more years the model gained increasing prominence in the art world. From being seen as a lowly and often dubious activity, the occupation rose to attain its own professional status. By the early twentieth century the most successful models became glamorous figures in their own right, consorting on equal terms with the artists who studied and depicted them.

The exhibition is divided into four sections. The first section, 'From Academy to Art School', traces the development of the use of the model in art education from the study of the figure in the Royal Academy Schools to its use in the Government Schools of Design, private art schools and institutions such as the Slade School of Art where aspects of the French atelier system were introduced. Issues addressed here also include the propriety of using the naked model in state-funded institutions; the rights of women to study the model; and the status of models themselves within the *status quo*.

The second section, 'Behind the Screen: The Studio Model', looks at the use of the studio model by the professional artist during the period. It explores the complex social relations between artist and model, as well as the increasing public interest in the studio as a site of mystery and sexual intrigue.

The third section, 'Models and Muses', looks at the myths that arose around the model. From the time of the Pre-Raphaelites onwards the image of the female model was shaped as a *femme fatale*, an inspiring yet at the same time dangerous and potentially destructive presence. By the end of the century, models were becoming famous in their own right, both in fact and in fiction. To some extent the myth of the model became a reality, as many artists in the early twentieth century focussed on a particular model, who acted as a personal companion and muse. Although such models were predominantly female, there were many male models who fulfilled this dual role.

The final section, 'The Naked and the Nude', returns to the problem of sexual morality and the depiction of the naked figure. The growing prominence of the use of the nude model in art schools, and the presence of naked figures in paintings and sculptures, fanned a public debate in the Victorian period, with many arguing that all depictions of nakedness were essentially immoral. Others argued for a distinction between the 'artistic' nude and the use of naked figures for pornographic purposes. In the twentieth century the debate has shifted with a growing acceptance of public nudity. The naked figure has become a symbol of frankness and honesty, as well as a pawn in the game of gender politics.

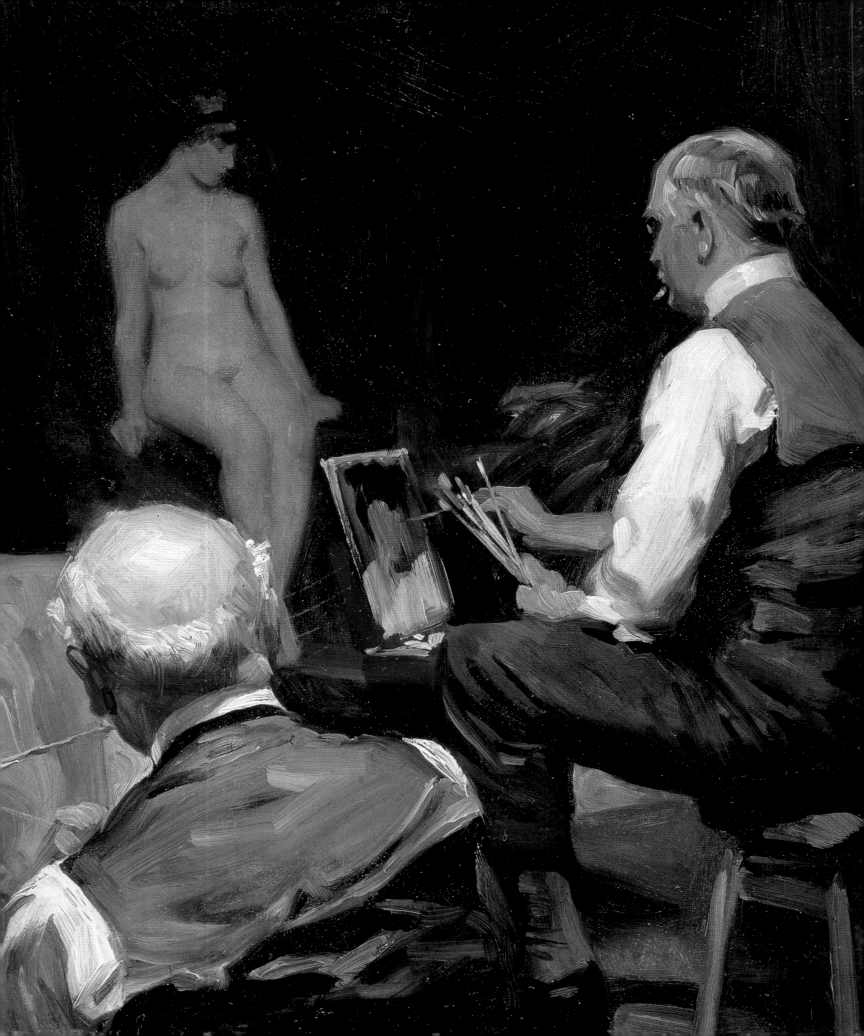

From Academy to Art School

MARTIN POSTLE

In 1837 the Royal Academy moved to a new home in the National Gallery. Life classes were held during the summer months high above Trafalgar Square in the Gallery's dome, a room affectionately nicknamed the 'pepper-box'. Here, the ageing Academician William Etty spent numerous evenings studying the living model. Seated alongside students thirty years his junior, Etty was a stubborn, disconcerting, even embarrassing presence. (He invariably sat right at the front, close to the model.) The countless oil studies he made there remain among the most sensual, provocative and subversive images of the living model. Etty's life studies, especially his female ones (cat. 1, 92), evoke the silent rituals of the life class; the fetid atmosphere; the smoke and heat of the oil lamp; the naked model, transfixed by the slow trickle of sand through the hour glass and the collective gaze of male art students. In Etty's studies the model retains a flesh-and-blood presence, and that for many Victorians presented a real dilemma.

In the 1830s the regulations governing the study of the figure had changed little since the foundation of the Royal Academy in 1768. Teaching took place in two schools, the 'Plaister Academy' and the 'Academy of Living Models'. All students began their studies in the 'Plaister Academy'. Only when they had demonstrated their proficiency in drawing from the cast were they allowed to move on to the life class. Students were supervised in their studies by a series of 'Visitors' drawn from the ranks of Academicians. The Visitors were often among the most skilled draughtsmen of their generation, men such as Dyce, Mulready, Cope, Millais and Leighton, all in their own time praised for their skill and dedication to the cause of life drawing in the Academy's schools. Yet, as the century progressed, the life class, once the heart and soul of the Academy, was rendered increasingly moribund as reactionary forces gained the upper hand.

Etty had been encouraged to paint from the model by Henry Fuseli, Keeper at the Royal Academy from 1804 until his death in 1825. Etty was not alone in adopting the practice, which spread to younger artists at the Academy, and was already widespread in Continental academies. By Etty's death in 1849, the Royal Academy operated two schools for painting the model: the 'Painting School', where clothed or costumed models sat for character, and where Old Masters were copied, and the 'School of Painting' where the nude model was studied. In 1847 the Keeper, George Jones, attempted to unite the two schools. "This", he said, "might be easily accomplish'd ... by placing the model on a small throne near the stove, and students might thus be employed from nature in the middle of the Room, whilst others were engaged by the pictures on the walls."[1] This would have brought life classes at the Royal Academy further into line with Continental practice. Yet, after a brief experiment, the practice was abandoned. In 1862 the residual possibility of introducing a system akin to the French atelier was effectively quashed by new laws limiting life painting to those students who had gained the approval of

the Academy's Council – on average about a quarter of the annual intake of students into the Academy's life class.[2] From now on any attempt at innovation was nipped in the bud as the Academy maintained a resolutely orthodox attitude towards the use of the living model.

As early as the 1830s, Turner and Constable, conscious of the lamentable standard of teaching in the Royal Academy Schools, had tried to enliven proceedings by introducing various props – although Constable's celebrated use of tree branches to make the female model resemble Eve simply made the students laugh.[3] Already, a handful of more enterprising students, disillusioned with the lack of an effective pedagogy within the Royal Academy, had opted instead to study abroad. They included George Frederick Watts and Edward Armitage, who in 1836 enrolled in the atelier of Paul Delaroche.[4] Ten years later, in 1846, John Zephaniah Bell and Charles Lucy, both of whom had trained in Paris (under Baron Gros and Paul Delaroche respectively) set up their own ateliers in London.[5]

In the French system the living model was studied predominantly in the private atelier, where indigenous students were directed towards a competitive system of prizes and awards, notably the prestigious Prix de Rome.[6] The atelier was quite literally a large studio, or series of studios, offering intensive instruction in drawing, painting and sketching by teachers under the general supervision of eminent artists and professors of the Ecole des Beaux-Arts. The regime was strict, yet spontaneity was often encouraged, Thomas Couture urging students to take the models by surprise: "Do not let them realise that you are looking at them." And, if they found a good pose, students were invited by their teachers to arrange private sessions with the model.[7]

According to popular mythology, the atelier was a scene of unbridled bonhomie and camaraderie. But it was also fraught with intrigue and petty jealousy. It was deeply hierarchical and conformist. Swearing, fagging and victimization were rife and, while women students were admitted, the atmosphere reeked of male chauvinism. Even so, unlike in Britain (where students and models were forbidden to speak to one another) the artist's model was not set apart, either by excessive reverence or by class or moral revulsion. Whereas protocol in Britain demanded that the model entered the life room dressed in a robe, the Parisian model often walked in fully dressed, then casually divested items of clothing on to the nearest chair.[8] For some, like Henry Scott Tuke, who attended the atelier of Jean-Paul Laurens, the experience proved vital to their future artistic career and personal liberation. For others, like Alfred Munnings, it presented an opportunity for some unaccustomed personal and professional freedom. However, by the time Munnings got to Paris, in the early 1900s, the atelier was deeply clichéd, the resort of gauche art students from Britain and America clinging to the remnants of a bygone educational regime.[9]

In Britain before 1837 relations between artists and models, even at the Royal Academy, had been free from interference by state or Church. That year, a new art school opened in Somerset House, the publicly funded Government School of Design.[10] At the outset it was decided that the living model was not a *desideratum* for students, who were classed as "artisans" rather than artists, and trained on public money for the aims of industry and the decorative arts. In a calculated counter-attack, Benjamin Robert Haydon, the self-appointed scourge of the art establishment, set up a rival art art school, the Society for Promoting Practical Design, with lectures in anatomy, antique classes and a "fine female model". The artisans came in droves. The School of Design was forced to capitulate, and in 1838 resolved that "the human figure

for the purpose of ornament be taught in the school", male and female models being supplied for the purpose.[11] Yet the living model remained in the eyes of the state-funded educators a necessary evil, grudgingly made available only to those who could prove that it was relevant to their future career (those, for example, involved in making figurative designs for pottery). Haydon remained a thorn in the flesh of this and further Schools of Design, touring the provinces and speaking out against the official government line. He was guaranteed large audiences, not only because of his formidable rhetorical skills, but because his lectures included the use of a live nude model.[12]

Haydon's greatest success was at the Manchester School of Design, where the living model was adopted as a central component of the curriculum. However, a female model was soon found "moaning in the corridor outside the headmaster's room 'by a gentleman and a lady'". Rumours of nude women living on the premises followed. The life class was suspended for ten years and replaced by a class for drawing casts for ornament.[13] This was not, however, the end of the model in Manchester, some enterprising senior students setting up their own life class in an attic. This private life study class (calling itself the 'Roman Bricks') lasted for some twenty years.

The importance of private art schools in providing access to the living model is increasingly evident by the 1840s, both in London and in the provinces. Among the first to have been set up was Haydon's own school, formally established in 1815 – although here the emphasis was on anatomy, leading to intensive study of the sculptures from the Parthenon housed at the British Museum. At about the same time the Hunterian Theatre of Anatomy in Windmill Street opened in the capital, offering specialist training in anatomy. Among the most successful private art schools in London were Sass's, Carey's, Leigh's (later Heatherley's) and the Artists' Society for the General Study from the Life, a subscription academy founded in 1830 (known in the 1840s as the 'Clipstone Street Society' and subsequently as the Langham School) with the specific aim of providing professional artists with the opportunity to work with the living model (fig. 1). Many of these private academies offered tuition in anatomy and perspective as well as life classes, for which models posed by day as well as in the evenings – for male and female students alike. While many young artists used the facilities at these private fee-paying institutions to make drawings in preparation for entry to the Royal Academy Schools, for others they simply provided unregulated access to the model.

At the Somerset House School of Design the position remained fraught. In 1845 the eccentric Master of the Figure School, John Rogers Herbert, was dismissed for paying too much attention to life drawing at the expense of the cast collection, lovingly assembled by the School's head, Charles Heath Wilson. Again students seceded, reforming themselves under James Matthews Leigh as 'The General Practical School of Design for Artists, Designers and Amateurs'.[14] The living model remained, tolerated at best, under the gradgrind regime of the new Master, John Callcott Horsley, renowned in later years for his tiresome campaign against the nude in art and in art schools.

Shunning the French system, in which students were taught to draw and paint freely, relying on memory as well as their own eyes, the Schools of Design, under the leadership in London of William Dyce, adopted a version of the German approach to art education, in which study of the living model came after a thorough grounding in various aspects of ornamental design. As

Fig. 1
Albert Henry Collings
A life class
Oil on board, *ca.* 1900
Private collection

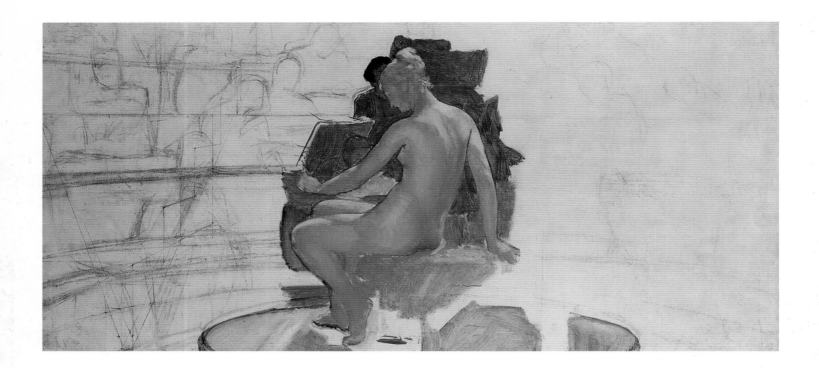

Fig. 2
Sir Lawrence Alma-Tadema
The Roman art class
Oil on canvas, 1877
Private collection

a result hundreds of industrious art students up and down the country laboured mechanically over detailed drawings of casts with stump and chalk, drawings which could occupy them for months – or years.[15] In the provinces many schools reluctantly adhered to the drab template provided by Dyce's government-sponsored *Drawing Book*.[16] In reality few masters and pupils in the Schools of Design were interested in being used merely as cogs in the wheel of industry. Some bent the rules, others revolted: William Bell Scott in Newcastle encouraged his students to study the living model, while cultivating an interest for figurative art among local art patrons, many of them prominent businessmen.[17]

Under Henry Cole (director from 1852 to 1873) the Schools of Design evolved a more enlightened regime. Little was done, however, to increase the availability of the living model to students, not least because of a regulation stipulating that life classes could only be set up with the permission of a local committee. Inevitably, owing to a widespread fear of attracting the disapproval of the Church and of their peers, committees usually failed to grant the necessary permission. Nor was it even possible to advertise life drawing classes in annual course lists in case they attracted undue attention from students with suspect motives. It was in such an atmosphere of fear and distrust that in 1860 Charles Adderley, MP, Vice-President of the Committee of Council on Education, proposed in Parliament that Government grants should be withdrawn from any publicly funded school employing nude female models.[18] The bill was defeated. Yet, as a result of Adderley's intervention, by 1863 only eight provincial Government-sponsored schools ran life classes. In the context of such censorship it is easier to understand why the Royal Academy, the independence of which was under continued threat from the Government, was unwilling to take an innovative stance towards the role of the living model in its Schools.

Indeed, in 1863 the curriculum of the Royal Academy came under the official scrutiny of a Royal Commission. A great deal of ink was spilt and a number of Academicians, notably

Fig. 3 (*opposite*)
Dermod O'Brien
The Fine Art Academy, Antwerp
Oil on canvas, 1890
The Ulster Museum, Belfast

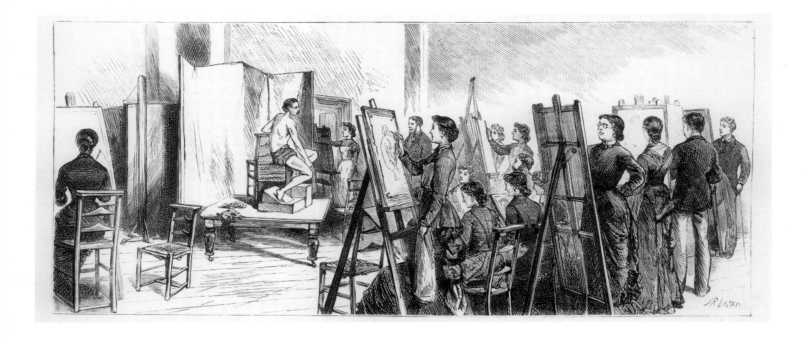

Fig. 4
The life class in the Slade School
Line engraving from *The Graphic*,
26 February 1881

Charles West Cope, spoke up in favour of the living model as the linchpin to artistic education.[19] However, even though it was granted a clean bill of health, the Royal Academy did not alter its position.

Those artists who had benefited from a Continental art education found the Royal Academy's attitude byzantine. In 1868 Charles Lucy bemoaned the preference given to the antique cast over the living model at the Royal Academy. Mark Anthony, also Paris-trained, went further, stating that it was the failure of the Royal Academy to provide proper art education that had given rise to the spate of private sketching clubs and to the Schools of Design (re-launched in 1852 as the National Art Training School under the Department of Practical Art). These remarks were significant, not least because they formed part of a dialogue then being conducted at University College London over the proposed foundation of a fine art department, which opened three years later, in October 1871, as the Slade School of Fine Art.[20]

The Slade School was founded with money bequeathed by the philanthropist and dissenter Felix Slade. From the beginning its primary object was "to afford the Student the most perfect means of making, and to aid him in learning to make, art studies from the life".[21] In order to carry out this objective the founders of the School appointed as the first Professor of Fine Art the thirty-five-year-old Edward Poynter, a former student in Rome and at the Paris atelier of Charles Gleyre. In his inaugural lecture Poynter stressed the central role to be played by "constant study from the life model". At the Slade students were to be encouraged to work directly from the model, at speed, in short bursts, and from memory. Poynter poured scorn on the activities of the students at the National Art Training School, whose drawings he doubted could be made in "under six weeks of painful stippling with chalk and bread".[22]

The impact of the Slade School on art education went far beyond artistic technique or the question of access to the living model to issues of class and of gender. For the first time women were permitted to work in public from the semi-naked living model (fig. 4), a right which was not extended to women students at the Royal Academy until 1894 – by which time women at

the Slade were working from the nude male model. The first Female School of Art had opened in 1842 under the aegis of the Government Schools of Design, while in 1857 the Society of Female Artists was formed, introducing the "costumed model" in 1863 and in March 1866 an evening class for the study of the "undraped Living Figure". In 1860, Laura Herford gained the memorable distinction of being the first woman to enter the Royal Academy Schools – because her drawing (marked *L.A. Herford*) was assumed to have been submitted by a man. Even though Herford was only permitted to work from the Antique, she supplemented her art education by attending evening classes run by Eliza Fox where both clothed and nude models were studied.[23] Other women art students made do by studying the model in private groups, while several brave souls crossed the Channel and enrolled in Parisian ateliers, where men and women were permitted to work side by side with the living nude model. An exception was the aptly named Frances Strong (later Lady Dilke), who gained special permission to work from the living model at the National Art Training School, South Kensington, simply by insisting upon her right to do so.[24]

Despite these inroads there was a residual stigma attached to the nude, and women generally shied away from living models of both sexes, afraid of attracting the opprobrium of a disapproving society, or the unwelcome attentions of male thrill-seekers and perverts who might offer themselves as models.[25] In 1872 female students about to enter a mixed life class were told in no uncertain terms that they alone bore the responsibility for maintaining decorum, inasmuch as by "looking neither to the right or to the left, they will never meet with annoyance, and will gradually form around them a pure, straightforward atmosphere".[26] Even Poynter, aware of the potential for mutual embarrassment, at first absented himself from the life room when female students were engaged in drawing the female model.[27] In reality, there was not much to distract the collective female gaze at the Slade until 1893, when the male model finally dispensed with his elaborate loincloth in favour of the more revealing *cache-sexe*.

Ultimately, the argument was not about the relative nudity of models in life classes, but about equality between the sexes and the erosion of the 'separate spheres' that divided Victorian men and women. Yet, in the 1880s, at the very time that female artists were gaining greater access to the living model, the crusade to ban the professional female model was at its height. Campaigners, we are told, trawled the streets in order to reform those women who earned, stated *The Times*, one of "the most pitiable sorts of female wages. Not alas! the most pitiable of all, but one too often adopted as the only practicable means of escape from a still worse alternative."[28]

Class was an issue as well as gender. For example, at the Slade in the early years students were unashamedly middle-class, an important criterion for admission being the ability to pay a stiff entrance fee.[29] Indeed free education, according to at least one interested party, would certainly be a mistake, "and the classes would consist of persons whose sphere is that of manual labour".[30] In art schools, too, the 'separate spheres' were not just of gender but of class. At the Working Men's College in the 1850s models were too expensive, forcing tutors and pupils to take it in turns to pose for life classes. The National Art Training School reinforced social barriers through the 'Morning Male Class' for artisans, the 'Special Gentleman's Morning Class', the 'Special Ladies' Class' and the 'Governesses' Class', reflecting a boom in interest among the bourgeoisie in art not merely as pastime but as a potential profession.[31]

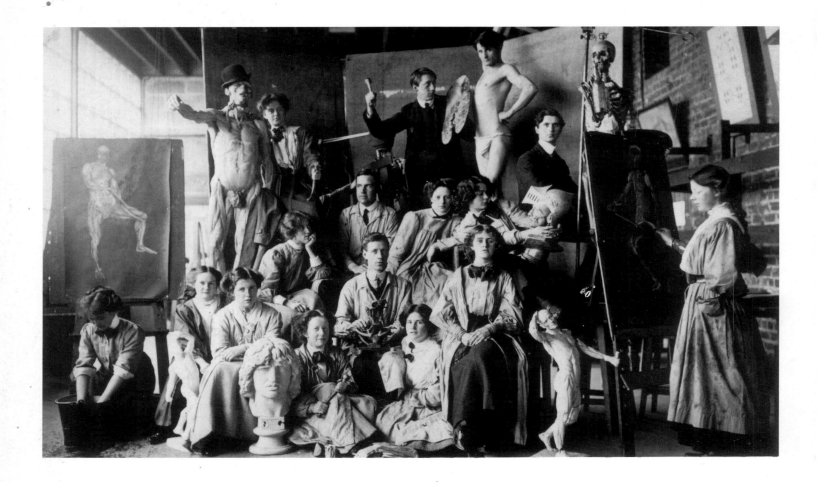

Fig. 5
*Students with a male model and
écorché figures, Anatomy Class,
Glasgow School of Art*
Photograph, ca. 1918
Glasgow School of Art

Fig. 6 (*opposite*)
Katherine Anne West
Life class, Slade School of Art
Oil on canvas, 1920–24
University College London

Towards the end of the nineteenth century nudity as a moral issue receded, and the model became more widely available to both sexes in art schools (fig. 6). The art student and the model were also corralled within a broader educational framework. In 1893 the London County Council established the Technical Education Board, and in 1896 the Central School of Arts and Crafts. Two years later the National Art Training School at South Kensington became the Royal College of Art, while Camberwell School of Arts and Crafts opened south of the river with life classes taking their place alongside courses on ceramics, metalwork, plumbing and bricklaying. By 1903 schools of art were run by local education committees, inaugurating the system which underpinned the art school in the twentieth century.

In provincial art schools educational regimes remained rigid, while in Scotland the traditional study of the Antique and anatomy remained the bedrock of artistic training (fig. 5). For art students in London, however, opportunities to study the living model increased dramatically – even before the outbreak of the First World War. Nina Hamnett, for example, enjoyed 'shopping around', studying the model at St Martin's Lane, the Westminster Technical Institute, Turnham Green, and privately with friends and lovers. Later, Robert Medley, who was enrolled at the Slade, also attended evening life classes at the Central School, run by William Roberts and Bernard Meninsky, and at Leon Underwood's private school in Olympia. Even at the Slade Medley adopted a casual attitude towards the life class: if he liked the look of the model he would make a drawing; otherwise he would chat on the School's steps with Rex Whistler and other friends.[32] Even the Royal Academy was affected. George Clausen, Director of the Schools

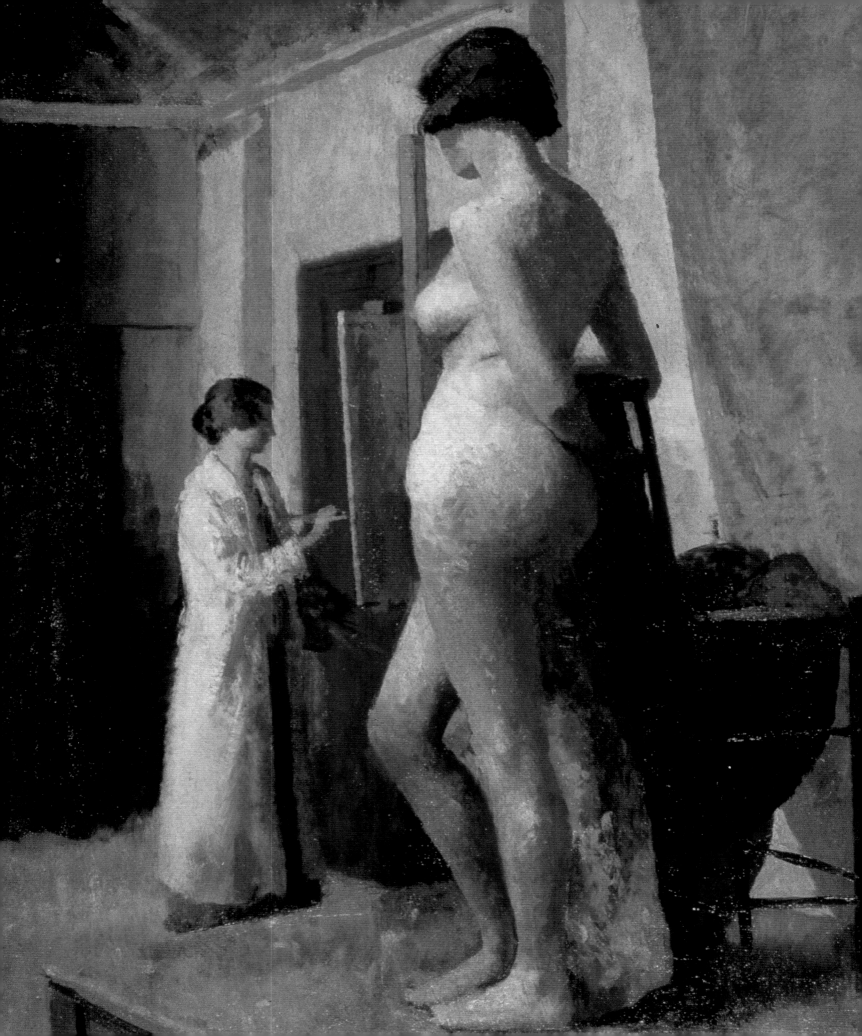

and Master of the Painting School, noted in 1926 that the rigid system of the life class in operation since the eighteenth century, with compulsory attendance, had all but disappeared, to the extent that it was "not so much a School as a rather freely-run life class". Later in the same decade the Royal Academy finally abandoned its 'Visitor' system, appointing instead salaried teachers.

As art schools changed and adapted to the needs of the modern world, artist's models, too, began to adapt. Paradoxically, as students became increasingly casual, models became more organized and professional. By 1920 they had a corporate identity and were able to assert their employment rights through the newly established Association of Artists' Models.[33] With the rise of naturism, and the increasing association of nudity with health and the outdoors, some of the residual social stigma surrounding modelling abated. In the 1940s it was observed that at least one of the female models at Camberwell (also the secretary of the models' union) was a naturist – "ensuring a deep all-over tan, especially in a hot summer".[34] It was not only the changing values of society, however, that demystified the model, but the attitudes of artists, notably those involved in the Euston Road School, intent on treating the figure as objectively as possible.

By the 1940s the Euston Road view of the model generally prevailed, certainly at progressive art schools such as Camberwell, where "in the life rooms a recurring selection of professional models stood, sat or lay in undramatic poses, the Euston Road ethos being that the nude human body was just another object whose structure must be analytically observed and transcribed unemotionally to canvas or paper".[35] It was this same ethos which cramped the style of the model Quentin Crisp, who, having twisted himself into impossible contortions for the benefit of the students, was told: "All you have to do is to stand as though you were waiting for a bus."[36] Today Crisp is a celebrity. But in the 1940s he was just another anonymous art-school model plying his trade at Camberwell, St Martin's and numerous suburban art schools in exchange for low pay, unsociable hours and poor working conditions. Whatever the social, economic and artistic changes of the previous one hundred years, the basic premise was unchanged: "To artists I was called 'Model', and addressed the teachers as 'Sir'."[37]

1 Quoted in Sydney C. Hutchison, *The History of the Royal Academy 1768–1986*, London 1986, p. 95.

2 *Laws Relating to the Schools, the Library, and the Students, Royal Academy of Arts*, 1862. The following year nine students were admitted to the Academy of Living Models, although only four were permitted to paint. In 1865, out of sixteen entrants, only four were allowed to paint.

3 See Ilaria Bignamini and Martin Postle, *The Artist's Model: Its Role in British Art from Lely to Etty*, exhib. cat., London, Kenwood, and Nottingham Djanogly Art Gallery, 1991, pp. 47–48 and 59–60.

4 See Robin Hamlyn, 'Sezession und Erneuerung. Kunstakademien in London 1837–1848', in *Viktorianische Malerei von Turner bis Whistler*, exhib. cat., Munich, Neue Pinakothek, 1993, p. 32.

5 *Ibid.*, p. 34.

6 Albert Boime, *The Academy and French Painting in the Nineteenth Century*, New Haven and London 1971, esp. pp. 19–23 and 50–57. For a detailed first-hand account of the Paris system in the late 1860s see Mark Anthony in Martin Postle, 'The Foundation of the Slade School of Fine Art: Fifty-nine Letters in the Record Office of University College London', *The Walpole Society*, 1996, LVII, pp. 165–66.

7 See Boime, *op. cit.* note 6, p. 34.

8 See John Milner, *The Studios of Paris: The Capital of Art in the Late Nineteenth Century*, New Haven and London 1988, pp. 11ff.

9 For further background on bohemia and its impact on artistic behaviour see Frances Borzello, *The Artist's Model*, London 1982, pp. 86–98.

10 Quentin Bell, *The Schools of Design*, London 1963, *passim*.

11 Stuart Macdonald, *The History and Philosophy of Art Education*, London 1970, p. 81.

12 *Ibid.*, p. 84. See also J. Paston, *Benjamin Robert Haydon and his Friends*, London 1905, p. 97; B.R. Haydon, *Table Talk and Correspondence*, London 1876, I, p. 201.

13 Robert Crozier, 'Recollections', 1879 MS, Manchester Reference Library 709.42 M2. Quoted in Macdonald, *op. cit.* note 11, pp. 174 and 87.

14 Hamlyn, *op. cit.* note 4, p. 34.

15 Macdonald, *op. cit.* note 11, pp. 193–96.

16 William Dyce, *The Drawing Book of the Government School of Design*, London 1843. See Macdonald, *op. cit.* note 11, pp. 122–24.

17 Macdonald, *op. cit.* note 11, p. 107.

18 See Alison Smith, *The Victorian Nude: Sexuality, Morality and Art*, Manchester 1996, pp. 30–32.

19 See *Report of the Commissioners Appointed to Inquire into the Present Position of the Royal Academy in Relation to the Fine Arts; together with the Minutes of Evidence*, London 1863.

20 See Postle, *op. cit.* note 6, pp. 127–234.

21 *Ibid.*, p. 159.

22 Edward J. Poynter, *Lectures on Art*, 4th edn, London 1897, p. 106.

23 For Eliza Fox's evening classes with nude models see Ellen C. Clayton, *English Female Artists*, London 1876, II, p. 83.

24 See Sara M. Dodd, 'Art Education for Women in the 1860s: A Decade of Debate', in Clarissa Campbell Orr, ed., *Women in the Victorian Art World*, Manchester 1995, p. 189.

25 See for example the letter sent by a man offering himself as a nude model to Louise Jopling's life class. Smith, *op. cit.* note 18, p. 234, quoting Louise Jopling, *Twenty Five Years of my Life*, London 1925, p. 86.

26 Mabel Kennington Cook, *Woman Magazine*, 3 February 1872, p. 35, quoted in Smith, *op. cit.* note 18, p. 154.

27 Randolph Schwabe, 'Three Teachers: Brown, Tonks and Steer', *Burlington Magazine*, June 1943, p. 142.

28 Smith, *op. cit.* note 18, p. 227.

29 The fee for the General course at the Slade was 7 guineas for an eleven-week term. By comparison students at South Kensington paid £4 for a five-month session, while students at the Working Men's College in Great Ormond Street paid 2s. 6d. for an eight-week life drawing class. See Postle, *op. cit.* note 6, p. 145.

30 William Collingwood Smith to Edwin Field, 19 October 1868, in Postle, *op. cit.* note 6, p. 178.

31 See Macdonald, *op. cit.* note 11, p. 143f. Also Paula Gillett, *Worlds of Art. Painters in Victorian Society*, Princeton NJ, 1990, pp. 18–68.

32 Robert Medley, *Drawn from the Life: A Memoir*, London 1983, p. 57.

33 See correspondence from the Education Officer of the LCC and the Registrar of the Royal College of Art concerning the working conditions and rates of pay for models as stipulated by the Association of Artists' Models: The London and Suburban Art Schools and the Artists' Models Association (London Branch), 1920, Royal Academy of Arts archives, Cab I, Box 27.

34 Alastair Gordon in Geoff Hassell, *Camberwell School of Arts and Crafts: Its Students and Teachers 1943–1960*, Woodbridge 1995, p. 195.

35 *Ibid*.

36 Quentin Crisp, *The Naked Civil Servant*, London 1968 (Fontana paperback edition 1986, p. 131).

37 Crisp in Hassell, *op. cit.* note 34, p. 28.

William Etty (1787–1849)

1 *Study of a male nude*

Oil on paper, 56 × 38.5 cm

1830–40s?

Royal Academy of Arts, London

2 *Study of a standing female nude*

Oil on paper, 55.7 × 38.3 cm

1830–40s?

Royal Academy of Arts, London

These two oil studies on paper of the male and female model form part of a series of nineteen such studies recently rediscovered in the archives of the Royal Academy. They represent Etty's oil studies of the model at their very best: fresh, lively and, to their great benefit, lacking clumsy classical landscape additions by later hands.

Like the majority of Etty's life paintings, they were probably made in the Schools of the Royal Academy. Generally, a finished academic oil study from the living model occupied Etty for three evening sessions – a total of six hours. During the first session he drew out the figure in charcoal or chalk on millboard (or, in this instance, paper). He then inked in the outline. At home he rubbed size into the board to prepare the surface for oils. During the second session he worked in oils, modelling the contours of the figure initially in sepia. On the final evening a glaze was added into which local colour was worked.[1]

As early as the 1820s Etty's treatment of the female nude was attracting criticism, but Etty could not understand the fuss, observing, "People may think me lascivious, but I have never painted with a lascivious motive. If I had, I might have made great wealth."[2] As a rule, Etty did not sell his studies of the model. As a result, at his posthumous studio sale at Christie's in 1850, there were over 800 of them up for auction, which, according to *The Athenaeum*, was "likely to be as pernicious to art as to morals". Most were bought by dealers, who added landscape scenery to 'finish' them and sold them on.[3]

MP

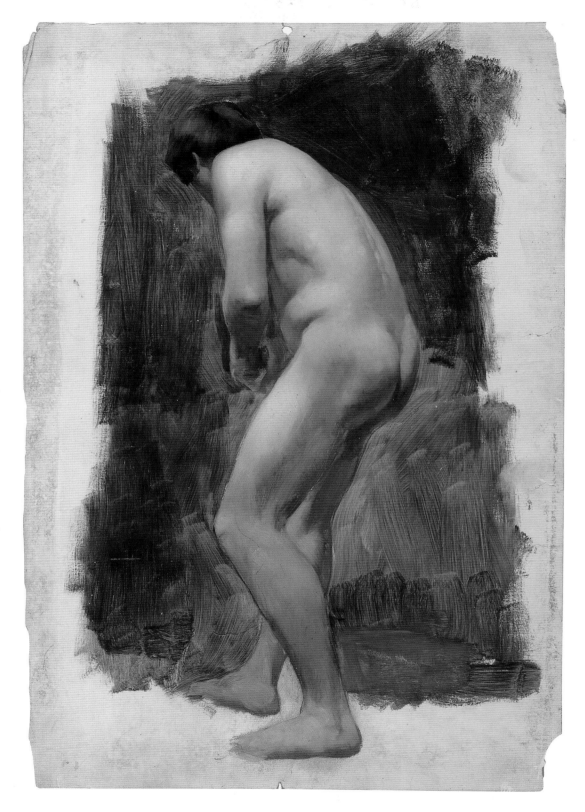

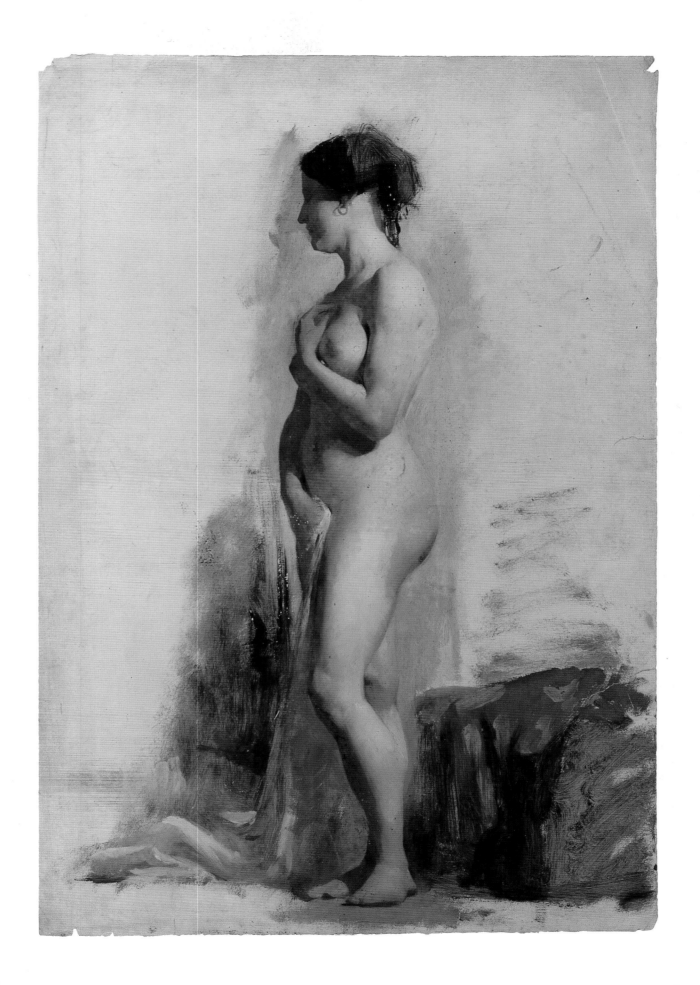

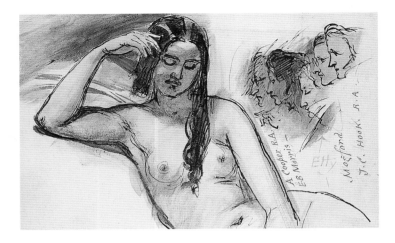

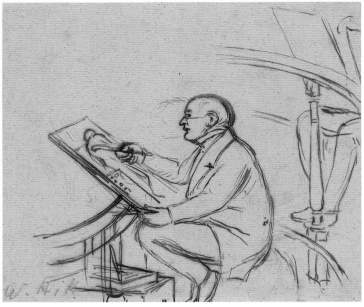

William Edward Frost (1810–1877)

3 *Study of a reclining nude, with profile portraits of artists*

Pen and ink and watercolour,
9.5 × 14.5 cm
ca. 1845
Private collection

A protégé of William Etty, Frost devoted a great deal of his time to drawing and painting the female nude. The present study, evidently made in the life class of the Royal Academy, includes profile portraits of Abraham Cooper (1787–1868), Ebenezer Butler Morris (*fl.* 1833–63), John Mogford (1821–1885), John Clarke Hooke (1819–1907) and William Etty.

MP

William Holman Hunt (1827–1910)

4 *William Etty in the Life School, Royal Academy of Arts*

Pen and brown ink over pencil,
10.5 × 12 cm
Signed in pencil: *W.H.H*
York City Art Gallery (purchased with the aid of the MGC/V&A Purchase Grant Fund and the Friends of York City Art Gallery, 1990)

Holman Hunt was admitted shortly after his twentieth birthday to the Life School at the Royal Academy, where Etty was to spend one last year before failing health forced his retirement to York. This slight sketch shows Etty working from the living model. The brush in his hand and the palette resting on his board indicate that he is working, as usual, in oils. The position of the student to Etty's right shows the raked, semi-circular seating arrangement in the Academy's Life Room. Many years later Hunt recalled how he had almost bumped into Etty when running up the spiral staircase to the Life Room in the dome of the National Gallery: "I was too late for retreat, for he turned and saw me. I made my gentlest salutation to the bearer of the burden of life, the more reverently, seeing that his infirmity did not quench his ardent habitual effort. He could scarcely speak, but stood aside and made signs for me to pass. I apologised, with assurance that I would follow. Beckoning me close to him he said, as he put his hand upon my shoulder: 'Go. I insist! Your time is more precious than mine.'"[1] The present sketch was used by Hunt as an illustration to his book *Pre-Raphaelitism and the Pre-Raphaelite Brotherhood*, published in 1905.

MP

Thomas Faed (1826–1900)

5 *A life study of John Mongo ('The Punka-walla')*

Oil on paper, laid on board, 66 × 52.8 cm
Inscribed: *Portrait of John Mongo/ the prize painting in Life Class September 1847/ by Thomas Faed/ Presented by him to Sir Thomas Dick Lauder Bart.*
National Galleries of Scotland, Edinburgh

Thomas Faed was admitted to the Trustees Academy in Edinburgh in 1843.[1] He was a prize-winning student both in the Antique School and in the life class, the present life study winning a prize in 1847. It was as a token of appreciation that the young Faed presented his study to Sir Thomas Dick Lauder, then a Member of the Board of Trustees of the Academy.

Despite the evidence of Faed's accomplished life painting, the Trustees Academy was facing a crisis by the mid-1840s. It was effectively split into two schools, one catering in theory for design students, the other for fine art students – although, in truth, few were genuinely interested in the design option. Teaching standards were privately perceived to be slipping, and the Trustees Academy was engaged in a bitter dispute with the Royal Scottish Academy, who claimed that life classes had been introduced by the Trustees with the specific intention of sabotaging its own attempt to start up an art school; which was especially galling as the Trustees Academy had been founded to assist manufactures, not high art, and did not therefore need to run life classes. The issue temporarily subsided, although life classes eventually slipped from the grasp of the Trustees Academy. The situation was a microcosm of a wider debate in nineteenth-century Britain over the nature of art education versus design education and the relative rights of artists and artisans – a debate in which the artist's model was an unwitting pawn.

MP

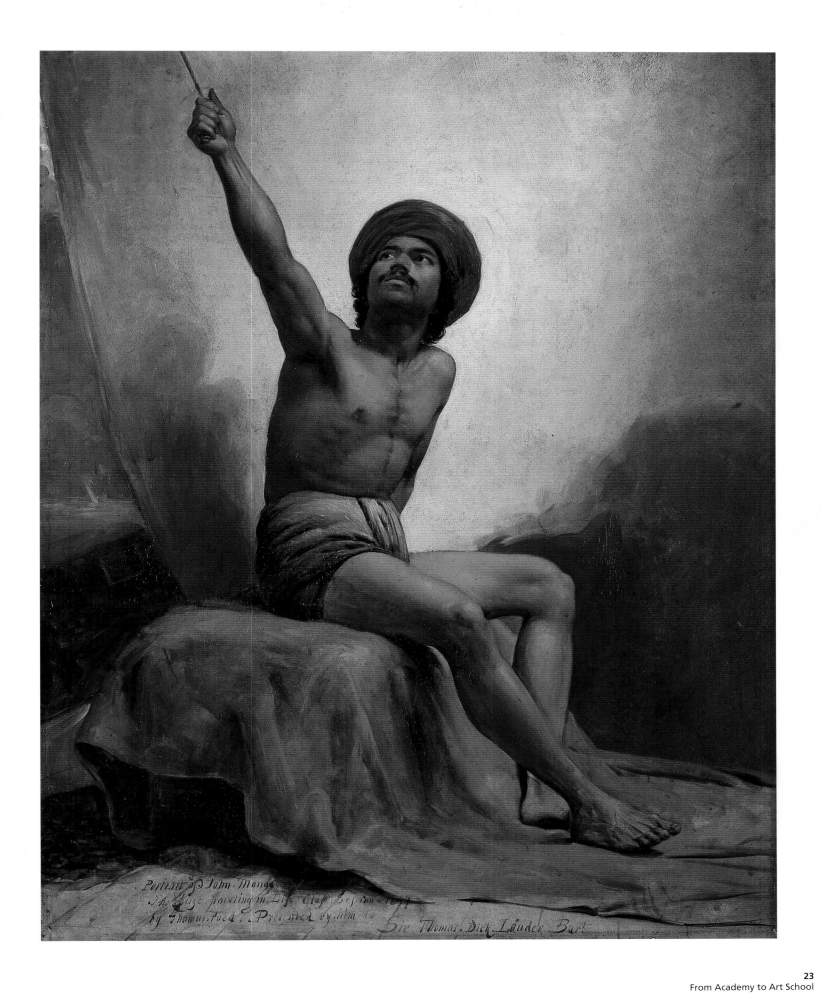

Portrait of Sr John Monro.
The Prize painting in Life Class Session 1849
by Thomas Faed. Presented by him

Sir Thomas Dick Lauder Bart

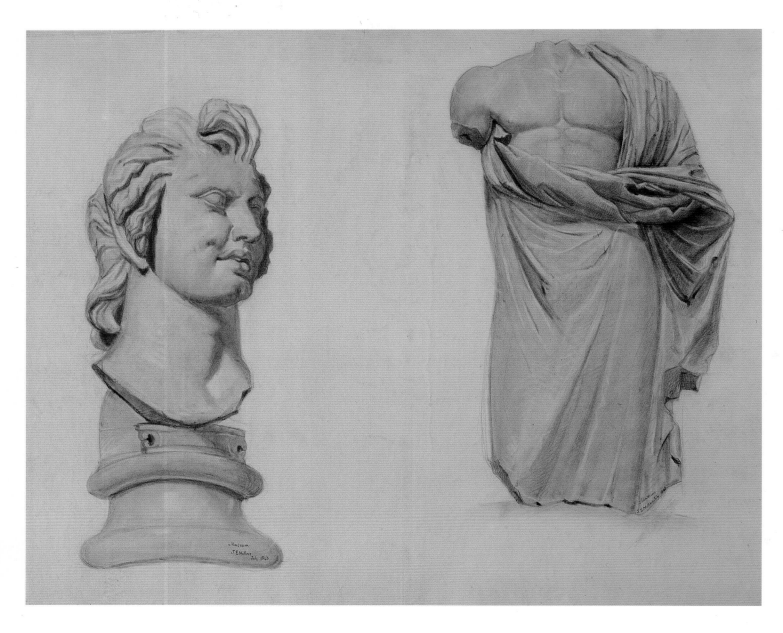

**Sir John Everett Millais
(1829–1896)**

6 Study of antique statuary

Chalk on paper, 53.4 × 66.3 cm
Signed: 'Museum/ J E Millais/ July 1843'
Royal Academy of Arts, London

As the inscriptions reveal, these
drawings were made by Millais at
the British Museum at the age of
fourteen. The head of a satyr on
the left was part of the Townley
collection (British Museum
catalogue no. 1661), while the
draped torso belonged to the
Elgin collection (British Museum
catalogue no. 551), although it is
now considered to be a Roman

copy of a Greek original.
It was while studying from the
antique at the British Museum
that Millais first encountered
Holman Hunt.

Millais's career allegedly began
at the age of four, under the
tutelage of a drawing master in
Jersey, who gave him engravings
after Old Master paintings to copy
as well studies from nature. In
London he drew from casts at
the British Museum, then began
drawing at Henry Sass's art school
in Streatham Street, where he
again worked from antique casts.
In 1839 he won the Silver Medal
of the Society of Arts for a chalk

drawing of a Greek warrior.
The following year, in July 1840,
Millais became a Probationer
at the Royal Academy Schools.
By December, having completed
the obligatory and supervised
anatomical and antique drawings,
he was admitted as a student.
Now aged eleven, he was the
youngest full student to date. In
1843 he was admitted to the life
class, although because of his age
he was only permitted to work
from the male model.[1]

MP

Sir John Everett Millais

7 *Male nude in the attitude of an archer*

Coloured chalks on paper, 71 × 49.5 cm
ca. 1847
Towneley Hall Art Gallery and Museums,
Burnley Borough Council

This drawing was probably made
at the Royal Academy of Arts,
where Millais drew the living
model from 1843. The model,
set in the attitude of an archer,
would have been posed by one
of the Academicians in the role
of 'Visitor'. At the time Visitors
included William Mulready, whose
highly naturalistic approach to
the nude model is echoed in the
present drawing. Because he was
then still a teenager Millais was
allowed to work only from the
male model, the female model
being available only to students
who were aged twenty and above
or were married. However, the
existence of studies by Millais
made from the female model,
dated 1846 and 1847, indicate
that he was also attending life
classes outside the Royal Academy
– possibly at Leigh's School or
Sass's.

MP

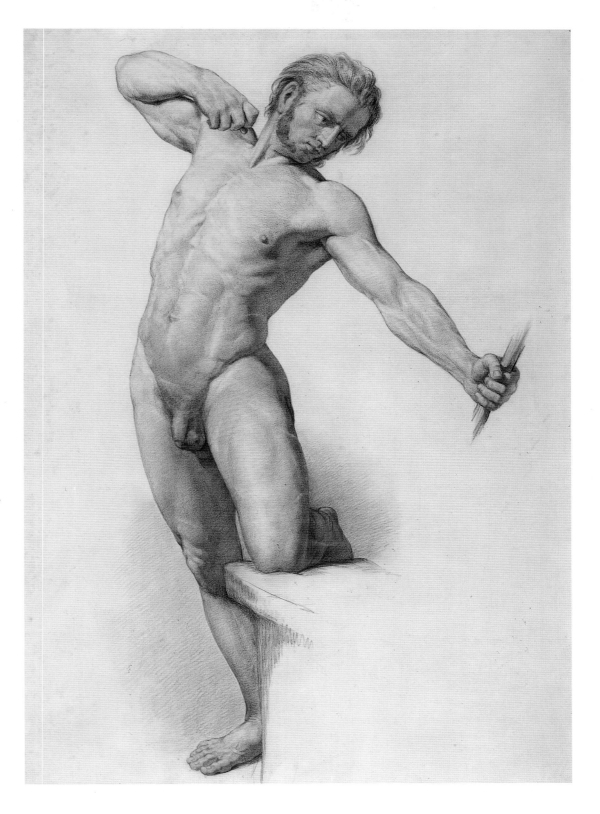

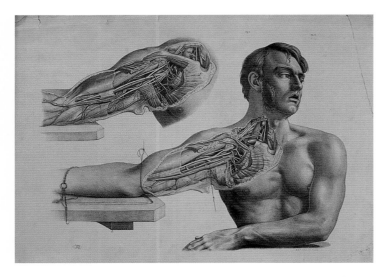

Joseph Maclise
(active mid-19th century)

8 Plate 6 from *Surgical Anatomy*,
London 1851

Lithograph, 37.9 × 51.4 cm
Wellcome Institute Library, London

This illustration from Joseph Maclise's *Surgical Anatomy* is a graphic illustration of the manner in which mid-Victorian techniques of life drawing permeated into medical treatises, and a reminder of the way in which the poor served as models in death as well as life.

Joseph Maclise, brother of the artist Daniel Maclise, was a surgeon and general practitioner associated with the medical school at University College London. In the present lithograph Maclise artfully presents a highly naturalistic study of the living model as a cadaver which – despite the graphic dissection of its upper arm – appears very much alive, and quite as unconcerned as if its pulse were being taken. These consciously tasteful anatomical illustrations are quite opposed to the contorted corpses depicted by an earlier generation, notably Charles Bell and Benjamin Robert Haydon and his school. In their promotion of 'taste' they look back to the classical skeletons and écorchés of Albinus, while at the same time absorbing

the hyper-realistic manner of life drawing then promoted by Mulready (see cat. 11).

In his introduction to *Surgical Anatomy* Maclise explained his reasons for minimizing the morbid nature of his plates: "We dissect the dead animal body in order to furnish the memory with as clear an account of the structure contained in its living representative, which we are not allowed to analyse, as if this latter were perfectly translucent, and directly demonstrative of its component parts." Formerly, the "dead animal" bodies upon which anatomists and surgeons performed dissections were those of executed criminals. Following the Anatomy Act of 1832, the use of paupers was allowed. Indeed, as Ruth Richardson has stated, "What had for generations been a feared and hated punishment for murder became one for poverty."[1]

MP

Sir William McTaggart
(1835–1910)

9 *Prize drawing after
the Antique*

Pencil and conté crayon on buff paper,
74 × 105 cm
1854–55
The Board of Governors, Edinburgh
College of Art

William McTaggart studied from 1852 to 1859 at the Trustees Academy in Edinburgh (see also cat. 5), this drawing winning him the second prize for Drawing from the Antique in the academic session 1854–55.[1] Accomplished by any standard, McTaggart's *Prize drawing after the Antique* signalled the climax of the first stage of his art education, following an intensive course in line drawings copied from 'the flat' and shaded drawings done from 'the round', a sufficient number of which have survived to gauge the painstaking labour which underpinned the mastery of form and tonality shown here.

The Trustees Academy had begun to assemble a collection of antique casts in 1798, although the cost of importing such objects meant that progress was comparatively slow. In 1837 a catalogue of the casts was compiled, by which time it was claimed to represent "the history of sculpture during a period of rather more

than two thousand two hundred years".[2] By the 1850s the cast collection contained many notable classical paradigms, including (as shown in McTaggart's drawing) the Borghese *Gladiator*, the *Dancing Faun*, the *Callipygian* and the *Celestial Venus*, as well as reclining figures from the pediment of the Parthenon and the figure of Christ from Michelangelo's *Pietà* (minus the Virgin).

It was not, however, the increased provision of casts that enhanced the educational opportunities at the Trustees Academy during McTaggart's studentship, but the inspirational teaching of Robert Scott Lauder (1803–1869), officially appointed as Director of the Antique in 1852. On his arrival Lauder set about cleaning the casts, rearranging them into groups, and lighting them dramatically for composition studies – as McTaggart's drawing admirably reveals. Lauder, in addition, imposed strict discipline and a competitive edge among the students, McTaggart's fellow-pupil recalling to him in 1860 "our enthusiastic talk, our quick march up to the academy, our earnest work, our purpose to take *the prizes* (which we did)".[3] Although firm, Lauder was not prescriptive in his teaching, encouraging his

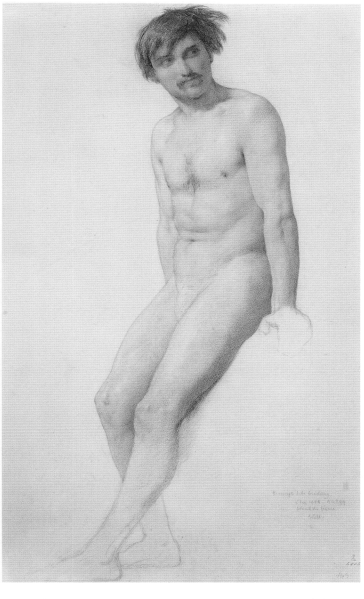

students to make paintings as they studied at the Academy, constantly applying the skills learnt through their studies to their work outside – an approach which was anathema to the rigid regime then in force at the Royal Academy Schools.

MP

George Paul Chalmers (1833–1878)

10 *Prize drawing from the Antique*

Pencil and conté crayon on buff paper,
78 × 107 cm
1855–56
The Board of Governors, Edinburgh
College of Art
(Withdrawn from Exhibition)

Chalmers's study was awarded first prize in Drawing from the Antique at the Trustees Academy in Edinburgh during the session 1855–56. A fellow-pupil of William McTaggart under Robert Scott Lauder (see cat. 9), Chalmers enrolled at the Academy in 1853. His study is a testament to Lauder's innovative use of grouped antique statuary at the Academy and the power of his pedagogy.

MP

William Mulready (1786–1863)

11 *Standing male model*

Black and red chalk on paper,
55.5 × 34 cm
Inscribed: *WM./ Kensington Life
Academy,/ 2 Dec. 1859. A.L. Egg/
placed the figure*
Victoria and Albert Museum, London

As the inscription indicates, the present study was made at the Kensington Life Academy, a private club which met three evenings a week, probably at the home of Richard Ansdell (1815–1885). Other members included William Holman Hunt and Augustus Leopold Egg, the artists taking it in turns to set the model's pose.[1] (A head-and-shoulder study of the same model by Robert Braithwaite Martineau (1826–1869), then a pupil of Hunt, belongs to Manchester City Art Gallery, inv. 1951.8b.)

The drawing shown here was made by William Mulready at the age of seventy-three, a testament to his life-long devotion to the living model.[2] Mulready had drawn from the model since at least 1800, when he was admitted to the life class at the Royal Academy. However, it was only in 1840 that he began to develop his meticulous, refined manner of drawing in coloured chalks. As the present drawing reveals, Mulready was concerned

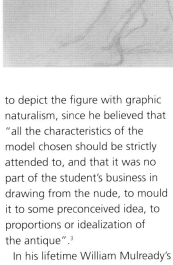

to depict the figure with graphic naturalism, since he believed that "all the characteristics of the model chosen should be strictly attended to, and that it was no part of the student's business in drawing from the nude, to mould it to some preconceived idea, to proportions or idealization of the antique".[3]

In his lifetime William Mulready's superb technical skill in drawing the model was widely acknowledged: several of his drawings were acquired by the Schools of Design in 1859, some of which were made into lithographs for use in provincial schools.[4]

Already, his nude studies had been exhibited at Gore House in 1853. Despite efforts to keep her away, Queen Victoria made a close inspection, "making frequent exclamations of admiration". She subsequently purchased five studies for Prince Albert.[5] Yet, on the whole, Mulready was reluctant to part with these studies, "fearing that they were appreciated for the wrong reasons".[6]

MP

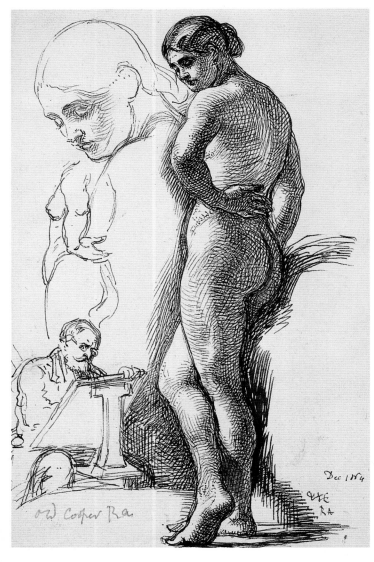

before which time any studies from the life made by students were copied in 'the flat' from drawings or engravings. By 1850 life classes were held from 8 to 10 am and 6 to 8 pm on weekdays, to allow for those students in employment. While male models posed in the evenings, female models worked in the mornings – perhaps, it has been suggested, to avoid their going home in the dark,[2] or alternatively to discourage students from socializing with them after hours. Certainly Robert Scott Lauder ran the life class with a rod of iron, suspending one of his students in the summer of 1853 "for having pointed out and taken notice of one of the Female Models in the street". The student was not allowed back until he had made a written apology to the Board on his own behalf and on behalf of the model.[3]

MP

Charles West Cope (1811–1890)

13 *Abraham Cooper drawing the female model*

Pen and ink, with traces of wash, on paper, 21 × 13.5 cm

Incribed: *Old Cooper RA/ Dec 1864/ CWC [monogram] RA*

Trustees of the National Portrait Gallery, London

Cope depicts the Academician Abraham Cooper seated at his 'donkey' in the Royal Academy life class, before the female model. The model's pose would have been retained for two hours, with a short break after one hour. (If the model needed a rest in the interim the hourglass would be set on its side.) Cope's drawing was made in the evening, between 6 and 8 pm, the hours set aside by the Academy for the winter Academy of Living Models; the summer Academy ran from 4 to 6 pm. Studies were made by artificial light (in summer the life class moved up to the dome of the National Gallery). According

to new rules set out in 1862 models were required to sit for at least six consecutive nights, while the students now drew lots for places.[1]

Abraham Cooper (1787–1868), the co-subject of Cope's study, had been elected an Associate Member of the Academy in 1817, although he was technically never a student in the Schools, having failed the tests for admission as a Probationer the same year. It was therefore ironic that Cooper, as an Associate, was entitled to enter any of the Schools whenever he liked.

The present study is one of nineteen lively and intimate sketches of working artists neatly mounted in a green leather-bound album in the National Portrait Gallery.[2] They date from the early to mid-1860s and were made during the time that Cope served as a Visitor in the Academy Schools. Each year nine Visitors were selected from the ranks of the Academicians to instruct in the Schools of Design – the Antique School and the various life classes. Visitors, who were paid, were required for a month at a time to set the pose of the model and to "examine the performances of the Students, to advise and instruct them, to endeavour to form their taste, and to turn their attention towards that branch of the Arts for which they shall seem to have the aptest disposition".[3]

The success and enthusiasm with which Academicians carried out their duties varied: Cope, Dyce, Millais and Leighton were all assiduous in their duties; Etty earnestly studied the model alongside the students; Edwin Landseer simply read a book. The Visitor system, which was peculiar to the Royal Academy, survived under increasing criticism into the 1930s, when professional teaching staff were introduced.

MP

Sir William McTaggart

12 *Life study of two nude female models*

Oil on canvas, 61 × 58 cm

ca. 1855

National Galleries of Scotland, Edinburgh

William McTaggart painted extensively from the living model at the Trustees Academy in Edinburgh from the mid-1850s onwards, winning third prize for life painting in 1855, first prize in 1856, and an honorary prize in 1857, since, as a previous winner, he could not be awarded the prize a second time. The present study is unusual in depicting two female models posing together. The similarity in physique and features

between the two models might suggest that the study was made from one model in two different poses, but the existence of at least two other studies of the same composition by McTaggart's fellow students indicates that the models, like the antique figures in the Academy, were deliberately positioned together in order to present an additional challenge.[1] Though an innovation at the Trustees Academy, this had been common in the French Academy since the eighteenth century and at the Royal Academy from at least the 1830s.

The living model was not incorporated into the curriculum of the Trustees Academy until the 1830s,

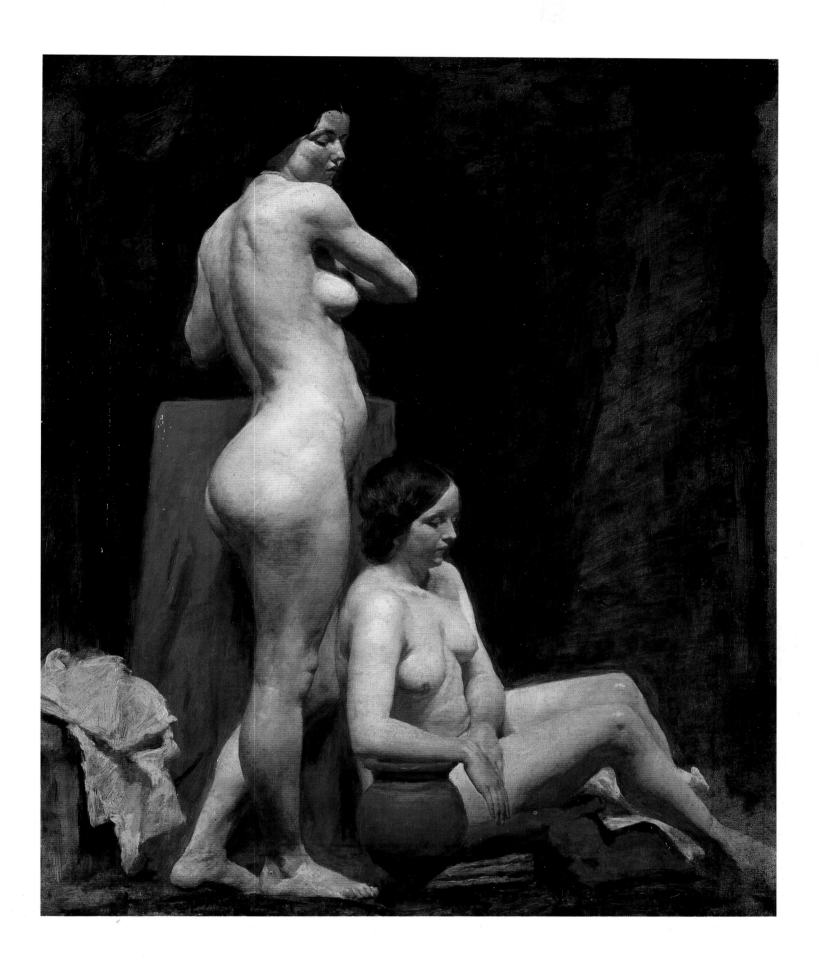

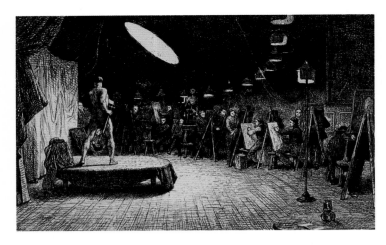

Charles West Cope

14 *The life class at the Royal Academy*

Etching, 15.3 × 24 cm

Inscribed: *WC 1865 Life School. Royal Acad[y]*

The Trustees of the British Museum, London

Cope's modest etching is among the most evocative portrayals of the life class at the Royal Academy, and a personal record of his devotion to his role as Visitor during the years 1861 to 1866. The male model, quite possibly posed by Cope, stands in the dramatic attitude of a classical warrior drawing a sword – a common device in British and Continental art schools, allowing a *contrapposto* posture which maximizes the muscle tension in the figure. The model is lit by a large, angled gas lamp, his form silhouetted against a large white sheet. The students' studies are illuminated by smaller shaded individual lamps above their heads. According to an inscription on one impression the students were competing for one of the annual medals awarded by the Academy.

The first medal for painting from the life – as opposed to drawing – was awarded in 1849. At that time any student in the School of the Living Model could choose to paint or draw the living model. In 1862 the laws were tightened: from that time students wishing to paint the model were compelled to submit to the Council "a finished Drawing from the Male Model, which drawing, if approved, shall admit such Student that privilege. Students not admitted to Paint from the Nude Model, to be restricted to the use of black, white, and red chalks".[1] In 1865, the year of Cope's engraving, sixteen students were admitted to the School of the Living Model, but only four were permitted to paint.

In view of the sex of the model in Cope's engraving, and the fact that permission to paint from the living model was granted on the basis of drawings made from the male model only, it is relevant that during 1854 to 1858 (the only years in which the names of models are given in the Royal Academy register of medal-winning drawings) only male models posed for competition in the life class – underlining the continuing primacy of the male model over the female in the academic hierarchy, despite the rising tide of interest in the female model in the public domain.

MP

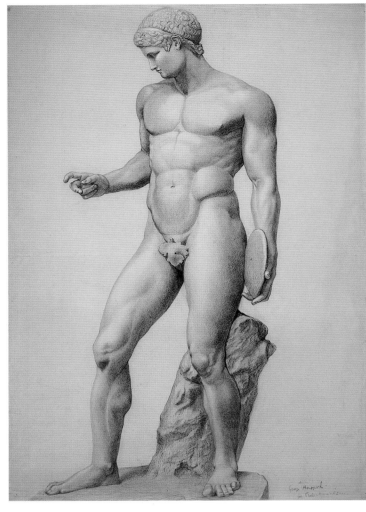

George James Howard, 9th Earl of Carlisle (1843–1911)

15 The *Discobolus*

Graphite and black and white chalk on grey paper, 76 × 43.5 cm

ca. 1864–66

Inscribed: *George Howard for Probationism*

The Trustees of the British Museum, London

George Howard apparently made this drawing as a probationary drawing for entry to Heatherley's School. (The drawing is lined on the back with a sheet of heavier grey paper, covered by a page from *The Times* dated Thursday, 10 May 1866.) Howard, who was educated at Eton College and Trinity College, Cambridge, went on in 1865 to study at the Schools of Design at South Kensington and privately under Giovanni Costa (1826–1903) and Alphonse Legros.

MP

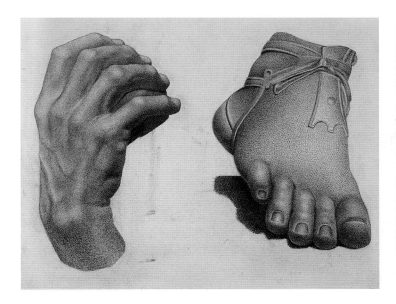

Samuel Butler (1835–1902)

16 *Studies of casts of a hand and foot*

Pencil on paper, 33 × 48.2 cm
1868
By permission of the Master and Fellows of St John's College, Cambridge

In 1865 Samuel Butler gave up sheep farming in New Zealand and decided to train as an artist. He began by taking lessons at the Bloomsbury art school run by Francis Stephen Carey (formerly Sass's School), before moving on to Heatherley's School, where he made a number of painstaking drawings from plaster fragments after the Antique – for generations, among the most elementary exercises undertaken by students. Butler had already attended the Cambridge School of Art, where he had made similar drawings "from the flat and then from the plaster" – that is outline drawings made from prints, and shaded drawings from three-dimensional plaster objects. According to a fellow student Butler was then "very anxious to become an Academy student. He sent in his drawings several times, but they were never passed."[1]

MP

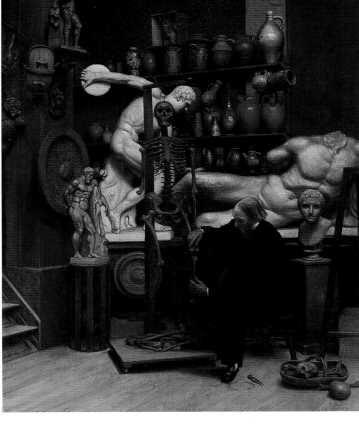

Samuel Butler

17 *Mr Heatherley's Holiday: An Incident in Studio Life*

Oil on canvas, 92.1 × 70.8 cm
1874
Tate Gallery, London. Presented by representatives of Jason Smith, 1911

Although Samuel Butler initially saw Heatherley's School as a stepping stone towards entry to the Royal Academy Schools, by the mid-1860s he was already deeply sceptical of institutions in general, and quickly came to distrust what he saw as the dead hand of current academic training. *Mr Heatherley's Holiday* was painted in the early 1870s, when he had, as he recalled, "drifted back to the fatal self-deception of going to Heatherley's".[1] Rather than a straightforward record of the minutiae of Heatherley's School, Butler's painting is, according to Elinor Shaffer, an emblem of his personal rebellion, an "ironic critique of the academic style", against which he was simultaneously reacting in his satirical writings and burgeoning interest in the new art form of photography.[2] The obsessive Heatherley allegedly never took a holiday, preferring instead the claustrophobic atmosphere of his London art school. The academy is here characterized as a fusty lumber room, the vital presence of the living model supplanted by a (female) skeleton caressed by a grey-haired old man.

Thomas J. Heatherley (1826–1914) became principal of Leigh's Art School in 1860, following the death of the founder James Matthews Leigh (1808–1860).[3] Leigh had advertised his private art school in 1841, shortly after the death of Henry Sass, who had run one of the capital's most successful art schools. Classes ran from 6 am to 6 pm and from 7 until 10 pm. Male and female students were admitted upon payment of a set fee. Leigh, who had trained privately under William Etty and on the Continent, was particularly responsive to the more liberal regime operated in the schools of Paris, allowing his students to evolve their own style in working from casts and from the living model. Among those who benefited from training there were Thackeray and Rossetti (who was admitted *gratis* to the life class as he was then too poor to afford the fees). Although this was an independent art school, its facilities were also used by artists to prepare for entry to the Royal Academy Schools.

Although Heatherley changed the name of the school in 1860 to reflect his proprietorial status, the same relaxed, if doctrinaire, atmosphere was maintained, Heatherley even adopting Leigh's bohemian garb and manner. Over the years Heatherley continued to accumulate a huge collection of artistic props: suits of armour, skeletons, historical costumes, stuffed animals and pottery. Many of these were housed in his Antique Room, alongside his cast collection.

MP

Sir William Hamo Thornycroft (1850–1925)

18 *Study of a nude male model, seated*

Black chalk on paper, 75 × 52.5 cm
1873

Inscribed on verso: *W Hamo Thornycroft March 30 1873 For Life Competition Third Silver Medal 10 Dec 1873*

Leeds Museums and Galleries (City Art Gallery). Presented by Mrs Elfrida Manning, the sculptor's daughter, 1982

Thornycroft was admitted as a sculpture student at the Royal Academy Schools in June 1869. He graduated in 1870 to the life class at the Royal Academy, where he was greatly inspired by the teaching and example of Leighton. At that time sculpture students were not taught separately, but worked alongside students drawing the model. As Thornycroft complained to Leighton, while conditions were good for drawing they were far from ideal for the sculptors; in response Leighton prompted the Council to raise the height of the models' dais for the benefit of the sculpture students.[1]

Thorneycroft's distinguished academic record was rounded off in 1875, when he was awarded the biennial Gold Medal for the Best Work of Sculpture over his close rival at the Schools, Alfred Gilbert. Having been made an Associate Royal Academician in 1883 he began teaching at the Academy life class. Later in the decade, on becoming a full Academician, he campaigned vigorously for the rights of female students to study from the nude model, and to introduce mixed life classes.[2] It was not coincidental that three of Thornycroft's sisters had studied at the Royal Academy Schools, Helen Thornycroft gaining admission in 1864 aged sixteen.[3]

MP

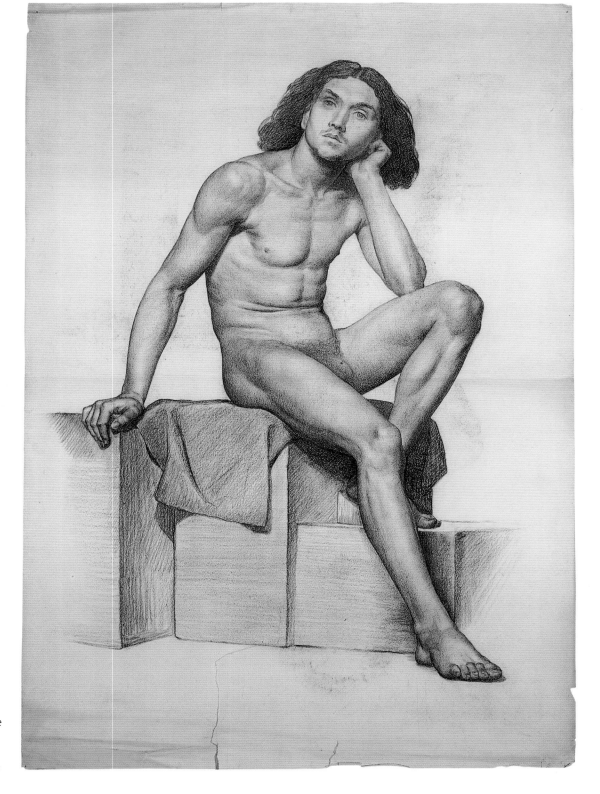

Sir Edward Poynter
(1836–1919)

19 *Figure, forearm and hand studies for the fresco of St Stephen, South Dulwich*

Black chalk on paper, 37.8 × 28.2 cm
Inscribed: *St. Stephen Fresco/ June 26. 72*
The Trustees of the British Museum, London

Poynter's figure study, possibly based on an Italian model, was one of a series of drawings made for a fresco cycle in St Stephen's, Dulwich, shortly after his appointment as first Professor at the Slade School of Art in 1871. Here it acts as a paradigm of the drawing style he wished to promote through his pedagogy. In his inaugural lecture to Slade students in 1871 Poynter stated that the school was to be based on the French atelier system, where speed of execution and fluent draughtsmanship were valued above minute attention to detail.[1] In his 1872 lecture he rebutted accusations that he did not care about finish: "What I really want is that you acquire the habit of finishing as highly as you can in the time given."[2]

Poynter's suitability for the post of Professor at the Slade rested on his intimate knowledge of French academic practice – and his natural *gravitas*. Trained initially at Leigh's School and at the Royal Academy Schools in London, Poynter had subsequently spent four years in the atelier of Gleyre, from 1856 to 1859. While in Paris he had also shared a studio with George Du Maurier, who used him as his model for the art student, Lorrimer, in *Trilby*: "a most eager, earnest, and painstaking young enthusiast, of precocious culture, who read improving books, and did not share in the amusements of the Quartier Latin, but spent his evenings at home with Handel, Michel Angelo, and Dante, on the respectable side of the river".[3]

MP

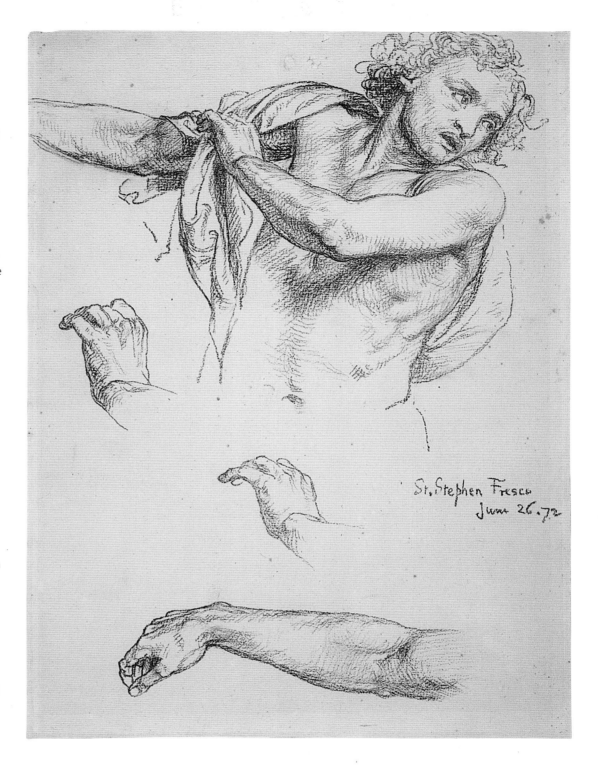

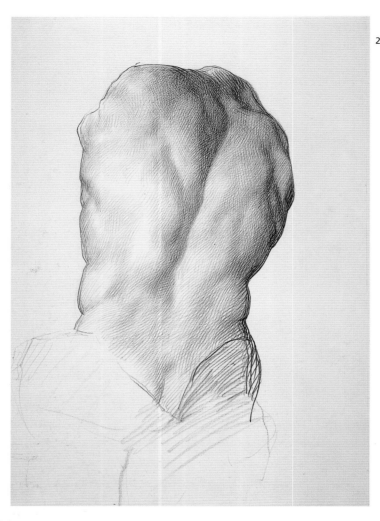

Alphonse Legros (1837–1911)
20 *Study of the Belvedere Torso*

Black chalk on paper, 43.2 × 30.4 cm
ca. 1880s?
The Trustees of the British Museum,
London

Alphonse Legros's drawing, made
from a cast of the celebrated
Belvedere *Torso*, was presented by
the artist to the British Museum.
Aptly, it demonstrates the artist's
superb draughtsmanship and
disciplined control of line and
tone, those qualities Legros
promoted to students at the Slade
School of Art from 1876 to 1892.
Legros, a fine etcher, believed in
drawing "with the point", which
was used in fluent, firm strokes to
indicate the outline and the major
"junctions" of the body. Shading,
as here, was indicated not with
the stump, but by a series of
closely hatched lines. The
drawing, too, has an abstract
quality, determined in part by
the unusual angle chosen. In this
respect, it is interesting to recall
Poynter's disparaging comments,
made a few years earlier, about
the French obsession with tone
at the expense of "constructive
drawing", to the point that the
object of the artist's attention
loses its specific identity.[1]

Legros instructed his Slade
students to study their models
"with such a thoroughness as
to get them by heart".[2] While
his technique was perceived as
radical, he maintained a reverence
for tradition and the Old Masters.
At the Slade he mounted large
photographs of drawings
by Leonardo, Raphael and
Michelangelo for copying. (Legros
would have been aware that the
fame of the Belvedere *Torso*
derived in part from the high
esteem in which it was regarded
by Michelangelo.) He also
expected all students to begin
by working from the Antique,
initially from fragments, then
from complete figures. It was
principally by example that
Legros communicated with his
students, his verbal comments on
their work being restricted to little
more than a gnomic "*pas mal*".

Legros had first been persuaded
to move from Paris to London by
Whistler in the 1850s, subse-
quently gaining a teaching post
in etching at the National Art
Training School in Kensington
under Henry Cole. In 1876
Poynter lobbied for his appoint-
ment as Professor at the Slade
School of Art. In addition to
drawing, Legros taught etching
and painting, impressing students
with his demonstrations of
painting character studies of
heads at tremendous speed and
with great dexterity. Even so he
did comparatively little to
encourage painting from the
life at the Slade — one reason,
perhaps, why Slade students
increasingly felt the need to
augment their training with
sessions in the ateliers of Paris,
Antwerp and other Continental
cities.

MP

Sir Alfred Munnings
(1878–1959)
21 *Male nude model*

Oil on canvas, 81.5 × 65 cm
1902
The Sir Alfred Munnings Art Museum,
The Castle House Trust, Dedham,
Colchester, Essex CO7 6AZ

The Académie Julian had been founded in 1873 by its namesake Rodolphe Julian (1839–1907), a rather louche character with an eye to a business opportunity. Julian's rapidly rose to be the most popular teaching studio in Paris, attracting native French artists such as Bonnard, Maurice Denis, Vuillard, Matisse, as well as a host of visiting artists from Europe and the United States. Some studied casually, others in earnest, preparing for admission to the Ecole des Beaux-Arts. Julian's was not one but a series of studios dotted about Paris. Classes were run on an everyday basis by teachers, with weekly visits by major artists such as Bouguereau, who, according to Munnings, restricted his pedagogy to a passing "*pas mal*" (also the habitual response of Legros at the Slade).[1]

Munnings, who made two brief trips to Paris in 1902 and 1903, worked in the large ground-floor atelier at Julian's. Here models posed for a fortnight, new models being selected on Mondays: "Each mounted the throne, one after the other, amid cries of approval or dissent. I felt sorry for the poor women who were too unattractive to please."[2] As for the general standard of work produced at Julian's, George Moore, who had also studied there, was unimpressed: "That great studio of Julian's is a sphinx, and all the poor folk that go there for artistic education are devoured. After two years they all paint and draw alike, every one; that vile execution – they call it execution – *la pâte, la peinture au premier coup.*"[3]

Ostensibly, Munnings went to Paris to study art, although he also wanted to soak up the bohemian atmosphere, his impromptu decision to attend Julian's being fuelled by lurid tales told in his local pub by a fellow artist and by his obsession with Du Maurier's *Trilby* (which he had not only read but seen in a staged version). Armed with £70 in savings Munnings and an unnamed friend ("a slack, slothful idler") set out to enjoy Paris.

By the time he entered Julian's, Munnings was an experienced draughtsman with a burgeoning professional career. At fourteen he had begun a six-year apprenticeship with a lithographic firm in Norwich, while attending evening classes at Norwich School of Art. There he followed the traditional curriculum of the National Art Training School, progressing from drawings of cones, cubes and spheres through antique figures to the life class, which more advanced students were permitted to attend twice a week. Munnings befriended one of the female models, a beautiful auburn-haired woman. However, he terminated their friendship when she invited him back to her lodgings.

MP

Anonymous

22 *A life class*

Conté crayon and white highlights,
44 × 67 cm
ca. 1890s
Wellcome Institute Library, London

The location of the academy
featured in this drawing has yet
to be established. The general
ambience is somewhat remi-
niscent of Alick Ritchie's *Life class
in the Antwerp School of Art*,
illustrated in *The Studio* in 1893,
although there are significant
differences which indicate an
alternative location.[1] There are
some clues. First of all the artists,
who are mature, are painting,
rather than drawing, suggesting
that this is an advanced class.
Secondly, two women artists
are present, indicating that, if
it were Antwerp for example,
it must date from at least the
late 1890s, since women were
only admitted in 1889, and then
in segregated classes. The écorché
figure is a cast of Jean-Antoine
Houdon's *Écorché au bras tendu*,
made in Rome in the 1760s.
By the following century it had
become a standard fixture
in European academies and
art schools.

The authorship of the present
drawing is unknown, the only
evidence being the pencil
inscription *Swain Tues 10*, on
the reverse. However, Swain may
not necessarily refer to the artist
but possibly to an engraver (such
as Joseph Swain) who was to
have reproduced it. Indeed, the
confident, fluent style and air of
reportage present in the drawing
suggests that it was made by
a professional graphic artist
specifically for reproduction in
a periodical.

MP

Anonymous

23 *Sketchbook*

Brown conté crayon and pencil
ca. 1880s
49.5 × 32.4 cm
Wellcome Institute Library, London

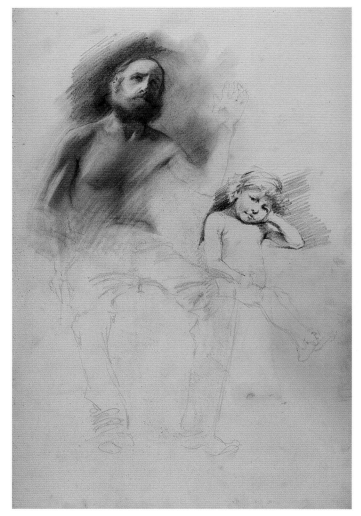

The various life drawings of artists
and models contained in this
sketchbook were made by an
unknown artist, possibly at the
Akademie der Bildenden Kunst,
Munich.[1] The provenance is
unknown, although what appears
to be the faint trace of a name on
the cover of the album suggests
that it is not the work of a British
artist.[2] Stylistically, the studies
suggest a date somewhere in the
1890s, when increasing numbers
of British and American artists
were attending academies and
art schools in cities such as Paris,
Rome, Antwerp and Munich.

The forty leaves in the sketch-
book include a wide variety of
models: nude studies of children
and adults (male and female),
and older models employed for
character studies. There are also
several drawings of older artists
working with models. The
technique in the drawings is

fluent and assured, the general sense of *reportage* suggesting that the artist was quite experienced, rather than a younger art student.

MP

Harold Knight (1874–1961)
24 *Standing male model*

Oil on canvas, 74.9 × 54.6 cm

ca. 1893

City of Nottingham Museums

This is one of a series of prize-winning oil studies of the male model made by Harold Knight at Nottingham School of Art in 1893. Knight was considered the best student in the School, his wife Laura Knight recalling that he "won so many prizes that at one point he was obliged to carry home the books he was presented in a wheel barrow".[1] By that time Nottingham had established an enviable reputation as among the best of the provincial public art schools run under the aegis of the National Art Training School. Under its principal, Wilson Foster, students were encouraged to make meticulous, detailed drawings while at the same time being allowed to develop their own particular strengths and interests. Knight's progress at Nottingham as a precocious seventeen-year-old can be compared with that of his future wife, Laura, then also a student. At first they drew together from casts and draped living models in the same class, although during their second year a decision was made to segregate male and female students.[2] While Harold made rapid progress, Laura felt ignored by the teaching staff and, although she was permitted to make studies from the clothed model, the nude model was forbidden to her.

MP

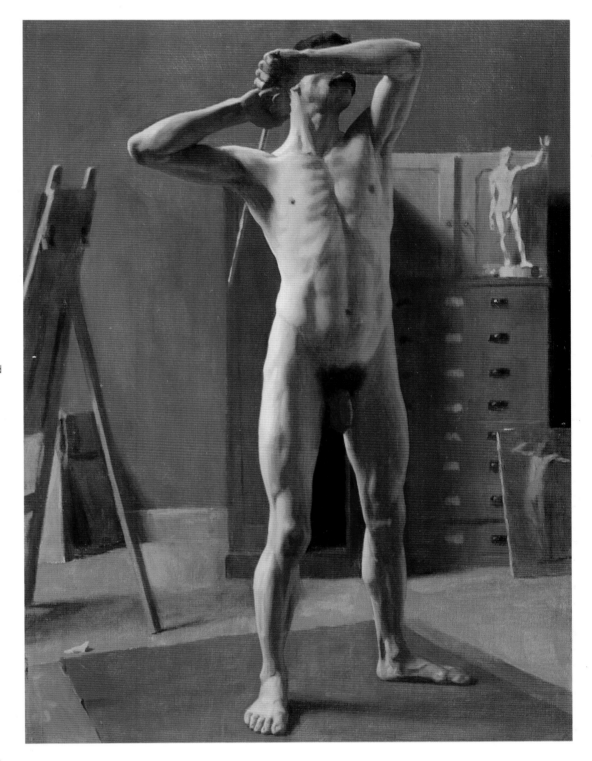

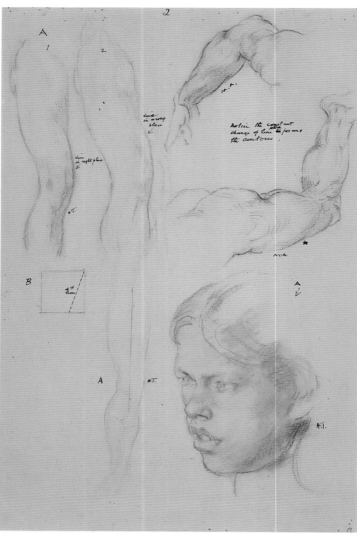

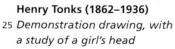

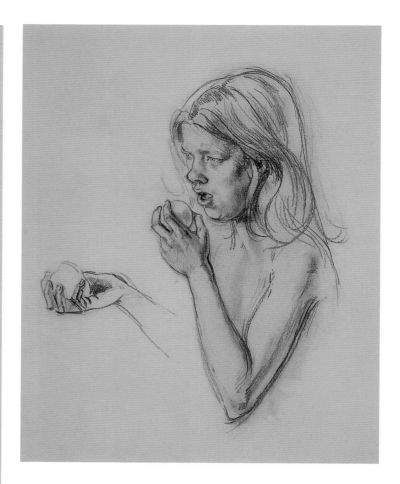

Henry Tonks (1862–1936)

25 *Demonstration drawing, with a study of a girl's head*

Pencil and brown chalk, annotated in black ink, on paper, 38 × 25.3 cm
Inscribed: *Notice the constant change of line which forms the contour*
ca. 1920s
The College Art Collection, University College London (2793)

Tonks's particular expertise in anatomical drawing derived from his training as a surgeon, some of his first serious attempts at drawing being made from cadavers in hospitals: "If he could not draw the living, he would fall back upon the dead; by bribing the *post-mortem* porter, he induced him to fix a corpse on the table for his benefit, which he could then draw at ease."[1]
He subsequently took evening classes at Westminster School of Art under Fred Brown, who, on becoming Professor at the Slade, appointed Tonks his assistant. In 1918 Tonks succeeded Brown as Professor, remaining at the Slade until his retirement in 1930. Tonks's profound knowledge of anatomy underpinned his drawings, both as a teacher and as a professional artist, and he once confessed "he had no idea what the figure looked like to anyone who was unacquainted with anatomy".[2] Tonks's empirical approach informed his teaching: "All I can do," he said, "is to give you a few facts about drawing."[3]

While Tonks was an intimidating presence for students in the life class, he was unusually considerate to the models, ensuring that they took proper rests and that the room was warm enough for them when posing nude. Nor did he indulge his own tastes, as one Slade model recalled. "Calling at other schools I have often been spoken to in an abrupt and curt way, when one was unlucky enough to be Mr. So-and-So's pet dislike in the way of a figure. Mr. Tonks never allowed his preference for certain types of figures to influence him. He gave the school sittings to all, first come first served."[4]

MP

Henry Tonks

26 *Girl eating an apple*

Black chalk on paper, 34 × 27cm
ca. 1920s
The College Art Collection, University College London (2794)

This head is that of the same adolescent female model in Tonks's anatomical drawing (cat. 25). It was probably made from a young Slade School model. It also relates to Tonks's full-length nude study of a young girl, entitled *Eve*, in the Victoria and Albert Museum.

MP

Thomas Gillot (1886–1913)

27 *A life class*

Oil on canvas, 74.9 × 54.6 cm

1912

City of Nottingham Museums

Thomas Gillot enrolled at Nottingham School of Art in 1906, there developing his particular interests in anatomy and animal painting. In July 1912 he was admitted to the Upper School of Painting at the Royal Academy. A year later, he died. The present prize-winning study of 1912 was made in the life class of Nottingham School of Art. As the presence of the female student indicates, by this time men and women were allowed to work together from the living model. Here the seated male model, wearing a blue *cache-sexe*, takes up a pose reminiscent of a piping Pan.

Nottingham School of Art was recognized as a branch of the Schools of Design in 1843. From 1845 under its headmaster, James Hammersley, students were encouraged not only in the principles of design, but in drawing and fine art.[1] Traditionally, training at Nottingham School of Art was closely allied to the needs of local lace manufacturers, although by the early 1900s the School was coming under increasing attack for neglecting the teaching of lace design in favour of freehand drawing, sketching and painting. In 1906, the year Gillot enrolled, only 25 of the 752 students at the School specialized in lace design, a fact which seriously undermined the initial aim of the National Art Training Schools of supplying the needs of industry.[2]

MP

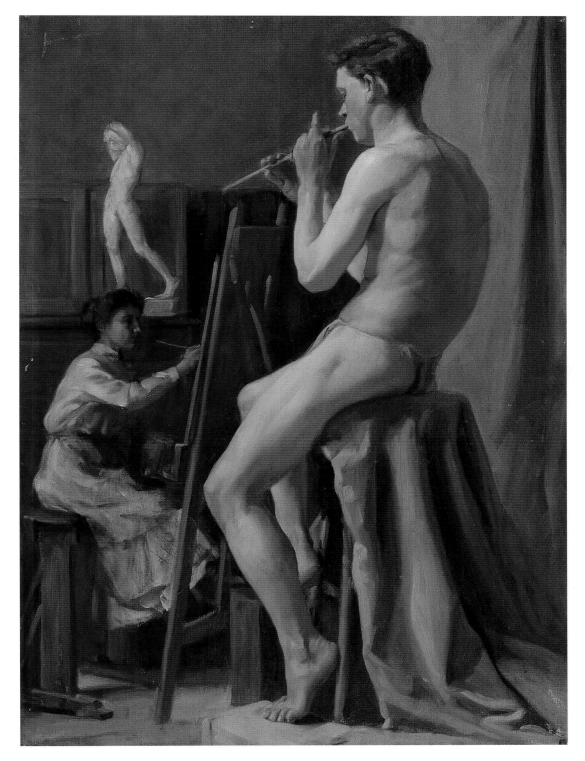

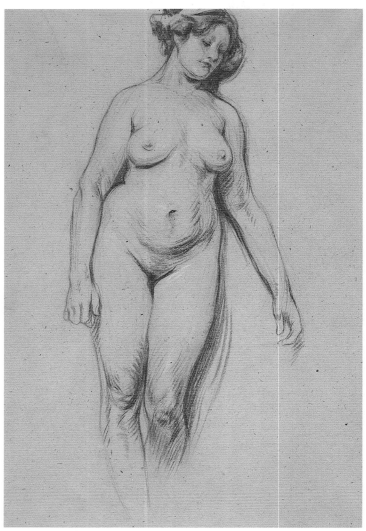

Isabel Lilian Gloag (1865–1917)

28 *Standing female nude*

Red chalk on grey paper, 31.4 × 28.8 cm
Mid-1880s onwards?
The Trustees of the British Museum,
London

Gloag's fine study of the female
model was possibly made at the
Slade School, where she studied in
the 1880s under Alphonse Legros,
although on stylistic grounds it
could well be later. At the Slade
women students were by this
time permitted to study from
the "undraped" (nude) model.
Yet, while the practice was
accepted within more liberal art
schools, prejudice continued to be
expressed about women working
from the nude model. In 1899
Henrietta Rae received a letter
from a man who had viewed her
paintings of the female nude at
the Royal Academy exhibition.
Such figures, he said, stimulated
the "volcanic force" in men's
nature: "Then as regards the
models themselves. For women
to sit to women in this way is
probably not so deteriorating
to their moral sense. But, as you
know, it habituates them to sit
thus also to men – and herein
must be found a trespass upon
feminine modesty on the one
hand and also on masculine
chivalry on the other."[1]

MP

Augustus John (1878–1961)

29 *Male nude*

Black chalk on paper, 85.5 × 65.2 cm
ca. 1896
The Trustees of the British Museum,
London

Augustus John went to the Slade
in 1894. He had a brilliant career
there, winning a prize with *Moses
and the Brazen Serpent* (University
College London) in 1898. He was
particularly praised for his
exceptional gifts of draughts-
manship, in which a spontaneity
of vision was combined with a
degree of mannerism borrowed
from the Old Masters. This
influence shows the impact of
the practice encouraged at the
Slade of studying works of art in
the British Museum and the
National Gallery.[1]

 This study was presumably made
in the Slade life class, where the
students were taught according
to a rigorous and exacting method
under Henry Tonks. The method
was explained by William
Rothenstein, a fellow student:
"We drew on Ingres paper with
red or black Italian Chalk, an
unsympathetic and rather greasy
material.... The use of bread or
indiarubber was discouraged ...
at a time when everywhere else
in England students were rubbing
and tickling their paper with
stump, chalk, charcoal, and
indiarubber." Rothenstein added
that they were taught "to draw
freely with the point, to build up
our drawings by observing the
broad planes of the model. We
studied the relations of light and
shade and half-tone, at first
indicating these lightly, starting
as though from a cloud, and
gradually coaxing the solid forms
into being by super-imposed
hatching."[2]

 John was able to master this
exacting technique with
flamboyance and panache. His
drawing manner contrasts with
the more careful and measured
approach of his sister Gwen, also
a student at the Slade between
1895 and 1898 (cat. 104).

WV

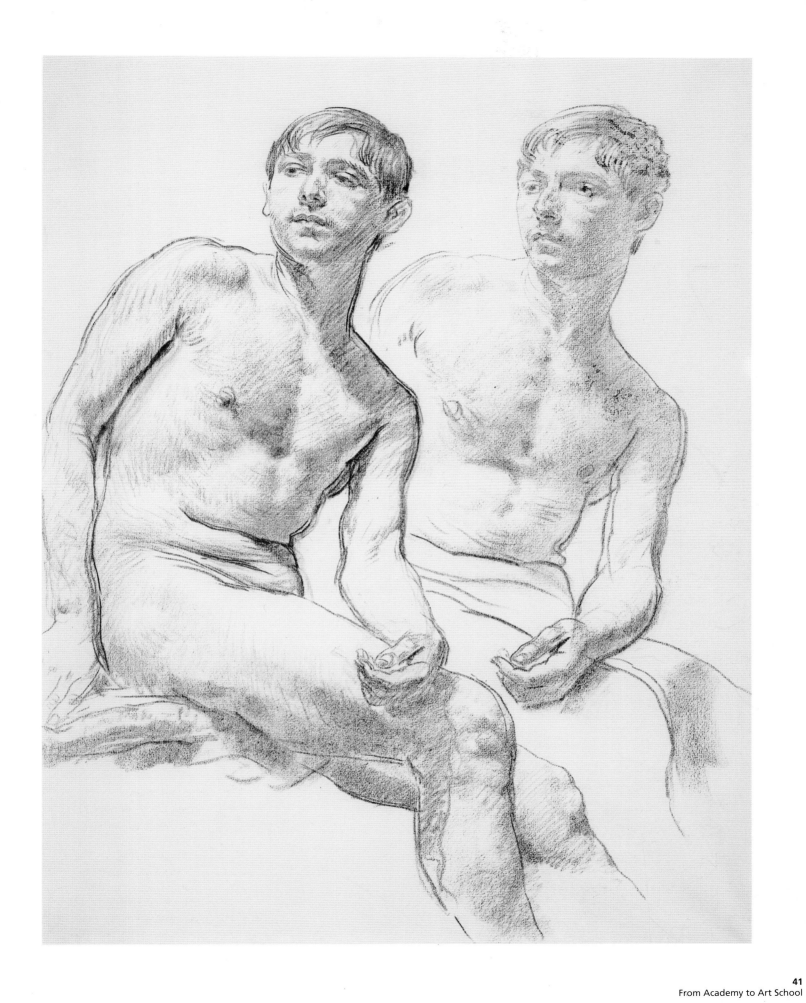

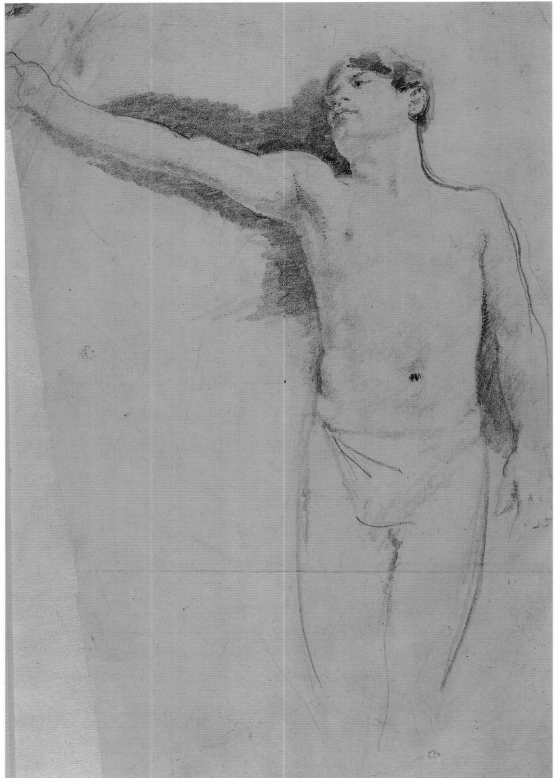

Dame Ethel Walker (1861–1951)

30 *Male nude*

Pencil, 27.9 × 19.4 cm

ca. 1900

Courtauld Gallery, University of London

One of the foremost figurative artists of his day, Walker studied at the Westminster School of Art and at the Slade (1899–1901). This would seem to be an art school model, wearing a posing pouch. Walker was of the generation that would first have been able to study the male nude at art school.

wv

Edward Wadsworth (1889–1949)

31 *Male nude in the Life Room of the Slade School*

Oil on canvas, 61 × 50.8 cm

1911

The College Art Collection, University College London (5192)

Edward Wadsworth was one of several precocious young students at the Slade around 1910. The painting was awarded first prize for figure painting in 1911.[1] It shows the male figure class of the Slade. There is some sense of the influence of Sickert and other 'Camden Town' painters in the interest in depicting the ambience of the classroom and in the careful tonal painting employed. There is no hint of the modernist style that Wadsworth was to employ a few years later when he became a member of the Vorticist group. Only in its meticulous and consummate technique is there a connection between this work and Wadsworth's later styles.

wv

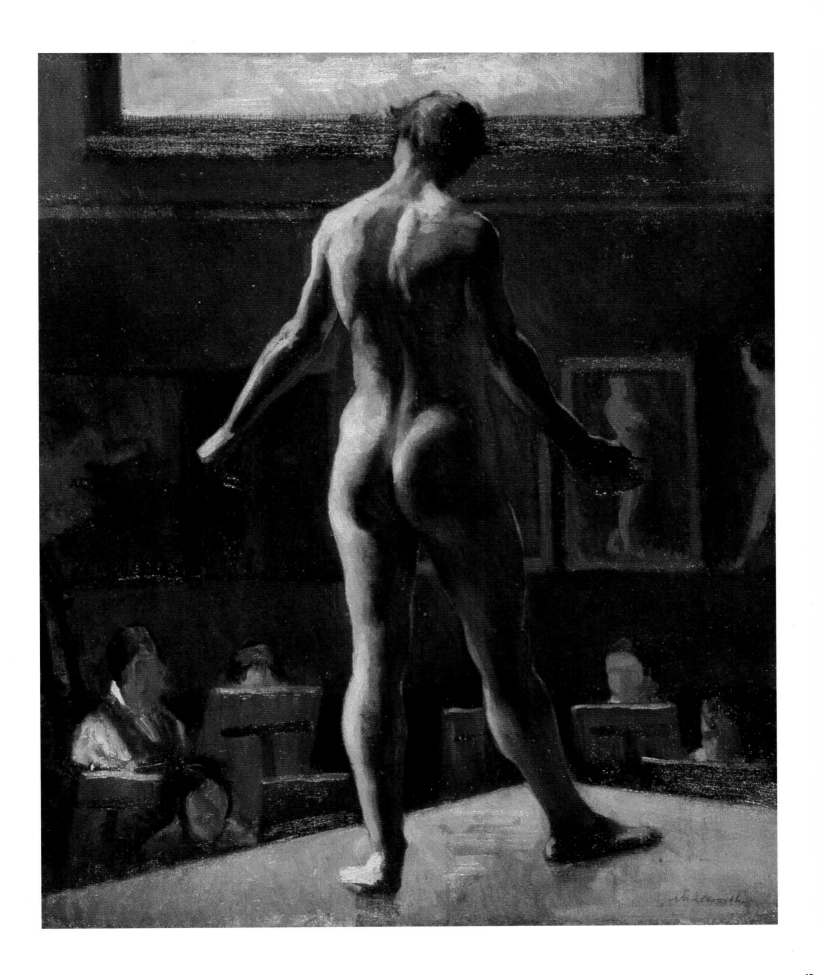

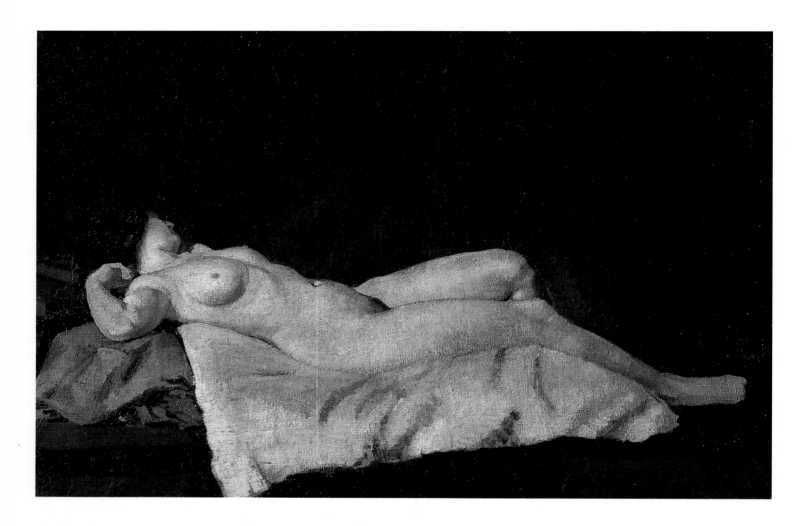

Dora Carrington (1893–1932)

32 **Reclining female nude**

Oil on canvas, 51 × 76.2 cm

1911–12

The College Art Collection, University
College London (5204)

This picture received second prize
for figure painting at the Slade
School in 1912. The following
year Carrington received first prize
for a standing female figure
viewed from the back. In contrast
to the prize-winning Slade figure
paintings by Wadsworth (cat. 31)
and Hookham (cat. 38), these
works are viewed against a dark
background and attention is more
closely focussed on the figure.

WV

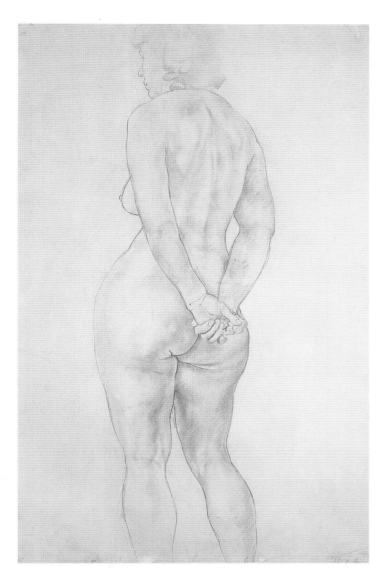

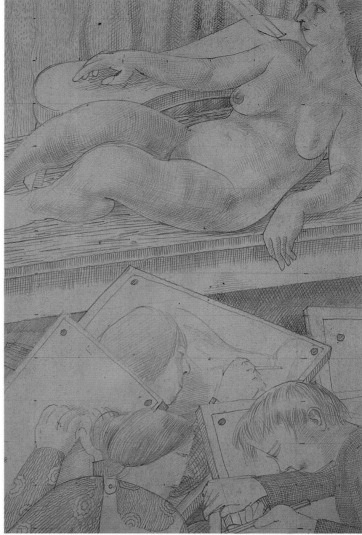

**Sir Stanley Spencer
(1891–1959)**

33 *Standing female nude*

Pencil on paper, 55.9 × 37.5 cm
ca. 1908–12
Victoria and Albert Museum, London

This appears to be a study made
while Spencer was studying at the
Slade between 1908 and 1912. It
shows the kind of work carried
out in the life class – which he
later recorded in one of his
scrapbook drawings (cat. 34).

WV

Sir Stanley Spencer

34 *The Life Room at the Slade
School of Art*

Pencil on paper, 40.5 × 28 cm
1943–44
Stanley Spencer Gallery, Cookham,
Berkshire. Private owner

Spencer's gifts as a draughtsman
were recognized early on, though
he did not start winning prizes for
figurative compositions as his
interpretations were regarded as
too eccentric. In his last year,
however, he won the Composition
Prize with *The Nativity* (University
College London).

 This representation of the Life
Room at the Slade School was not
made at the time that Spencer

was studying there. It is one of
a series of drawings recollecting
moments of his life that he
drew between 1939 and 1949,
assembling them in four
scrapbooks.[1] These were not
intended to be accurate records,
but rather imaginative recreations
of the essential events in his life.

 Spencer made four drawings
altogether of life at the Slade,
showing both the Antique and
the life class, a moment of
lunchtime relaxation and the time
when his first wife Hilda began to
study at the Slade. In this drawing
Spencer is presumably the young
man sharpening his pencil in the
bottom right of the drawing.

WV

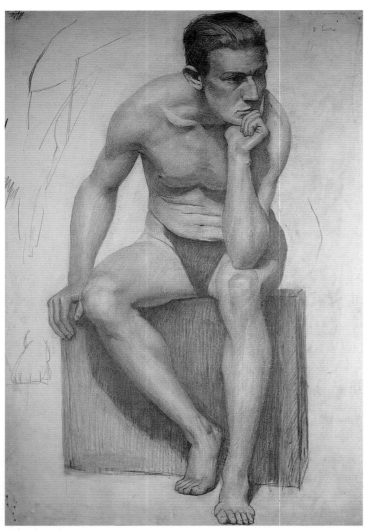

L.S. Lowry (1887–1976)

35 *Seated male nude*

Pencil on paper, 54.8 × 34.9 cm

ca. 1914

City of Salford Art Gallery

Lowry's fame rests on his seemingly naive depictions of industrial townscapes, based on his home town of Salford. Yet he was in no sense a primitive artist. Before developing his distinctive manner Lowry had studied as an evening student at Manchester School of Art from 1902 to 1922, and attended part-time drawing classes at Salford School of Art from 1915 to 1928, where he had developed a competent if not particularly inspired way of studying the human form, working from both the Antique and the living model (naked and draped). This study was made during one of these sessions.

Lowry's development of his individual style in the 1920s can be related to a growing vogue for the primitive at the time. He was encouraged by one of his teachers, Bernard D. Taylor, to give his pictures white backgrounds, which eliminated shadows and emphasized flatness. Lowry himself felt very deeply that his breakthrough was the result of his meticulous training in the life class, rather than a rejection of it. "I am tired of people saying that I am self-taught, I am sick of it. I went one day to Art School and I said 'please I want to join', and I took Preparatory Antique, light and shade, and then, after a time, the Antique class, and when they thought that I was sufficiently advanced in Antique I went into the Life Class; I did the life drawing for twelve solid years as well as I could and that, I think, is the foundation of painting."[1]

As this quotation suggests, Lowry, although studying as a part-time student while working as a clerk and rent collector, was able to go through a systematic academic training. He was a beneficiary of the system of instruction that had been set up with the establishment of the Government Schools of Design in the 1830s, and which remained in place until after the Second World War.

Lowry, however, seemed to take an unusual and destructive attitude to his drawings. A fellow student in Manchester records, "He used to sit in front of the model and by the time he had finished he made a swipe from the neck to the ankle more or less. It looked as if it had been axed with a meat cleaver."[2] The present drawing appears to have been one of the few that escaped the cleaver.

wv

Henri Gaudier-Brzeska (1891–1915)

36 *Female nude*

Pen and ink on paper

ca. 1913

Victoria and Albert Museum, London

During the years leading up to the First World War Gaudier was developing rapidly as an artist, stimulated both by the Parisian avantgarde and by the new sympathy for modernism that emerged in London in the wake of Roger Fry's 'Post-Impressionist' exhibitions.

In 1912 he attended life drawing classes, where he astounded his fellow students by making numerous rapid sketches rather than a few meticulous studies. In a letter to his lover Sophie Brzeska he described this difference: "The people in the class are so stupid, they only do two or three drawings, in two or three hours, and think me mad because I work without stopping – especially when the model is resting, because that is much more interesting than the poses. I do from 150 to 200 drawings each time, and that intrigues them no end."[1]

wv

Even allowing for exaggeration, it is clear that Gaudier made many rapid studies, and saw this method as essential for grasping a sense of life and movement. He was following a method advocated both by Rodin and by Epstein – as well as being practised by Matisse. The resultant rapid sketches that survive (such as this work) have a lyrical beauty, as well as a sense of elegance and wit.

wv

Nina Hamnett (1890–1956)
37 *Life class at the Westminster Technical Institute*
Pen and black ink on paper,
29.2 × 16.5 cm
1919
The Trustees of the British Museum, London

In 1918 Sickert decided to retire from teaching at the Westminster Technical Institute and recommended that Nina Hamnett take his place. Hamnett taught three evenings a week. She resigned her post there when in March 1920 she went to live in Paris again. She had to hire and pose the models as well as teach. At first she was very nervous and used to wear a large grey hat, rammed down over her eyes. But gradually she relaxed and began to draw with the students. The present study was presumably made when she was sketching with the students in such a session.

When encouraging her to take the job Sickert wrote to her: "I am convinced that once the students have had a fortnight's experience of you, you will create an enthusiastic following, because, firstly you have been through so much, and secondly because you have so much intellectual vitality and students quickly feel that."[1] The numbers soon swelled from five to thirty and Hamnett took care to get to know them all. She made a particular friend of the elderly actress Gertrude Kingston, for whom Shaw had written *Major Barbara*. It is just possible that the woman sketching in this drawing is Gertrude.

The picture shows the fine outline technique that Nina Hamnett developed originally under the influence of Gaudier-Brzeska and which she was to use with great effect in her studies of contemporary life scenes – particularly those of pubs and restaurants and cafés. In keeping with such studies, it is the total situation that she is recording rather than making a particular study of the model. The study does show, however, that Hamnett had no scruples about posing the male nude for female students.[2]

wv

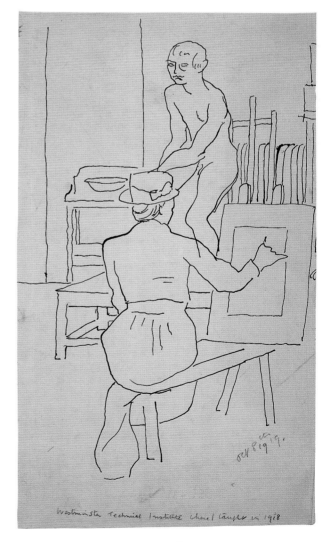

**John Gerald Hookham
(fl. 1919–38?)**

38 *Seated female nude, Slade
School of Art*

Oil on canvas, 76.2 × 50.8 cm

1923

The College Art Collection, University
College London (5243)

The Slade School of Art is unique
amongst art schools for having
kept the majority of prize-winning
works by its students from its
inception up to the 1960s.
Many of the prize-winners –
such as Augustus John, Edward
Wadsworth (cat. 31), Stanley
Spencer and Rex Whistler (cat. 39)
– went on to become prominent
artists. Others, however, remained
obscure and their identity is often
hard to trace. Little is known
about Hookham beyond the
fact that he studied at the Slade
between 1919 and 1923, and
that this work gained equal first
prize for painting from the life
in 1923. He may be identical
with the John Hookham who
occasionally exhibited portraits
and figurative subjects at the
Royal Academy between 1922
and 1938.

 The remarkable quality of this
study demonstrates how
frequently works by 'minor' artists
can be of major interest, as well
as emphasizing the value of the
Slade's collection for providing
an insight into the practices and
achievements of art schools in the
period covered by this exhibition.
The model appears to be the
same woman who features in Rex
Whistler's prize-winning painting,
also made in 1923 (see cat. 39).

 This work was produced in the
latter years of the reign of the
formidable Henry Tonks at the
Slade. The remarkable staging of
this work, with its hint of Vermeer,
is perhaps a reflection of the
encouragement that the head
of the Slade gave his students to
study the Old Masters carefully.
But it also seems a highly
appropriate way to bring across

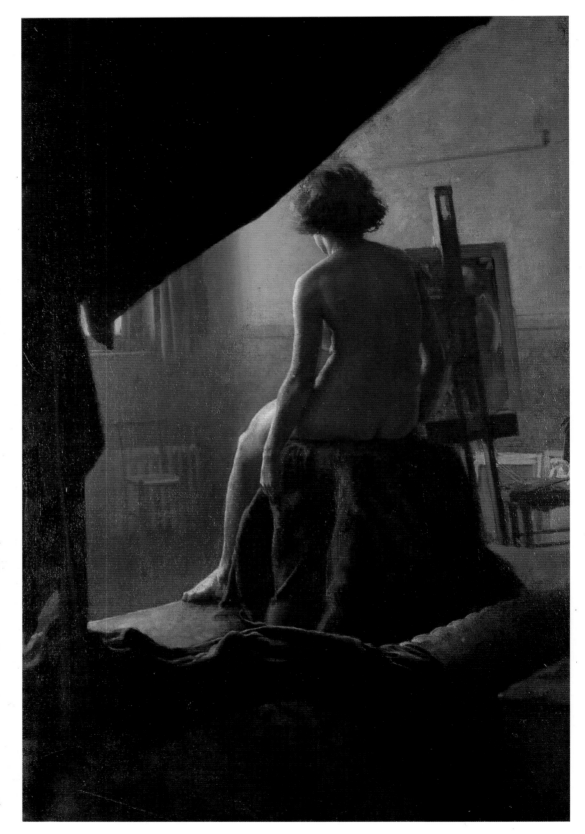

some sense of the vulnerability of
the model and the curious
expectancy of the life class.

wv

Rex Whistler (1905–1944)

39 *Seated female nude, Slade School*

Oil on canvas, 76.5 × 51.4 cm

1923

Inscribed: *H.G.S./ 1923/ PRIX DE ROME/ SC—-INGS* [illegible]

The College Art Collection, University College London (5338)

Whistler came to study at the Slade in 1923, after a term at the Royal Academy Schools. He had been asked to withdraw from the Academy on grounds of "incompetence", a truly astounding judgement in view of Whistler's supreme dexterity. At the Slade he was greatly appreciated by Tonks, who said the art school had seen "no one so distinguished since Augustus John".[1] During his time at the Slade Whistler won prizes for almost every category of life study, as well as for pictorial compositions.

The present study won first prize, which brought with it an award of £5.[2] The fluidity of handling evident here was soon to gain Whistler a reputation as a consummate mural painter. It was Tonks – a keen supporter of mural painting – who engineered the beginning of this career by setting him to work in 1924 on murals for the Highways Club, Shadwell, an achievement that led Lord Duveen to commission the artist to paint the decorations for the Tate Gallery restaurant, *The pursuit of rare meats*, in 1925.

WV

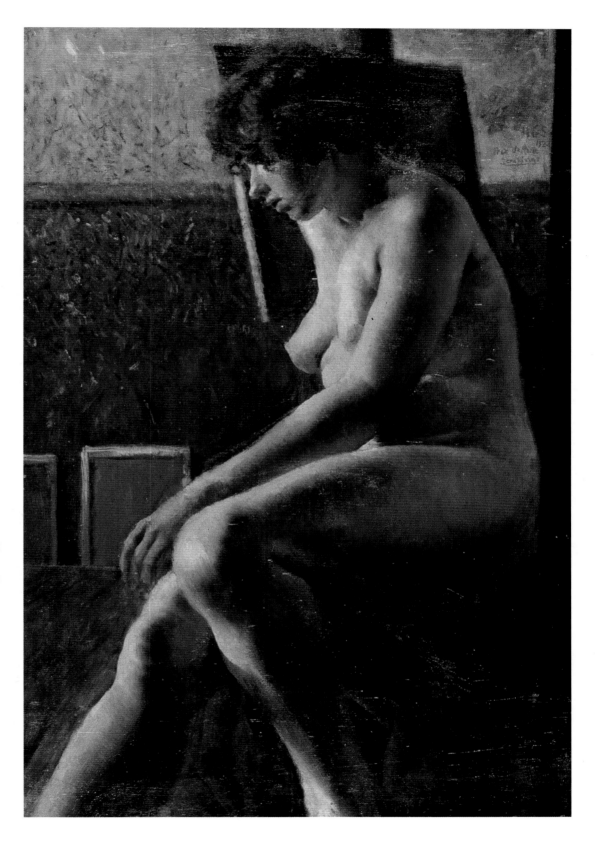

Jacob Kramer (1892–1962)

41 *The anatomy lesson (clay)*

Oil, 71.7 × 91.4 cm
1928
Leeds Museums and Galleries (City Art Gallery)

This painting was based on extensive study made by the artist in the dissecting room of the Leeds medical school. The result is a tough yet moving portrayal of a human cadaver – a decaying piece of inert matter that still preserves the features of humanity. In this work Kramer aligns himself with a tradition of realist art that had produced such remarkable portrayals of the dead human

form as Holbein's *Dead Christ* (Basle) and Rembrandt's *Anatomy lesson of Dr Tulp* (Amsterdam). Despite this, when the picture was shown in a retrospective exhibition of the London Group at the New Burlington Galleries in April 1928 there was considerable controversy whether such a subject was legitimate for a work of art.[1]

A close friend of Epstein (cat. 80–82), and like him from an émigré Jewish background, Kramer shared the sculptor's interest in developing a new relevance for realist art in the mid-twentieth century.

wv

Sir William Orpen (1878–1931)

40 *Anatomical figure*

Coloured chalks on black paper
ca. 1912
Private lender

Orpen came to London to study at the Slade after having first received instruction at the Metropolitan School of Art in his native Dublin. While at the Slade he cut a figure alongside Augustus John for his brilliant draughtsmanship.[1] Unlike John, however, Orpen continued to be interested in making precise figure studies throughout his life. Later he taught the study of the figure at the Metropolitan School of Art in Dublin where "his thoroughness and dislike of

humbug made him a most stimulating teacher".[2]

While at the Slade, Orpen was taught by Henry Tonks (cat. 25 and 26) and developed a similar concern for anatomy. This led to a series of remarkable studies, of which the present drawing is among the most impressive examples.

wv

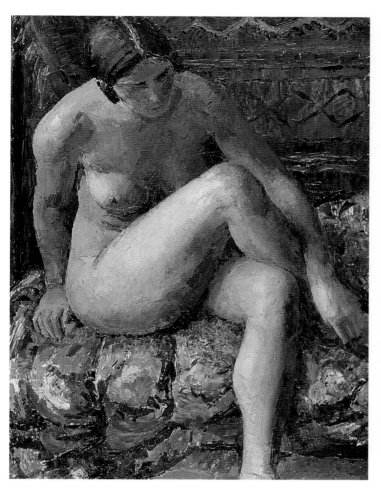

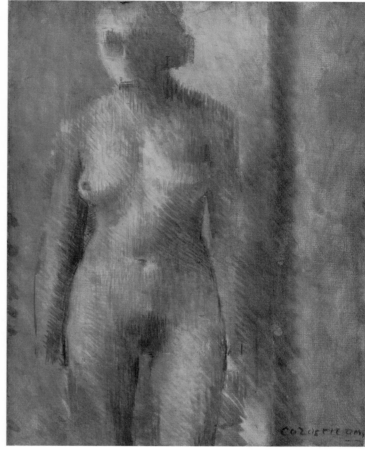

Raymond Coxon (1896–1997)

42 *Model resting*

Oil on canvas, 89 × 66 cm

1931

Manchester City Art Galleries

Born in Stoke-on-Trent, Coxon was a fellow student of Henry Moore (cat. 115) at both Leeds School of Art (1919–21) and the Royal College of Art (1921–52). In the 1920s they were particularly close, founding the British Independent Society in 1927 together with Leon Underwood. While a student Coxon was particularly noted for his bold and striking figure-drawing style. *Model resting* relates to Coxon's experiences as a part-time teacher at Chelsea School of Art. He began working there in 1930 and remained teaching until the late 1960s.

wv

William Coldstream (1908–1987)

43 *Standing female nude*

Oil on canvas, 45.7 × 35.6 cm

1937

Tate Gallery.

Lent from a private collection 1989.

This is the only surviving picture of Coldstream's painted in the School of Drawing and Painting set up by himself, Claude Rogers and Victor Pasmore (later joined by Graham Bell). It was painted at the School's first location at 12 Fitzroy Street in the autumn of 1937.[1] Coldstream, Rogers and Pasmore were leading figures in the group that became known as the Euston Road School, which sought to re-invigorate realist art at a time when modernism was increasingly being associated with abstraction and Surrealism. While depending on the meticulous standards of life study practised at the Slade School, where they had been students, these artists also had a great interest in using such study to make social and political commentary. Coldstream was encouraged in this by his friend the radical poet W.H. Auden, who suggested that leading politicians should be painted nude, in order that their naked bodies could reveal their corrupt natures.[2] The current work appears to have a less ambitious aim, though it does strive for an objective and analytical portrayal, a quality that made Coldstream's art an inspiring example for others who were committed to the survival of figure painting.

wv

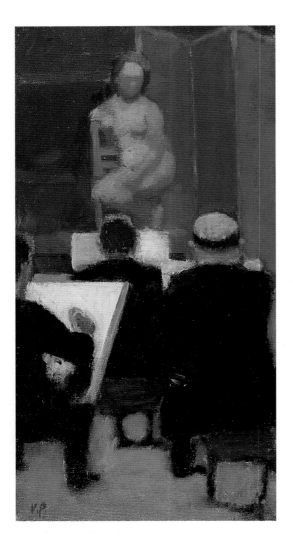

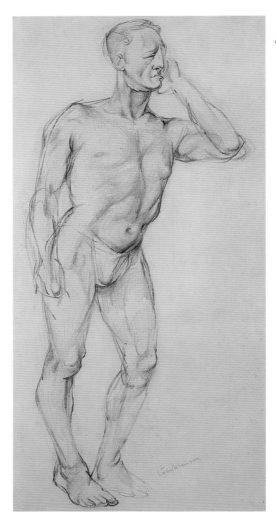

Victor Pasmore (1908–1998)

44 *The life class*

Oil on canvas, 61 × 30.8 cm

1938

Wakefield Museums & Arts

In 1937 Victor Pasmore joined with Claude Rogers and William Coldstream (cat. 43) in setting up a painting school that later became known as the Euston Road School. *The life class* comes from the period when Pasmore was teaching there. It appears to represent the school in session. The sombre tones and the mature appearance of the men studying the nude figure suggests the earnestness of the school. The nude model that rises above the students against a dark background is scrutinized in an impersonal manner – she is almost the antithesis of a muse. Typically for Euston Road painting, great attention is paid to the exact placement of forms on the canvas. Pasmore had recently made a study of Vermeer's *Lacemaker*.[1] There is something of the Dutch master's sense of precision about this work.

Later, after the Second World War, Pasmore made his name as a constructivist, painting abstract works. However, he remained faithful to the teaching methods of the Euston Road School when subsequently teaching a life class at Camberwell School of Art (see cat. 46).

wv

John Minton (1917–1957)

45 *Male life study*

Pencil

ca. 1940

Collection of Mr and Mrs G Hassell

John Minton was one of the leading figures in the British neo-Romantic movement of the 1940s. While initially responsive to French post-Cubist work, his mature style developed out of the English tradition of spiritualized landscape, particularly the work of Samuel Palmer. He also remained concerned with direct, observational study of the human form, an interest that connected with his employment as a teacher at Camberwell School of Art (see cat. 46). The male nude was a particular obsession of his.

wv

Gordon Richards (1926–1998)

46 *Male model (Quentin Crisp)*

Pencil on paper, 39.1 × 28.6 cm

1946

Inscribed: *G. Richards 46./ Quentin Crisp*

Collection of Mr and Mrs G Hassell

This drawing was made at Camberwell School of Art. Gordon Richards first studied at Camberwell in 1942–44, and returned to complete his training there in 1946 after serving in the Navy. He attended the Saturday life classes run by Victor Pasmore (cat. 44). Later he worked as a studio assistant to Pasmore and as a musician, scene-painter and teacher at the London College of Furniture.[1]

Camberwell was one of many art schools at which Crisp worked as a model during the 1940s. In a later recollection Crisp commented that the school "had its own aura that I judged to be 'arty' without being precious".[2] A former art student himself, Crisp could judge the experience of being a model from both sides. "What every model needs are two apparently contradictory attributes – abject humility because, while at work, he is really only a thing, and unshakeable self-assurance without which he could never survive the contempt in which he is held by the students."[3] Crisp, it should be remembered, was one of the 'lowly' art school models that professional artist's models such as Marguerite Kelsey viewed with disdain (cat. 87). Despite this, Crisp was determined to bring the highest standards to his work. Remembering with disappointment the 'minimum risk policy' adopted by the models he drew when he was a student, he tried to stretch the students by adopting challenging poses. "When I became more painted against than painting, I decided to be as Sistine as hell. I climbed up the walls; I rolled on the floor; I hung from beams; I held chairs over my head. The students were

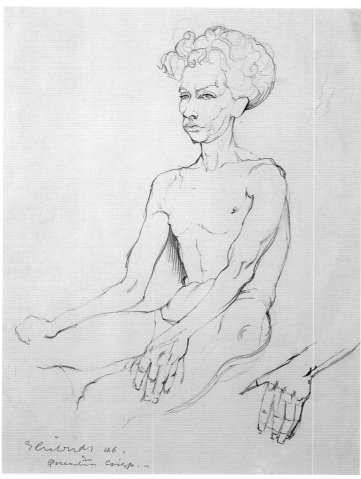

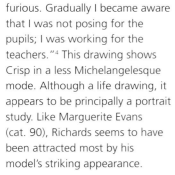

furious. Gradually I became aware that I was not posing for the pupils; I was working for the teachers."[4] This drawing shows Crisp in a less Michelangelesque mode. Although a life drawing, it appears to be principally a portrait study. Like Marguerite Evans (cat. 90), Richards seems to have been attracted most by his model's striking appearance.

WV

Anthony Fry (born 1927)
47 *Students with the Antique*

Oil on canvas, 61 × 51 cm
1948
Owned by the Artist

Following an initial art training at Edinburgh College of Art Anthony Fry (a great-nephew of Roger Fry) enrolled at Camberwell School of Arts and Crafts in 1949, winning a Rome scholarship in 1950. By that time the collective influence of the Euston Road School at Camberwell was well established through the teaching of William Coldstream, Claude Rogers and Victor Pasmore. While drawing and painting from the life was the focal point of the curriculum, study of the Antique was not entirely neglected. The Antique Room, in Fry's painting dominated by a cast of the *Venus de Milo*, was located beneath the Life

Room. Unlike the Life Room, where students fought for spaces, the Antique Room was never overpopulated: "In this latter [room] there was occasionally a clothed model but usually it was deserted save for a few contemplative souls painstakingly working out their personal nirvanas in paint; except for one – Terry Frost – who made detailed and accurate drawings of the antique with an H pencil."[1]

MP

Behind the Screen: The Studio Model

MARTIN POSTLE

The idea has survived since antiquity of the studio model, quite distinct from the academy model. Generally, the academy was the domain of the male model, while the female model was confined to the studio – a truism which was largely reflected in artistic practice until the nineteenth century. In the academy the male model was subjected to the collective scrutiny of male artists, bound together in a brotherhood, the artist, through the model, exploring the self. In the studio the female model was the 'other', the object of a subjective, admiring, gaze. In the studio the myth was fostered of male artist and female model as muse, companion, partner and possession – from Apelles and Campaspe to Raphael and La Fornarina. Like priest and confessor and doctor and patient, artist and model, cocooned in the studio, enjoyed a privileged, closeted existence. But behind the smoke screen of myth lay the reality of a financial transaction; the reality of social and sexual inequality; and the reality that studio models were not only young, female and nubile, but old, infirm, orphaned and plagued by debt and disease. Yet the myth persisted. It persists today.

Before the nineteenth century the studio model had been depicted in Britain through a conventional range of classical myths and allegories. It had also been a happy hunting ground for satirists such as Thomas Rowlandson, who in the late eighteenth century exploited the subject for a whole series of suggestive prints and drawings. Yet, with the rise of modern-life genre painting in the 1820s, it was only a matter of time before the subject of the artist and model in the studio found its way into normative pictorial narratives. Among the earliest Victorian pictures to address the subject was *The artist's studio*, exhibited by William Mulready at the Royal Academy in 1840. The picture is lost but a detailed chalk study survives (fig. 8). A close reading of the artist's gesturing hand and of the intimate, submissive body language of the woman suggests that the attractive young model is also the mother of the baby, and that he, to his evident surprise, is the father. Mulready was not explicit about the picture's meaning, entitling it simply *An interior*. Yet his close interest in the social relations between artists and models is revealed in notes he prepared for models some time later when a Visitor in the Royal Academy Schools. Female models ought not, he cautioned, converse or form any sort of social contact with male artists, regardless of their marital status: "An intelligent woman who, at the commencement of this dangerous profession, is well prepared for … danger, will have much fewer cases of trouble, than poor innocent creatures who with distracted minds are flung unprepared amongst its smiling faces, flattering manner, its painting and gilding."[1] Perhaps, in his reference to the affable manners of artists and the allure of "painting and gilding", Mulready had his own artist-model parable in mind. And Ford Madox Brown noted in 1856 how Mulready had recently, at the age of seventy, "seduced a young model who sits for the head & has a child by her, or rather she by him".[2]

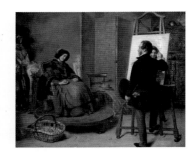

Fig. 7
William Powell Frith
The sleepy model
Oil on canvas, 1853
Royal Academy of Arts, London

The perceived moral pitfalls lying in wait for unsuspecting male artists were increasingly apparent as models thronged studios to meet increased demands of a growing phalanx of genre painters. With the increase of subjects drawn from contemporary life, the gap between real circumstances of model and their imagined role in art closed. With this heightened realism came an increased awareness of models as individuals in their own right. It is in this context that the most celebrated of Victorian artist's model pictures, Frith's *The sleepy model* (fig. 7), can be fully appreciated. *The sleepy model*, painted in 1853, was William Powell Frith's diploma picture. On one level it is a personal, and wholly sympathetic, statement about one artist's relationship with his studio model, a pretty young costermonger, plucked from the London streets to re-enact a role integral to her daily life. Once in the studio, she falls asleep, her weariness induced not so much by the strains imposed by modelling but by the rigours of her working day.

Frith's model is wholesome, and passive – a world away from the libidinous street vendors presented in countless 'fancy' pictures and prints, whose inviting leers and lewd cries suggest their desire to trade sexual favours along with their assorted comestibles. Bundled up in her shawl the sleeping model finds in Frith's studio a safe haven, and the chance to dream of a better life. The artist's self-image as a trustworthy, reassuring, paternal presence has a visual counterpart in the chatty, avuncular approach adopted by Frith in his autobiography some thirty years later. For Frith the studio was his stage, a microcosm of the city which surrounded him, with its cast of colourful, 'Dickensian' characters – poor, down on their luck, but invariably cheerful. In reality, as Frith occasionally let slip, he at times found them to be dirty, diseased and illiterate (see cat. 49). One year after Frith presented *The sleepy model* to the Royal Academy, Gustave Courbet produced a far more controversial account of the artist and his model – the enormous *Artist's studio* (Musée d'Orsay, Paris). Situating himself and his naked female model between his own intellectual coterie and the denizens of the gutter on whom his art fed, Courbet laid bare a strand of truth that Frith artfully concealed. Unlike Frith, who maintained a polite social distance between himself and his model (and concealed his mistress from his wife and family), Courbet flaunted his nude model, his muse, as a physical, dangerous, destabilizing presence, and a symbol of his own position outside the sphere of polite, bourgeois society.

The physical presence of the model within the domestic sphere had been for generations a cause for concern. In the eighteenth century Angelica Kauffman, compelled to study the academy model at home, was, we are told, constantly chaperoned, while George Romney, who made a series of highly erotic life drawings in Rome, was excused by his clergyman son on the grounds that the model never posed "except in the presence of her mother".[3] In the mid-nineteenth century constraints were still in place. In 1851, when the young bachelor Dante Gabriel Rossetti rented a studio in Red Lion Square his landlord posted a notice in the hall stipulating that visiting models must be "kept under some gentlemanly restraint, as some artists sacrifice the dignity of art to the baseness of passion".[4] Within the marital home, the female model could prove an even greater destabilizing presence. Ford Madox Brown recorded the following confrontation between the wife of the painter Charles Lucy and her husband's model while he was out at breakfast: "'I'm sure I can't think however a woman can be so nasty indelicant [*sic*] as to take off all her things before a man; it is a filthy disgusting thing to do, and I can't think how they can get any woman to do [it]. I wouldn't,' says she, 'no that I wouldn't.'"

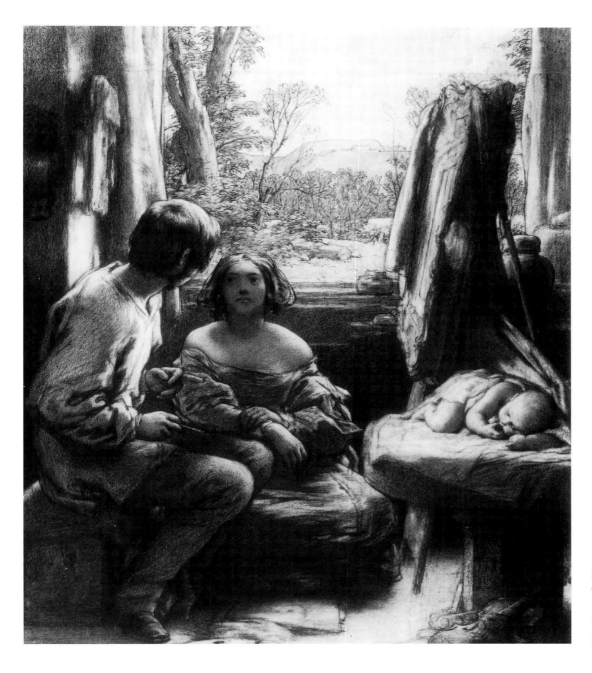

Fig. 8
William Mulready
The artist's study
Red chalk and pencil, *ca.* 1840
Manchester City Art Galleries

The same model suspected that Mrs Lucy was in the habit of spying upon her and her husband through a skylight of the studio – although Lucy told her it was merely the wind rattling through the roof tiles.[5] It becomes clear why so many self-respecting Victorian artists took pains to ensure that their studio remained immune from intrusions by the rest of their *ménage*.

From the 1860s a spate of elaborate custom-built artist's villas sprang up in London, centred on the fashionable neighbourhoods of Kensington, Hampstead and St John's Wood.[6] Here artists could re-enact fantasies purveyed in their paintings: Pompeiian splendour for Lawrence Alma-Tadema; a magnificent Arab Hall for Leighton; for the Bavarian-born artist Carl Haag an exotic establishment complete with a set of private apartments including a models' room – or, as visiting journalist supposed, a secret harem.[7] An essential feature of many exclusive artistic establishments was the incorporation of a separate entrance, staircase and even changing

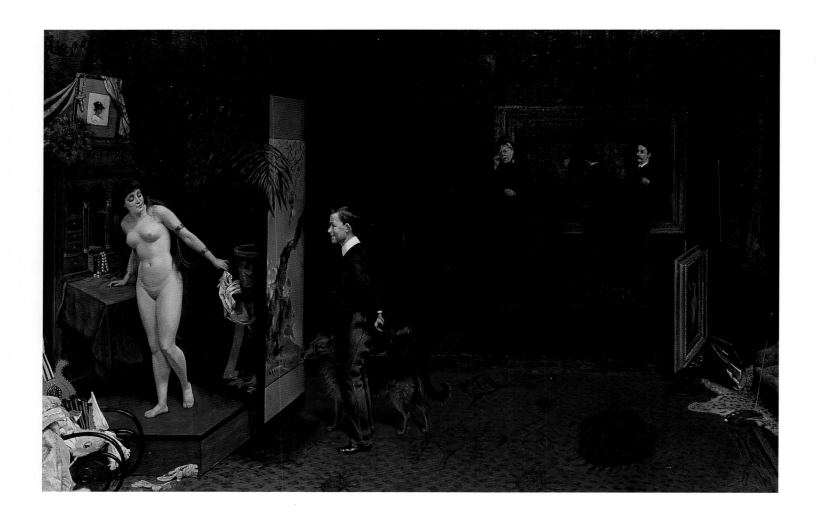

Fig. 9
Frank Hyde
The artist's studio
Oil on canvas, *ca.* 1880s
Private collection

rooms for models (Millais, at Palace Gate, incorporated a trap door in the floor of his studio through which large canvases and visiting models could be transported).[8] One reason for the provision of special facilities for models was to maintain a sense of propriety and social hierarchy. Marcus Stone had three gates to his house: one for friends and family; one for servants and tradesmen; and, furthest away, a models' entrance.[9] For others the strict division of domestic arrangements was a means of maintaining absolute privacy.

In 1867 Burne-Jones moved to a rambling eighteenth-century residence in Fulham, then still virtually in the countryside. While the house was difficult enough to reach, the studio remained out of bounds even to the artist's own family, his grandson recalling only that "sinister people called 'models' lived there who had trays taken up to them at lunch and tea time".[10] It was shortly after the move that Burne-Jones began his torrid affair with his model Mary Zambaco (see cat. 68) – although there was very little secrecy in the way it was conducted. Leighton was far more discreet. He loved the company of his models, but took care to entertain them away from his studio, visiting his favourites, the Pullen sisters, in their home, and lavishing gifts and money on them.[11] Rumours and gossip he loftily brushed aside. Victorian artists were concerned in varying degrees about what society gossips said. Val Princep happily allowed models to wander his house, even after his marriage. Whistler and Tissot openly set up house with their respective model-cum-mistresses in Chelsea and St John's Wood, while Rossetti revelled in his menagerie of models, mistresses, hangers-on and exotic wildlife in Cheyne Walk, Chelsea.

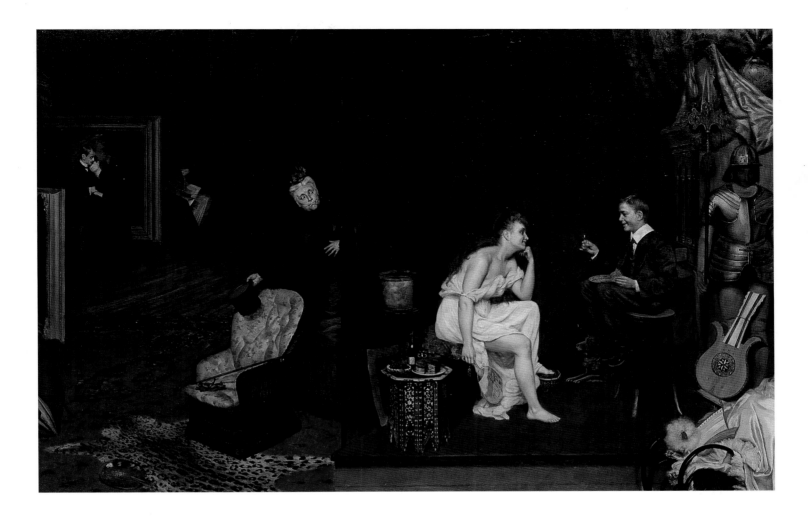

Fig. 10
Frank Hyde
The Eton boy
Oil on canvas, *ca.* 1880s
Private collection

The concept of the studio as a shrine, immured from the taboos that policed other private spaces, was founded upon the patriarchal mythology of the male artist and his female model, typified by Burne-Jones's *Pygmalion* series (fig. 13, p. 80), Edwin Long's pendant pictures of Zeuxis and the Women of Crotona (cat. 74), and Alma-Tadema's *Sculptor and his model*. In one sense, these pictures were an aspect of a revival of interest in classical culture. Yet it is significant that the image of the sacerdotal male artist inspired by his female model and handmaiden coincided with the construction of these modern 'palaces of art'. Nor can it have been mere coincidence that the notion of the studio as a palace or fortress came to the fore at the very time when not only the role of the female model was under increasing public scrutiny (see previous chapter), but when women artists themselves were threatening the exclusivity of the studio as a male preserve, just as they had already 'invaded' the nation's academies, art schools and other educative institutions.

As male artists conspicuously feathered their nests, and fuelled their fantasies, so genre paintings featuring the artist and model in the studio gained increasing popularity. Raphael and Rembrandt proved popular and, from more recent history, domestic scenes involving famous British artists: Romney and Emma Hamilton; Reynolds and Mrs Siddons; even Hogarth and Captain Coram.[12] Scenes from contemporary studio life emphasized the theatricality of the studio, notably Sir John Gilbert's and Louis Haghe's paintings of models posing as cavaliers,[13] and Frank Hyde's prurient pendant pictures, *The artist's studio* and *The Eton boy* (figs. 9 and 10).

Hyde's pictures exploit a vein of schoolboy humour based on the popular myth of the artist and model, although any suggestion of sexual high jinks in the first picture is deflated in the dénouement in the second as the boy is seduced by the offer of cake and a glass of sherry by the scantily clad model – the archetypal 'tart with a heart'. Similar vignettes appeared in artists' memoirs of the period. George Storey recalled being taken unawares by visitors while working on a painting of Lady Godiva. As his naked model crept behind the screen Storey created a diversion, so that by the time she was spotted all that was seen was "a simple maiden completely dressed, eating an apple, and reading the *Family Herald*".[14] Again any potential for impropriety is quashed by an injection of mawkish humour, while at the same time underlining the male artist's exclusive access to the model's naked form.

Scenes from studio life involving the artist's model were increasingly evident in artists' autobiographies and memoirs by the late nineteenth and early twentieth century, as publishers encouraged artists to dwell on the more intimate aspects of the profession. Often these artists' anecdotes took the form of mild leg-pulling at the expense of the model, who was portrayed as poor, dishonest, enfeebled or none too bright. While artists such as Frith usually spoke with sympathy for the plight of the model, the common assumption was that studio life was an easy ride compared to art school: "They have only one man to please," remarked the illustrator Harry Furniss, "and one, moreover, who understands his work."[15] In this, and similar male chauvinist accounts, the collective impression is that the ideal model was tractable and quiet, like Furniss's model Nellie, who "was not endowed with much brain, but had sufficient intelligence to understand the pose you required".[16] Although models were apparently not allowed an intellect they were on the whole portrayed as decent and hard working, resorting to modelling as a means of paying off family debts or caring for sick relatives. Professional models were acknowledged to be poor and forced into modelling by circumstance, although abject poverty could be a disqualification, Frith recalling in the 1880s that artists were no longer able to recruit models from the workhouse as they habitually spent their earnings on drink.[17]

The prime purpose of the model's presence in the studio was to assist the artist in realising a figure in a specific work of art. By the late nineteenth century, the public appetite for vignettes from studio life led artists to record extraneous events surrounding the central ritual – models arriving at the studio door, models eating their dinner, models playing with paintbrushes or models admiring themselves in the studio mirror. Collectively these images constructed an image of the model as a pet or plaything, Harry Furniss remarking how one fellow graphic artist, although he did not use a model, liked to have one "knocking around" the studio while he worked – with his back towards her (fig. 11). This was an attitude which informed the bohemian behaviour of subsequent generations of artists such as Augustus John. Indeed, even today, the nude female model is regarded as an essential prop in populist images of the artist's studio, irrespective of whether the artist actually uses her in the course of his profession.[18]

While in certain quarters Victorians expressed moral outrage at the artist's privilege of having unlimited private access to the nude model in the studio, others were simply envious. In 1871, the year he published *The Descent of Man and Selection in Relation to Sex*, Charles Darwin observed to the sculptor Thomas Woolner: "I daresay you must often meet and know well painters. Could you persuade some *trustworthy* men to observe young and inexperienced girls who serve as models, and *who at first blush much*, how low down the body the blush

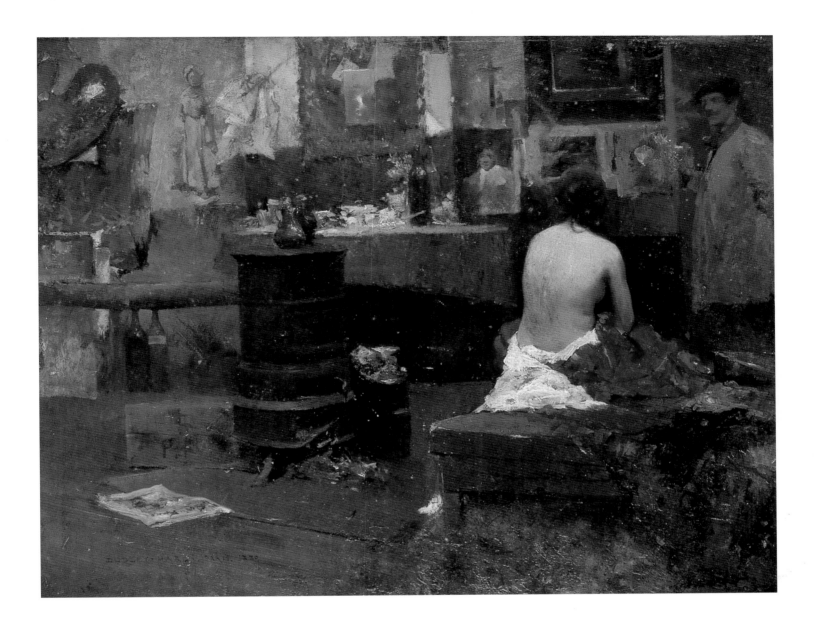

Fig. 11
Dudley Hardy
Idle moments
Oil on board
Signed and dated: *Paris 1889*
Private collection

extends?"[19] The voyeuristic satisfaction that some of Woolner's peers evidently derived from the model is epitomized by Edward Gregory's *A Look at the Model*, in which the bewhiskered artist portrayed himself apparently taking in the view of his (presumably naked, female) model much as he might enjoy a good cigar.[20] Gregory's picture was reproduced in 1884 in *The Magazine of Art*, a periodical which, it has been asserted, was "one of the most active agents of the resurgence of male domination in British art".[21]

Contrary to the fantasy of models as studio pets providing inspiration or creature comfort, artists privately acknowledged that prostitution remained an alternative or a supplement to female models' wages, Landseer stating, upon recommending a model to Mulready, that "perhaps an *honest penny* may be put in her way".[22] A handful of women, like Steer's model, Rose Pettigrew, or Connie Gilchrist, who went on to marry into money and title, profited materially and socially from their liaisons with artists. But while some enjoyed, and courted, their reflected glory, the majority preferred anonymity. Names of models were circulated privately, and when, in 1841, an artist published a list of names and addresses he was

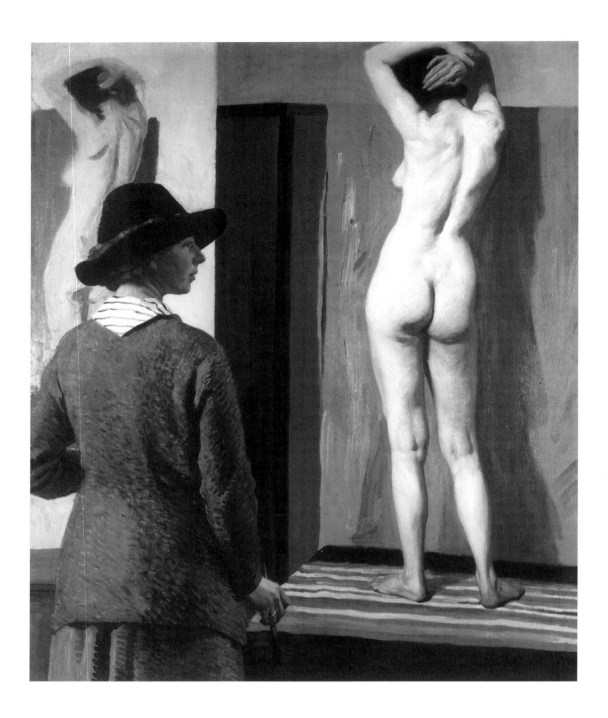

Fig. 12
Dame Laura Knight
Self-portrait with nude model
Oil on canvas, 1913
National Portrait Gallery

chastised, it being claimed that "such a publication as this will go very far to destroy that which all artists have taken so many pains to establish, I mean the respectability of the persons named therein".[23] The private lists of models' addresses kept later in the century by the graphic artist Linley Sambourne, together with the notes on them in his diaries, provide a more realistic insight (cat. 53). In the 1880s and 1890s Sambourne took countless photographs of naked and clothed models, both as the basis for drawings and for pleasure. His male models included a local policeman and his coachman. The women, categorized by their physical attributes – "good figure", "long slim legs", "ugly and stupid" – journeyed to Sambourne's home in Kensington from slum dwellings in Holloway, Euston and Fulham – a reminder of the financial inducement that attracted models to artists, and their wretched existence beyond the studio.[24]

By the end of the nineteenth century, as artists crossed the Channel in increasing numbers to study in the more liberal environment of Continental art schools, the codes of behaviour that regulated studio life also became less hidebound. Intimate and casual observations of the model, pioneered in England by Sickert and his followers, deliberately confused the boundaries that formerly existed between the professional sphere of the studio and the domestic sphere of the boudoir and bedroom. Sickert, who had an intimate knowledge of French artistic life, was a vital influence in this direction in the early years of the century, through his Venetian studies of female models in domestic settings and more especially his sequence of studies made in and around rented studios in Camden Town. Rather than concealing or suppressing their grim circumstances, Sickert developed a vicarious fascination with the lurid lives of the working-class women who modelled for him, and of the men "who lived on them, now & again hitting them with 'ammers, putting poisonous powders on cakes, trying to cut their throats, drugging their whisky &c."[25] It was this frank acknowledgement that the living model was far more interesting than any second-hand ideal that encouraged artists to pursue them into the streets, the country, the boudoir and the bedroom.

Emblematic of the freedom younger male artists enjoyed in their social relations with the female model by the early years of the twentieth century are the paintings and studies that William Orpen made from Emily Scobel, a model at the Slade and his lover. Among these were *The mirror* and *The English nude*, a highly sensual painting of Emily seated on the large four-poster bed she shared with Orpen in a basement flat in Fitzroy Street.[26] Orpen returned to the theme of the artist and the model time and again (cat. 55), his subsequent works tending to reinforce the stereotype of the studio as a male domain in which the female model was possessed and pacified. By Orpen's death in 1931 the genre of the artist and studio model was desperately clichéd. Serious artists continued to work from the model in the studio, artists and models continued to form relationships, but the concept of the studio as a site or sign of social or sexual freedom was largely bankrupt.

Away from the heady atmosphere of Fitzrovia and the glamour of London's Café Royal (see below), the studio remained problematic, not least for women artists whose right of tenure was still be to be fully acknowledged. In one sense the position of women in the studio presented a paradox. In the public imagination female models – particularly nude models – were an indelible fixture of studio life. Less well known was the fact that, as artists, women had been compelled for generations to work from the model in the privacy of the studio – since their presence was barely tolerated in the public sphere of the art school. Laura Knight, although she was the same age as Orpen, did not enjoy the same freedom as he had. Denied the opportunity to work from the life, she bravely invited one of the models, a half-blind young man named Jack Price who worked at her art school in Nottingham, to pose nude for her in the studio: "I, almost afraid to look at him, when the first hourly rest became due, took his outstretched hand in my own to help him down from the model throne. As it turned out, he was not asking for help, but for a piece of chalk to mark the exact position of his feet. I blushed at the thought that he might think I was making advances ... it was a terrible ordeal altogether."[27] Subsequently Knight found peace and relaxation, away from the metropolis, in a hut in Cornwall. There she painted her model, Ella Naper, including *Self-portrait with model* (fig. 12). It is a powerful image, and a worthy icon for the artist and model in the twentieth century.

1 Kathryn Moore Heleniak, *William Mulready*, New Haven and London 1980, pp. 158 and 257, note 13. Mulready's MS notes are in the Victoria and Albert Museum.

2 V. Surtees, ed., *The Diary of Ford Madox Brown*, New Haven and London 1981, p. 189.

3 William Hayley, *The Life of George Romney Esq.*, London 1809, p. 57.

4 Quoted in Diane Holman Hunt, *My Grandfather: His Wives and Loves*, 3rd edn, London 1987, p. 62.

5 *Ibid.*, p. 70.

6 See Giles Walkley, *Artist's Houses in London 1764–1914*, London 1994, esp. pp. 58–138.

7 *Ibid.*, p. 103. See also M. Phipps-Jackson, 'Cairo in London', *Art Journal*, New Series, 1883, p. 74.

8 Walkey, *op. cit.* note 6, p. 73.

9 *Ibid.*, pp. 60–62.

10 *Ibid.*, p. 206. See also A. Thirkell, *Three Houses*, London 1930, p. 19.

11 Mrs Russell Barrington, *The Life, Letters and Works of Frederic, Lord Leighton*, London 1906, II, p. 272.

12 See, for example, William Breakspeare, *Lady Hamilton in Romney's studio* (Sotheby's, 7 October 1980, lot 142); Frank Dadd, *Lady Hamilton in Romney's studio* (Sotheby's, 27 February 1985, lot 459); John Bridges, *Thomas Webster painting his pupils* (Sotheby's, 7 October 1980, lot 135); H. Pilkington, *Morland and his model*, British Institution, 1851 (no. 172); William Quiller Orchardson, *Mrs Siddons in Reynolds's studio*, Royal Academy, 1903.

13 Sir John Gilbert, *An artist in his studio* (Sotheby's, 28 July 1977, lot 322); Louis Haghe, *The artist's studio: painting a Cavalier* (Christie's, 11 October 1983, lot 176).

14 G.A. Storey, *Sketches from Memory*, London 1899, pp. 273–75.

15 Harry Furniss, *Some Victorian Women, Good, Bad, and Indifferent*, London 1923, p. 109.

16 *Ibid.*, p. 104.

17 W.P. Frith, *My Autobiography and Reminiscences*, 2nd edn, 1887, I, pp. 63 and 275–76.

18 Furniss, *op. cit.* note 15, p. 103.

19 Amy Woolner, *Thomas Woolner, R.A., Sculptor and Poet: His Life in Letters*, 1917, p. 288.

20 Exhibited Royal Institute 1884. Reproduced in *The Magazine of Art*, VII, 1884, p. 353. See also Pamela Gerrish Nunn, *Problem Pictures: Women and Men in Victorian Painting*, Aldershot 1995, p. 16 and fig. 1.6.

21 Pamela Gerrish Nunn, *Victorian Women Artists*, London 1987, p. 19.

22 Heleniak, *op. cit.* note 1, p. 257, note 13.

23 'Living Models', *The Art Union*, September 1841, p. 160.

24 Mary Ann Roberts, 'Edward Linley Sambourne (1844–1910)', *History of Photography*, XVII, no. 2, Summer 1993, pp. 207–12.

25 Quoted in Wendy Baron and Richard Shone, eds., *Sickert Paintings*, exhib. cat., London, Royal Academy of Arts, 1992, p. 204.

26 Bruce Arnold, *Orpen: Mirror to an Age*, London 1981, pp. 75f. and 64, plate 2.

27 Laura Knight, *The Magic of a Line*, London 1965, p. 97.

Sir David Wilkie (1785–1841)

48 *Female nude climbing a ladder*

Black and red chalk, with watercolour,
touched with bodycolour, 33.1 × 22.7 cm
Signed and dated: *D. Wilkie – July 18.
1840*
The Trustees of the British Museum,
London

Female nude climbing a ladder is
one of Wilkie's final studies of the
nude model, made shortly before
his departure for the Holy Land in
August 1840, a journey from
which he never returned. The
study is unusual in its casual
informality, the model paused,
paint pot in hand, on a ladder in
the artist's studio.[1] Wilkie had
entered the Royal Academy
Schools in 1805. Yet, although he
was proficient in drawing from
the Antique and from Academy
models, he preferred to portray
the figure in a more spontaneous
manner, even making studies of
his own body in the mirror. Later
in his career he was influenced
increasingly by the example of
Rubens, although the present
study may also owe a debt to his
contemporary, William Etty.

MP

**William Powell Frith
(1819–1909)**

49 Study for *The sleepy model*

Pencil and charcoal on paper,
53.5 × 71.1 cm
1853
Royal Academy of Arts, London

The sleepy model, for which this is
the study, was Frith's diploma
work, presented to the Royal
Academy in 1853. The model in
question was an orange seller,
"of a rare type of rustic beauty",
whom Frith spotted in Albany
Street, Regent's Park. Originally
Frith had intended to paint her
laughing but, having failed to
amuse her sufficiently, painted her
asleep. Frith, who had only with
difficulty persuaded the woman to
model for him – since she was a
strict Catholic – asked the girl

whether she was often bothered
by soldiers and "street-loafers".
"'Yes, sometimes she was
bothered; but it was by swells.
Gentlemen', she said, 'is much
greater blackguards than what
blackguards is.'"[1] Frith, who made
extensive use of models in his
crowded narrative pictures, made
frequent reference to them in his
autobiography: they included
Brunskill, the male model too
drunk to hold his pose; the
modest Miss B____, compelled to
model nude in the Academy to
prevent her father going to
debtor's prison; Jim Bishop, part-
time model and pig breeder; Mr
Bredman, the "pious" con-man
model; and the venerable Ennis,
who he believed had sat to
Reynolds as a boy. While he
discoursed amiably about his

models and their foibles,
occasionally we glimpse a sense of
revulsion: the ordinary working-
class female models whose
grammar "caused a shudder",
or the young crossing-sweeper, a
"low, dull, Irish boy ... one degree
removed from a pig".[2]

MP

William Powell Frith

50 *Self-portrait with a model*

Oil on canvas, 61 cm × 46.4 cm
Signed *W.P. Frith 1867*
Trustees of the National Portrait Gallery,
London

Frith's *Self-portrait with a model*
contains a strong autobiographical
element, with the artist seated at
his easel in the parlour of his
home at 10 Pembridge Villas,
Notting Hill. The picture is lent a
deliberate air of mystery as the
pretty young woman dressed in
black (perhaps a widow) lifts her
veil, revealing her identity to the
privileged gaze of the artist.
Indeed, the narrative is
reminiscent of Frith's description
of his initial encounter with "the
ill-starred Mrs Rousby", his model
for Amy Robsart in the scene from
Kenilworth which he exhibited at
the Royal Academy in 1871: "I
shall never forget", he wrote,
"the vision of beauty that burst
upon us when she entered the
drawing-room at Pembridge Villas
on her first visit here."[1] Later in his
career Frith returned several times
to the subject of the artist and
female model – notably *The new
model* of 1892, where a young
woman adjusts her gloves on
leaving the artist's studio, turning
from the easel on which rests the
painting of a female nude for
which she has been modelling.
It was in pictures such as this, as
well as the handful of nudes he
painted during the 1890s, that
Frith revealed a more explicit
interest in the sexuality of the
female model. But by then he had
also revealed the existence of his
mistress of many years, Mary
Alford, who had borne him two
children out of wedlock, and
whom he had married shortly
after the death of his first wife
in 1880.

M P

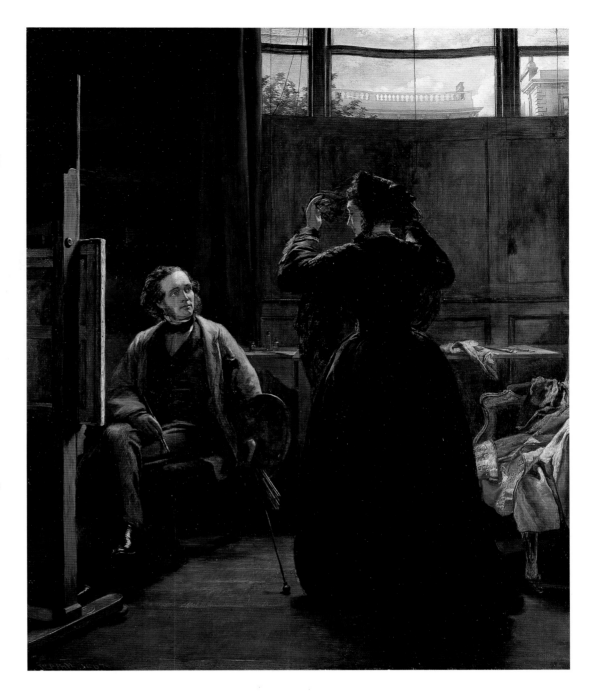

Frederic, Lord Leighton (1830–1896)

51 *Study for Iphigenia*

Bronze mounted on green marble,
14 × 59.4 × 23.8 cm
ca. 1882–83
Royal Academy of Arts, London

This bronze sculpture was made from a plaster figure, used by Leighton as a miniature lay figure for his painting *Cymon and Iphigenia* of 1884 (The Art Gallery of New South Wales), in which the pose of Iphigenia was a reversal of Ingres's *Odalisque and the slave*.[1] However, the sculpted figure was used not only for studying the nude – for which drawings would have sufficed – but for complex drapery patterns, through the application of sheets of sized muslin to the figure. As Leighton noted, these sketch models were made "only for the sake of ten minutes drawing, the

serious study of drapery being made from the living model or lay figure".[2]

Leighton had been in the habit of using wax and clay models as pictorial aids since the mid-1870s, when he produced a small "sketch model" for a figure in *The Daphnephoria*, and continued to do so to the end of his career. From these plaster casts were made, some of which he displayed in his studio; some also were given to friends. After his death Leighton's sisters presented his plaster casts to the Royal Academy: a number of them, including the present figure, were then recast in bronze (in the course of the process the cast itself was destroyed).

MP

Richard Polak (1870–1957)

52 *The artist and his model*

Platinum print, 21.1 × 17 cm
1914
The Royal Photographic Society Collection, Bath

Richard Polak was born in Rotterdam and studied photography with Karl Schenker in Berlin before coming to London around 1910. He began exhibiting photographs in 1913 and became a member of the London Salon of Photography in 1915. In the same year he moved to Switzerland and seems to have given up photography soon afterwards.[1]

During his short career as a photographer he concentrated on tableaux that imitated seventeenth-century Dutch paintings. Some of these were published by F.J. Mortimer in *Photographs from Life in Old Dutch Costume*, 1923. The

present study of an artist in his studio is heavily dependent upon the work of Vermeer, in particular *The painter's studio* (Kunsthistorisches Museum, Vienna). In contrast to that artist's clothed figure posing as the Muse of History, Polak has the more contemporary image of a model-muse, the naked female. Polak seems to be engaging in a degree of parody here, and was perhaps influenced by the treatment of the theme of the studio by artists currently at work in Britain, in particular Orpen (cat. 55).

WV

**Edward Linley Sambourne
(1844–1910)**

53 *Two studies of Sambourne's
coachman, Ottley*

Cyanotype, 12 × 16.5 cm
8 November 1894
Linley Sambourne House (The Royal
Borough of Kensington and Chelsea)

Sambourne's coachman Ottley
acted as his model in many
photographs, often posed, as
here, in the back garden of his
house at 18 Stafford Terrace,
Campden Hill. Sambourne clearly
had great fun posing his models
with impromptu props, here
transforming Ottley into the
emperor Nero with the aid of a
bedsheet and a fire guard. These
two photographs were used as
the basis of the cartoon *A Political
Conference*, which appeared in
Punch on 17 November 1894 (see
right). As usual, the subject would

have been decided upon, some
nine days earlier, at a meeting at
Punch (Wednesday 7 November);
Sambourne would have taken the
photographs the following day
and made the design on Friday
(9 November), just over a week
before it was published. Here,
as with the majority of his photo-
graphs, Sambourne used the
cyanotype process, which was
cheap and technically
straightforward.[1]

M P

A POLITICAL CONFERENCE.
"Gladstonius parvam rem Horatianam compositionis suæ ad Rosebelium recitans."

William Strang (1859–1921)
54 *The studio*

Etching, 25.8 × 35.2 cm
Inscribed: *W Strang 1911*; signed in
pencil: *David Strang. Imp./ Final St./
William Strang*
Private collection

This etching is one of several
works by Strang focussing on the
theme of the artist and model.
Here the nude female model
bends forward, possibly to retrieve
her clothing, while the artist,
seemingly oblivious of her
presence, busies himself
retouching a framed canvas. It can
be compared to one of Strang's
earliest etchings, *The model*, of
1882, where the artist had
depicted himself with the female
nude model, hovering over her
prone body with his shadowy
accomplice, in a manner more
reminiscent of a surgeon with a
cadaver than an artist in the
studio.[1] Here, the mood is less
oppressive, the various elements –
the model, the printing press and
the framed picture – acting as a
collective manifesto for Strang's
devotion to etching and painting
the figure.

Scots by birth, Strang was a
product of the Slade School under
Legros, whose assistant he
became in the etching class in
1880. Strang shared Legros's
liking for the "macabre and
mysterious", a characteristic
which emerges in a number of his
model-related works, notably *The
worshippers* of 1913, in which a
group of voyeuristic men gather
round a seated nude female
model.[2]

MP

55 *The studio*

Oil on canvas, 76.5 × 80 cm

ca. 1910

Leeds Museums and Galleries (City Art Gallery)

Like *The draughtsman and his model* (cat. 108), this picture shows Orpen's concern with the theme of the artist and his model. In this case, he appears to be playing on the theme of seventeenth-century Dutch painting, and in particular the interiors of Vermeer – such as *The painter's studio* (Kunsthistorisches Museum, Vienna) and *A young woman standing at a virginal* (National Gallery, London). There is nothing historicist, however, about either the image of the artist painting (presumably Orpen himself) or the model, who seems to embody an utterly twentieth-century stereotype. It was works such as these that appear to have inspired the photographer Richard Polak (cat. 52) to produce his spoofs on seventeenth-century Dutch paintings.

wv

Francis Campbell Boileau Cadell (1883–1937)

56 *The model*

Oil on canvas, 127.2 × 101.6 cm

ca. 1909–15

National Galleries of Scotland

Long recognized north of the border as a major artist, Cadell deserves to be far better known in the south. This painting of a model in a domestic setting belongs to the period when he had returned from Paris in 1909 to settle again in Edinburgh.[1] It shows the fascination with reflective surface that he had at that time, his treatment of this forming an interesting contrast to that of Orpen (cat. 55).

wv

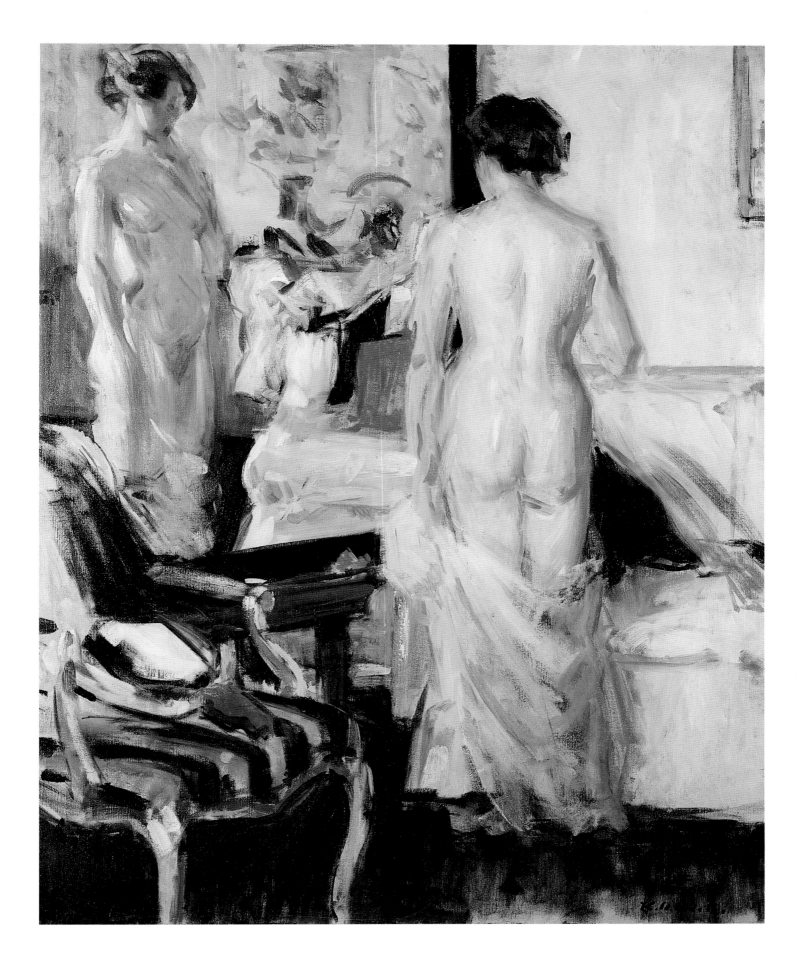

Christopher Richard Wynne Nevinson (1889–1946)

57 *A studio in Montparnasse*

Oil on canvas, 127 × 76.2 cm

1926

Tate Gallery, London

Presented by H.G. Wells 1927

Nevinson was a controversial figure, viewed with suspicion by the art establishment. His independence, however, gained him the respect of a number of patrons with radical interests, including the novelist H.G. Wells, who bought this work and presented it to the Tate Gallery.

The picture was painted when Nevinson was living in Paris, where he had studied before World War One. It shows the studio of the author and journalist Sisley Huddleston. As Nevinson recounts in his memoirs, Huddleston wrote to the press at the time the work was acquired by the Tate to protest that "there was a nude in the studio, and the studio was his". Nevinson claimed that he had not intended to produce anything sensational: "When I worked on the picture and put in the nude, I was thinking only of the design. But then I always forget the interpretation the average member of the public puts on a nude. Nothing startles me more than when the mayor and his aldermen representing various municipal galleries come to my studio to choose a picture, and they arrive all agog and begin lifting the curtains and peering into cubby-holes in the hope of seeing a naked lady."[1]

Despite his protest, it is hard to believe that Nevinson was not pandering to the stereotypical image of a bohemian Parisian studio, with the naked model stroking the cat as an emblem of sensuality.

WV

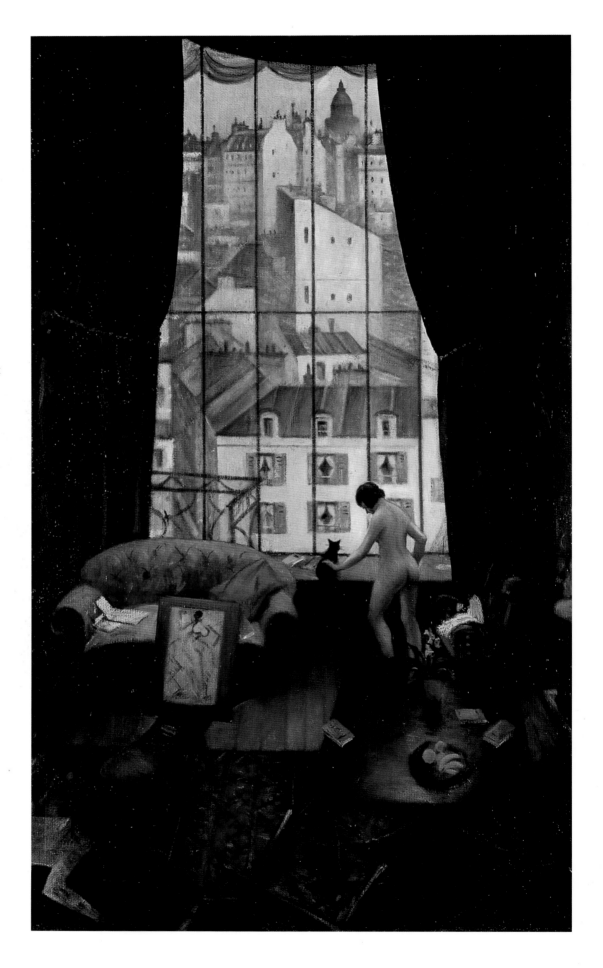

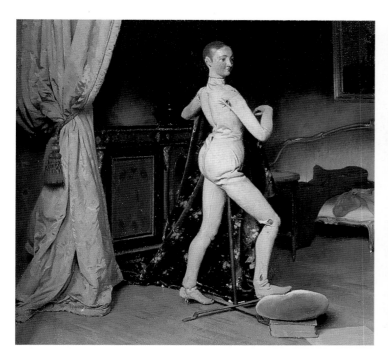

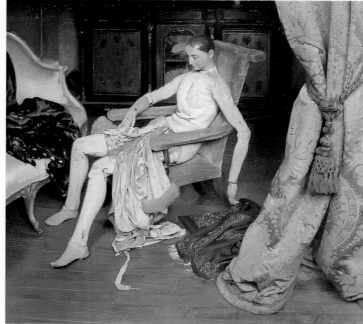

Alan Beeton (1880–1942)

58 *Posing*

Oil on canvas, 28.9 × 31.2 cm
ca. 1929
Lent by the Syndics of the Fitzwilliam
Museum, Cambridge

59 *Reposing*

Oil on canvas, 28.8 × 31.2 cm
ca. 1929
Lent by the Syndics of the Fitzwilliam
Museum, Cambridge

60 *Decomposing*

Oil on canvas, 34 × 39 cm
ca. 1929
The Trustees of the Tate Gallery, London

Decomposing is one of a set of four pictures of lay figures, entitled *Posing, Reposing, Composing* and *Decomposing*. Beeton subsequently produced a second set of three only, *Posing* (cat. 58), *Reposing* (cat. 59) and *Composing*. The first two of these latter are now in the Fitzwilliam Museum, Cambridge, the third is in a private collection.[1]

In these works Beeton plays on the tradition of the lay figure as an inanimate representation of the animate human form. It is hard to determine the extent to which he was aware of the use of automata based on lay figures in Dada and Surrealist art. Like many other academic painters, he was probably attempting to attract attention in the Academy by making a guarded use of the artistic innovations of the avantgarde. Perhaps he felt he had overstepped the mark with *Decomposing* (which is certainly the most radical of the set), since he did not include it in his second version of the series.

After exhibiting this series Beeton's reputation improved and he went on to be elected Associate Royal Academician in 1938. Doubtless he would have achieved full Academic honours had he not died a few years later.

wv

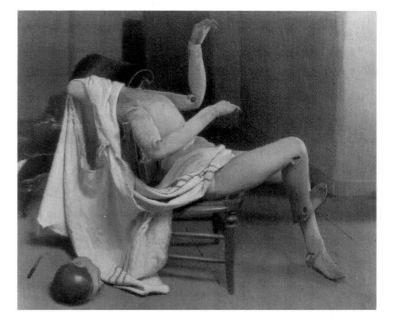

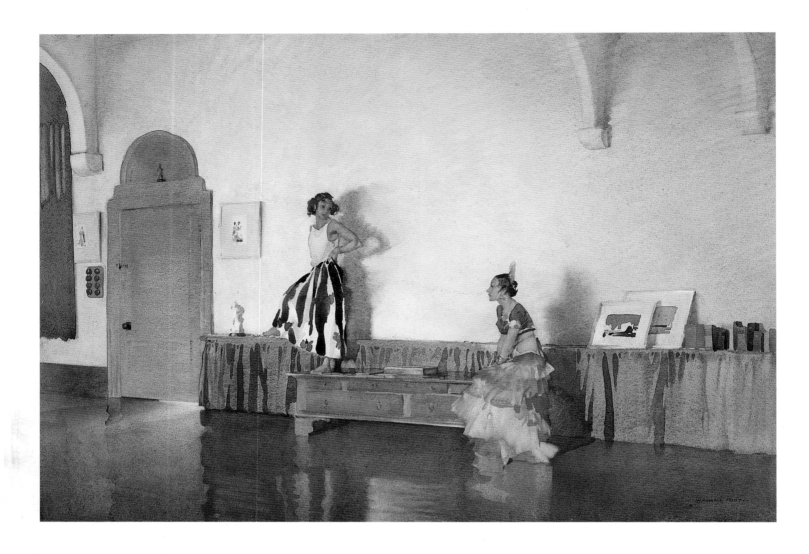

**Sir William Russell Flint
(1880–1969)**

61 *In a Campden Hill studio*

Watercolour, 33.9 × 50 cm

1934

Harris Museum and Art Gallery, Preston

Russell Flint's popularity and
commercial success during his
lifetime and since has never been
matched by critical acceptance –
a judgement which is without
doubt related to questions arising
over Flint's perceived lack of taste,
not least in his unashamedly erotic
treatment of the female figure.

Flint had first worked in London
as a medical illustrator, studying
part-time at Heatherley's Art
School and independently at
the British Museum. He made
extensive use of young female
models, on the pretext that he

found them a greater challenge to
draw than their male counter-
parts. Following visits to Spain he
became particularly enamoured
of Spanish dancers, whom he
painted and sketched in quick-fire
poses.[1] Flint was fascinated with
the history of the model, and
contemplated writing a serious
book on the subject, although in
the end he settled for a slight, and
slightly risqué, publication entitled
Models of Propriety, which
included a cast of imaginary
models, including Miss Maggie
Shrinkaway, who was shy of
posing nude, and Miss Euphemia
Meeker, "a resolute brunette,
pert, disobedient, daring", who
was in the habit of removing her
clothes at any possible
opportunity.[2]

MP

Bernard Fleetwood-Walker
(1893–1965)

62 *The model's throne*

Oil on canvas, 94 × 73.7 cm

1940

Private collection

The title of the picture is
somewhat puzzling, since it does
not show the kind of dais on
which a model would pose for
a life class, but rather a woman
seated on the floor in what
appears to be a private studio.
The presence of an artist's canvas
in the picture, however, does
establish that the theme is that
of the artist's model. The model
appears to be combing her hair in
preparation for a posing session.
The suggestion of vanity is further
emphasized by the title on the
book to one side of her, *Thaïs*.
Thais was an Athenian courtesan
who travelled with the army of
Alexander the Great during its
invasion of Persia. She is chiefly
known for having persuaded
Alexander to set fire to Persepolis
in the course of a drunken revel.
The name was frequently used for
courtesans during classical
antiquity and the Renaissance.
However, since the name is
written on a book, the reference
may be rather to the novel *Thaïs*
by Anatole France (1890), which
was the basis of an opera of the
same name by Massenet (1894).
The work was frequently
published in translation in English
in the early twentieth century, one
edition appearing in 1939, the
year before this picture was
painted.[1] The heroine of France's
book was a Christian saint who
was a reformed prostitute. Thais
is saved from her life of sin by an
anchorite monk who is in love
with her, and the story explores
his suffering and her eventual
spiritual triumph. The present
scene could relate to the moment
in the book when Thaïs reflects on
her beauty prior to the arrival of
her saviour.

WV

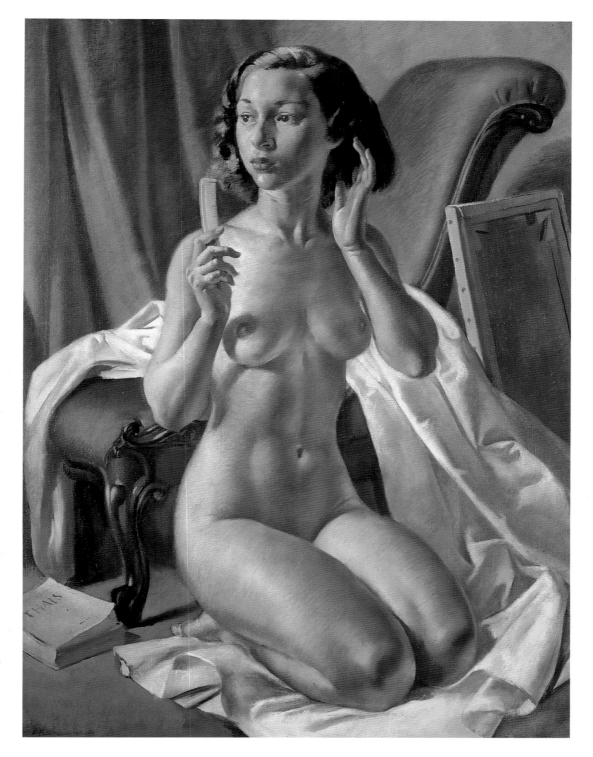

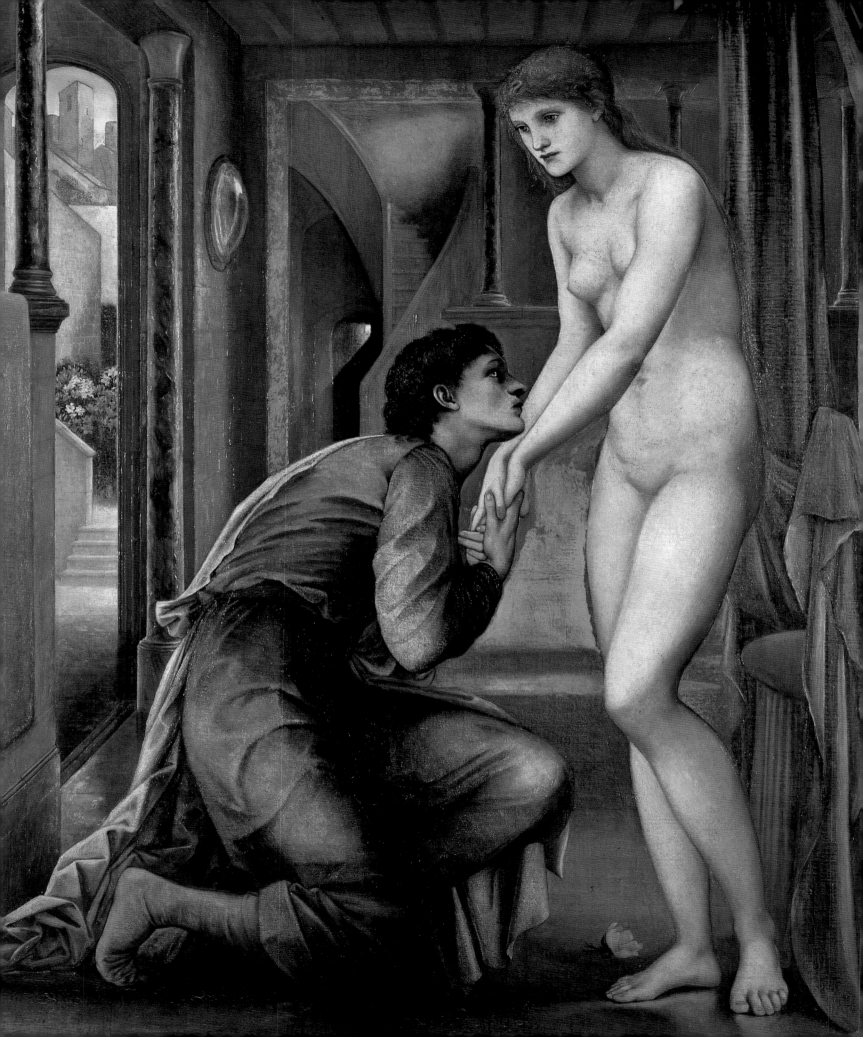

Models and Muses

WILLIAM VAUGHAN

He wanted to rid the house of Eloise Guimond, his model, his inspiration – and his mistress[1]

The gap between the myth and practice of the artist's model is large. In myth – as is suggested in the quotation above from a piece of pulp fiction, Norman Bligh's *Intimate Confessions of an Artist's Model* – the model is a seductive, racy female, a *femme fatale* shamelessly exposing her body and ensnaring the male (it is always male) artist in her thrall. In practice the model can be more or less anyone. At a time when artists still worked principally on subject pictures, models were of necessity of all types and ages. Unless a specialist in nudity like Etty (cat. 1, 92) or Tuke (cat. 98), the artist would probably spend more time studying and depicting figures with clothes on than off. Most models' lives were (and are) far from glamorous, involving endless hours of keeping completely still, often in uncomfortable positions, and being poorly paid. Before the twentieth century it was distinctly *déclassé* to be a model. Such people were on a par with tradesmen and servants. And while in fact on the whole 'respectable' (unrespectable people, after all, have discovered quicker ways of making money from their bodies), they were popularly associated with depravity.

In the twentieth century the social stigma disappeared, and was for a time at least replaced by an image that was positively glamorous. This change indicated a new perception of art and artists. In the Victorian period – the heyday of the Academy – artists had striven to be seen as gentlemen and emulated the conditions of bourgeois respectability. Most of them avoided, therefore, too close a public association with the lowly model. But with the growth of an artistic avantgarde in the latter years of the century bohemianism became the ideal. Artists now affected to live outside society, pursuing their aesthetic mission with single-minded dedication. In bohemia the model – of dubious class and respectability – was able to meet the 'outsider' artist on more equal terms. The aesthetic view of art, furthermore, encouraged the view that artistic excellence lay more in process than in subject. The model was held to provide a critical stimulus for the mysterious transformations performed by the artist, becoming an active participant in a highly eroticized notion of artistic creativity.

While the mythic model of the twentieth century is essentially an erotic fantasy, she had a more elevated forebear. The inspiring model of the past was more spiritual than sensual, being based on the classical image of the Muse, and to some degree on the Judaic-Christian view of the soul as a female entity. The great Victorian photographer Julia Margaret Cameron's *Whisper of the muse* (fig. 14) draws on this tradition. In this posed photograph the painter G.F. Watts is represented, not as a pictorial artist, but as a more generic image of the creative individual, fingering a violin – perhaps an updated reference to the lyre of Apollo. The muse that whispers in his ear is not the mature female of tradition but a child. Perhaps Cameron felt that this enabled the idea of inspiration to be represented with greater purity. For by the time that this photograph was taken, in the mid-1860s, the role of the model was already becoming

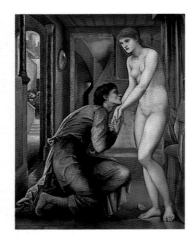

Fig. 13
Sir Edward Burne-Jones
Pygmalion and Galatea:
The Soul Attains
Oil on canvas, 1869–79
City of Birmingham Museum
and Art Gallery

problematic. It is a sign of the times that an adult woman could no longer symbolize innocence and purity.

The problem that Cameron was aiming to avoid in her image of the muse had to some extent been provoked by Watts's own work and by that of the Pre-Raphaelites. The latter had, indeed, pioneered a new view of the artist's model. When Hunt, Millais and Rossetti had formed their breakaway group with other discontented students at the Royal Academy Schools in 1848, they had proclaimed uncompromising pictorial truthfulness to be one of their aims. One aspect of academic teaching that they turned against was the use of professional models with their repertoire of stock poses and gestures. They preferred to use ordinary people as models. Frequently they used each other, or else chose people with professions appropriate to the subject being depicted. When Millais painted *Christ in the house of his parents*,[2] for example, the body of St Joseph was based on that of an actual carpenter. Similarly, Hunt used a real farm hand to model for the shepherdess in *The hireling shepherd*.[3]

Many of the female models used by the Pre-Raphaelites were drawn from among the shopgirls and seamstresses of the area in which they lived. Sometimes they were used to represent 'fallen women', as when Annie Miller (cat. 64) sat to Holman Hunt for the mistress who had realised the error of her ways in *The awakening conscience*.[4] But from the start the Pre-Raphaelites mingled such social-problem pictures with romanticized images of women as inspiring muses. While such models as Annie Miller and Fanny Cornforth (cat. 66) had personal lives that in no way fitted such an image, others were of a superior sensibility. Nobody represented this inspiring form of Pre-Raphaelite woman better than Elizabeth Siddal (cat. 63). She was idealized by Rossetti, being turned by him eventually into the Beatrice to match his Dante. Unfortunately, while encouraging this former shopgirl to develop her own creative talents, he failed to appreciate the extent to which he was imprisoning her within his own medievalizing fantasies. Siddal was soon to be joined in such imprisonment by another girl of the people 'rescued' by Rossetti and his acolyte, the young William Morris. This was Jane Burden, the daughter of a stable hand. The striking appearances of these women provided the basis for the archetypal image of the Pre-Raphaelite female ideal – probably the most persistent legacy of the whole movement. It also affected the imagery of other idealist painters of the day, such as Watts and Whistler (cat. 77).

The wish-fulfilment behind this constructed female ideal can also be seen in many of the myths depicted by the Pre-Raphaelites and their circle. The most telling of these is the Greek myth of Pygmalion, in which the statue of a beautiful female comes to life, a theme treated memorably by one of the 'second generation' Pre-Raphaelites, Burne-Jones (fig. 13). This theme might seem to represent the apotheosis of the model. But it is worth reflecting that it actually shows the reverse of the process practised by the Pre-Raphaelites. For in the Pygmalion myth the work of art becomes a person, whereas for them it was the person who was transformed into the work of art. Yet, no matter which way the process was working, in both cases it assumed a necessary link between the persona of the model and that of the image. Burne-Jones was every bit as dependent as Rossetti upon certain females to give visible form to his ideal. It was remarked at the time that the facial type that Burne-Jones constantly produced was that of his own wife, Georgiana, and that the models he chose in addition to her were of a similar cast. Ultimately this process turned full circle when their daughter grew up to become

Fig. 13 (*opposite*)
Julia Margaret Cameron
Whisper of the muse
(G.F. Watts with children)
Albumen photograph, 1865
Royal Photographic Society, Bath

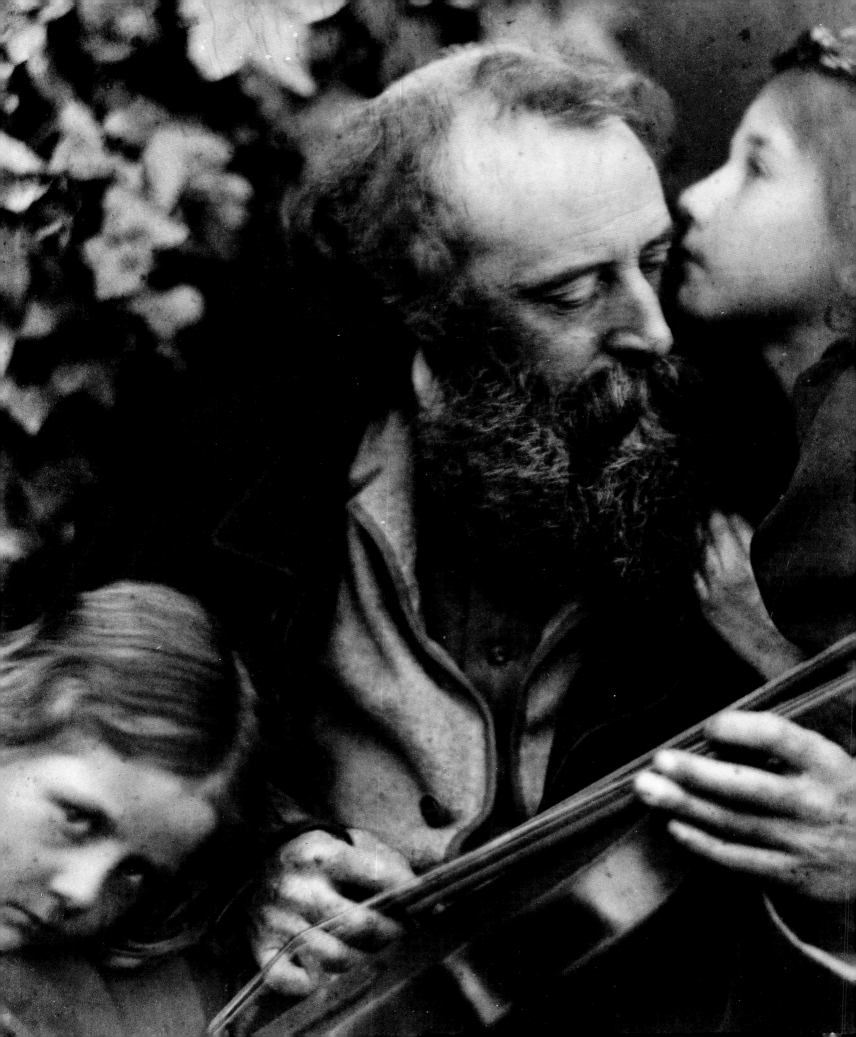

Fig. 15
'Ballad of the Professional Model'
Line engraving from *Punch*, 27 January 1894

the perfect visualization of a Burne-Jones woman. But however much the painter's models may have been reflections of his wife visually, they were not so in terms of personality. This was particularly the case with the fiery Greek Maria Zambaco (cat. 68), whose mother Euphrosyne Cassavetti commissioned the first version of *Pygmalion and the Image*. In this case the relationship between artist and model was of a different kind to that of earlier Pre-Raphaelites such as Rossetti and Siddal. For Zambaco was in no way materially dependent upon Burne-Jones. She was extremely wealthy and a sculptress in her own right. Posing as a model for Burne-Jones was an act of pure volition. However, while free of the social and financial pressures that constrained less fortunate women in Pre-Raphaelite circles, she was not exempt from scandal. When Burne-Jones exhibited *Phyllis and Demophoön* in 1870 it created a sensation because the profile of the half-naked Phyllis bore too strong a resemblance to Zambaco. A similar incident occurred when Burne-Jones's *Depths of the Sea* in 1886 had a naked mermaid in it with the face of another wealthy model, Laura Lyttelton. As Mrs Lyttelton had died the year before, this was taken to be a posthumous tribute – though an embarrassing one.[5]

One way in which Burne-Jones's *Pygmalion* differs from the earlier representations of Pre-Raphaelite 'stunners' is that the figure is nude. To a large extent the re-emergence of the nude in painting in Britain was a consequence of the development of the Aesthetic movement. For the more idealized art became, the more pictorial nakedness seemed removed from troubling associations with daily life.

The Aesthetic movement also encouraged an improvement in the status of the model. For it was felt that the model needed to be of a very particular kind to stimulate a great work of art. It was at this time that there was an influx of Italian models, many coming over from Paris, where they had long been established, as a consequence of the Franco-Prussian War in 1870.[6] In Italy there was a strong tradition of professionalism amongst models and whole families – males, females and children – specialized in the practice. Apart from appealing because of their business-like approach, they were also attractive on account of the warm tones of their skins. The men, moreover, tended to provide a more aesthetic image of maleness than the soldiers and labourers who had been used at the Academy. As William Blake Richmond wrote of one of them, Alessandro di Marco, "Alessandro was the most inspiring model I have ever drawn from, so different to the retired Grenadier or Cavalryman to whom we had been much used – fellows as stiff as drill could make them and as stupid as a conscientious Englishman can be."[7]

Unlike earlier British artists, those in Pre-Raphaelite and Aesthetic circles treated their models with respect. One of them, Gaetano Meo, complained that, in contrast to painters in Paris, most British artists "treated their models like dirt". But he added, "Not so Richmond and Rossetti, and Burne-Jones – God bless him! – they treated their models as human beings."[8] Meo, indeed, became a close friend of Richmond's and general manager of his studio. Such beautiful and sensitive male models became as much muses to certain painters as did any of the female models of the period.

The increasingly sympathetic and reflective attitude towards the model can also be seen in the treatment they begin to receive in the press around 1890. In 1894, for example, *Punch* published a 'Ballad of the Old Model', in which an ageing model regards a picture for which he has posed as it is displayed in a dealer's window, contrasting his fate with that of his painted image (fig. 15). Such reflections seem highly apposite in an age that had witnessed, in 1891,

the publication of Oscar Wilde's *Picture of Dorian Gray*, in which it is the picture, not the model, who suffers the vicissitudes of time.

It is a sign of the changing attitude to models that they should appear with increasing frequency in literature towards the end of the century. The culmination came with George Du Maurier's *Trilby* of 1894. Before becoming one of the leading illustrators for *Punch*, Du Maurier had been an art student in Paris. Trilby, the story of an artist's model who eventually dies in tragic circumstances, is based to some extent on his own experiences. Yet the image of Trilby herself – the beautiful waif who is part *femme fatale*, part victim – relates more to the *fin-de-siècle* obsessions of the period in which the book was published. The image of Trilby, in turn, helped to make the profession of artist's model seem even more glamorous.

If the 1890s were the time at which there began to be a new respect for the model in Britain, it was in the Edwardian period that they really came into their own. This was when a truly bohemian milieu can finally be said to have arrived – notably with the activities of Augustus John and his entourage, the Bloomsbury Group and such breakaway avantgarde movements as the Vorticists. The exotic model was an integral part of the new artistic society. In a revealing story by Saki, 'Quail Seed', a suburban grocer manages to prevent his clientele from abandoning him and going to shop in central London by staging a series of exciting incidents in his store with the help of an artist's model, a male, in this case, whose behaviour was as dramatic as his appearance.[9]

In emulation of their counterparts in Paris, avantgarde artists tended to meet increasingly in bars and cafés. The best known of these was the Café Royal. Located in Regent Street, on the edge of Soho, it soon became the haunt not only of artists but also of models "who used the place as a labour exchange".[10] It is significant, too, that the models in this bohemian haven were all female, and were to be distinguished by both striking appearance and striking behaviour. Many of Augustus John's favourite models were there, such as the pale and beautiful Euphemia Lamb. There were more passionate personalities as well, notably Betty May, the 'tiger woman', who had a violent unpredictable nature. She was introduced very early in life to the Café Royal and said of it, "no duck ever took to water, no man to drink, as I to the Café Royal".[11] Betty May was a favourite of Jacob Epstein's, as was Lillian Shelley, who used to entertain the customers at the Café Royal by standing on a table and singing lewd songs. The glamour of this bohemian life of models and artists also attracted bored and rebellious young socialites, such as the heiress Nancy Cunard. This *demi-monde* had its darker sides. Drug-taking was rife and some even resorted to black magic. The notorious Aleister Crowley began his career in this world. In later life Betty May, a friend of Crowley's, became involved in scandal when her fourth husband died as a consequence of one of Crowley's bizarre rituals.[12]

As in previous generations, it remained common practice for young student artists to act as models for themselves and each other, as when Charles Holmes explored his own physique (cat. 103) or Nina Hamnett posed for Gaudier-Brzeska (cat. 111). This was partly a process of self-discovery and partly an economic necessity. Few aspirant artists could afford to pay for substantial use of a professional model. With the change in the social status of the model, it also became more common for artists to act professionally as models. This was, inevitably, more the case for female than male artists. For not only were female models in greater demand by this time, but women artists were also likely to be in greater financial need than males. This was

certainly the experience of Gwen John (cat. 104). While her brother Augustus was being lionized in London, she was struggling to make ends meet as a professional painter in Paris. For some years she was obliged to supplement her income through modelling. At Augustus's suggestion she posed for Rodin, becoming as well the sculptor's mistress.

As has already been mentioned, the changing status of models was accompanied by a growing belief that they could provide not just a body to be studied, but also a critical source of inspiration for the artist. This view is exploited in a skit on Augustus John that was performed during the First World War in the *Monster Matinee in Aid of the Front* at the Chelsea Palace Theatre, 20 March 1917, by the John Beattie Chorus. Almost forty girls dressed as Augustus John models in costumes designed by Carrington and made by the Omega Workshop slouched on and arranged themselves in typical John poses, singing,

> "John! John!
> How he's got on!
> He owes it, he knows it, to me!
> Brass earrings I wear,
> And I don't do my hair,
> When I walk down the street,
> All the people I meet
> They stare at the things I have on!
> When Battersea Parking
> You'll hear folk remarking,
> 'There goes an Augustus John'."[13]

Models tended to identify themselves at this time by a clear visual code. In his autobiography *The Naked Civil Servant* Quentin Crisp gives a description of the uniform as it had evolved by the 1930s. Speaking of a friend in the profession he says, "She was an artist's model and dressed in accordance with the rigid dress laws of the time. She wore a vermilion polo-necked sweater, curtain-ring earrings and a black beret balanced at the ultimate degree of obloquy."[14]

The top models in the 1920s and 1930s enjoyed considerable power and independence. They were no longer required to become the 'muse' of one particular artist. Perhaps the most successful of them was Marguerite Kelsey, who worked for society and Academy artists of varying status and character, from Sargent to Charles Wheeler. The latter's Art Deco-ish sculpture of her as *Spring* (fig. 16) became one of the most celebrated images of the period. Kelsey came – like so many models – from a poor family. But as soon as she had begun modelling, she became a celebrity on account of her "gracious form". "We're going to make you tops," Sargent said when first meeting her. The same day he told his friends at his club, "I've just met a famous model." Kelsey was well paid for her work. At certain times of year, such as before the Royal Academy and the Royal Portrait Society shows, she would be booked months in advance. Such models had a strong sense of their own status. Kelsey took pains to stress the difference between such stars as herself and "the ordinary model, what we called 'the art school model'".[15]

Perhaps almost inevitably Kelsey finally married one of the artists who painted her. The period is littered with stories of liaisons and marriages between male painters and young models, Orpen and Monique (cat. 108), Kelly and 'Jane' (cat. 88), Brockhurst and 'Dorette'

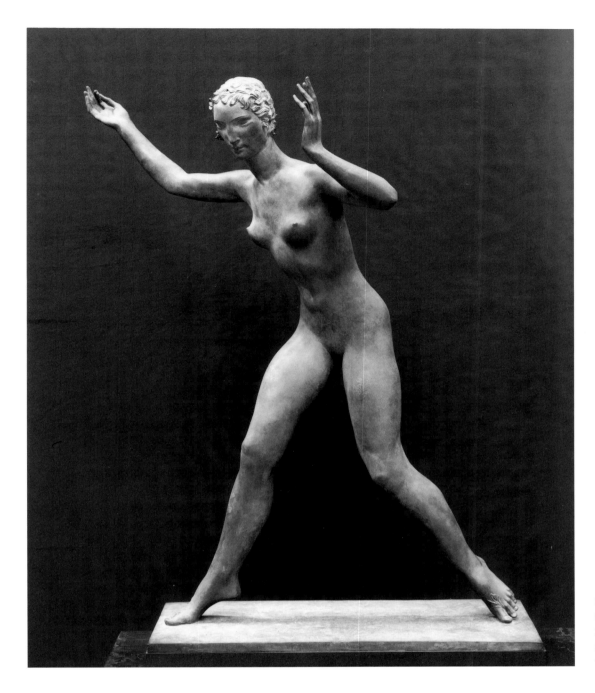

Fig. 16
Sir Charles Wheeler
Spring (Marguerite Kelsey)
Bronze, 1929–30
Tate Gallery, London

(cat. 119). Many, like Kelly and Brockhurst, made the portraits of their 'muses' a central part of their practice. They exhibited these regularly at the Academy, using them to enhance their careers as society portrait painters.

By the 1920s the myth of the 'muse' model was exploited largely by society and Academy artists. The most progressive artists no longer had much interest in it. As a young sculptor Henry Moore made drawings of his wife to help with the design of monumental figurative work for which he was beginning to receive commissions. Yet these studies are in no sense deifications of her (cat. 115). They are practical explorations of the human form. It is hardly surprising, either, to find that women artists addressed the myth critically. Laura Knight produced paintings of modelling that showed the less glamorous sides of the practice behind the scenes (fig. 12).

Dod Procter used non-professionals for her work and produced down-to-earth images of the modern, workaday woman (cat. 83).

Yet the image of the muse could still be inspiring, particularly when it related to some intense or unique form of experience. The academic painter Glyn Philpot became inspired in the last years of his life to experiment with a quite new and forward-looking form of painting when making portraits and studies of his manservant, the Jamaican Henry Thomas (cat. 85). These remarkable works are, like Stanley Spencer's contemporary portrayals of himself and Patricia Preece (cat. 91), confessional in the best sense of the word.

The appeal of male modelling to homosexual men was perhaps greater at a time when homosexuality was illegal in Britain. For, as one writer has put it, it became an opportunity for erotic display when other forms of gratification were risky.[16] Quentin Crisp had flaunted himself as a visually explicit homosexual for years before discovering the attraction of modelling in the late 1930s. He witnessed the last years of the great tradition and its decline in the post-war era, when art schools no longer regarded the life class as central to their practice and progressive artists moved further and further away from pictorial representation. Crisp himself attempted to keep up the tradition of the greatest models, devising challenging poses, but "my heroic postures on the throne now seemed more ludicrously outmoded than ever".[17]

For Crisp, writing in the late 1960s, there was a particular irony in the permissive age for which he and his friends had longed, bringing with it only tedium and apathy when it arrived. For him the decline in the status of the model was a consequence of a general lack of idealism. When asked for an interview by *The Scotsman* on the grounds that he was "the most famous model in the world", Crisp sadly explained that, "as far as I knew, the conditions in which anyone could be a famous model had vanished long ago. Those few of us who were still in the racket had dwindled into naked Civil Servants."[18]

1 Norman Bligh, *Intimate Confessions of an Artist's Model*, London 1953, p. 5.
2 1850, Tate Gallery, *The Pre-Raphaelites*, exhib. cat., London, Tate Gallery, 1984, no. 26, pp. 77–78.
3 1851, Manchester City Art Galleries: *The Pre-Raphaelites*, exhib. cat., London, Tate Gallery, 1984, no. 39, pp. 94–95.
4 1853, Tate Gallery: *The Pre-Raphaelites*, exhib. cat., London, Tate Gallery, 1984, no. 58, pp. 120–21.
5 Alison Smith, *The Victorian Nude*, Manchester 1996, p. 199.
6 Frances Borzello, *The Artist's Model*, London 1982, pp. 39–41.
7 A.M.W. Stirling (ed.), *The Richmond Papers: From the Correspondence and Manuscripts of G. Richmond, R.A., and his Son Sir William Richmond*, London 1926, p. 272.
8 *Ibid.*, pp. 273–74.
9 Hector Hugh Monro, *The Best of Saki*, London 1952, p. 163.
10 Denise Hooker, *Nina Hamnett: Queen of Bohemia*, London 1986, p. 44.
11 Betty May, *Tiger Woman*, London 1929, p. 45.
12 *Ibid.*, p. 46.
13 Michael Holroyd, *Augustus John, II: The Years of Experience*, London 1975, p. 210 (appendix).
14 Q. Crisp, *The Naked Civil Servant*, London 1968, p. 86.
15 Toby Glanville, 'Last of the Red Hot Models', *The Daily Telegraph Magazine*, 18 May 1991, p. 54.
16 Douglas Blair Turnbaugh (ed.), *The Erotic Art of Duncan Grant*, London 1989, p. 16.
17 Crisp, *op. cit.*, note 14, p. 206.
18 *Ibid.*, p. 214.

**Dante Gabriel Rossetti
(1828–1882)**

63 *Elizabeth ('Lizzie') Siddal,
seated*

Pencil on paper, 17.2 × 11.5 cm

1854

Birmingham Museums and Art Gallery

Elizabeth Siddal is known today as
the woman who lay in the bath to
model for Millais's *Ophelia*, and
for her brief, tragic marriage to
Rossetti, culminating in death
from an overdose of laudanum,
and the subsequent exhumation
of her body by her husband to
recover his love poems. Yet,
unusual among the train of
attractive young models who
posed for the Pre-Raphaelites,
Elizabeth Siddal had, herself,
ambitions to be an artist and
a poet, goals which, despite
obstacles, she to some extent
achieved. Professional modelling
occupied only two years of
Elizabeth Siddal's life. She was
among the first in a series of
young women to have attracted
the collective attention of the Pre-
Raphaelites as model and muse.
Yet she, more than any other of
the 'stunners' picked out by the
Brotherhood, suffered for their art
– not so much physically, or even
emotionally, but by the suppres-
sion of her own character and
achievements. Today, it is for her
own creative abilities and not
merely her ability to inspire crea-
tivity in others that she should
also be remembered – an image
quite at odds with the passive,
seated figure in Rossetti's drawing
shown here.

 Elizabeth Eleanor Siddal
(1829–1862) was allegedly first
spotted while working in a hat
shop in Cranbourne Street by
Walter Deverall (1827–1854),
who asked her to model for the
character of Viola in his painting
Twelfth Night. It is really only in
the last thirty years that detailed
facts of her early life and
background have gradually
emerged. She was born in

Holborn in 1829, one of seven
children of a Southwark
ironmonger. In 1851, when she
already had begun modelling, she

still lived at home – evidence,
as Marsh states, that from the
beginning she had a life, a family,
and an existence beyond her

legendary status as a Pre-
Raphaelite 'stunner'.[1]

M P

Dante Gabriel Rossetti

64 *Annie Miller*

Pen and ink, 25.5 × 24.2 cm

Inscribed: *Annie Miller/ aetat XXII/ 1860/
DGR* (monogram)

Private Collection (on loan to Manchester
City Art Galleries)

Annie Miller was the archetypal
Pre-Raphaelite 'stunner', beautiful,
promiscuous and working-class.
When discovered at the age of
fifteen by William Holman Hunt,
Annie was already working part-
time as an artist's model. She was
born in 1835, the youngest of
three children of a Chelsea
pensioner and veteran of the
Napoleonic Wars. When Hunt
found her Annie was working as
a bar-maid, and living in semi-
squalor behind the Cross Keys pub
in Chelsea.[1] Hunt, enamoured by
her good looks and vivacity, paid
for her education, including
lessons in deportment and
etiquette. At the same time she
sat to him for several pictures
including *Il dolce far niente* and
The awakening conscience
(although he subsequently
substituted her face with that of
another model). By now Hunt
hoped to marry Annie. In 1854
Hunt left for Syria. During his
absence Annie modelled for
Millais and for Rossetti, with
whom she began an affair. By the
mid-1850s she was very much in
demand as a model – and a
mistress – although Hunt
continued to regard her as his
particular possession. Their stormy
relationship eventually ended in
1859, when Hunt broke off the
engagement. Annie resumed
sittings with other artists, George
Price Boyce noting: "Annie Miller
came and sat to me. Rossetti
came in and made a pencil study
of her. She looked more beautiful
than ever."[2]

In 1863 Annie married a cousin
of Lord Ranelagh, with whom she
had also had a protracted affair.
Hunt recalled meeting her some
years later on Richmond Hill, "a

buxom matron with a carriage full
of children". Happily, the marriage
survived. Annie's husband died in
1916 at the age of eighty-seven.
She died in 1925, aged ninety, at
Shoreham-by-Sea.[3]

M P

Dante Gabriel Rossetti

66 Study for *Found (Fanny Cornforth)*

Ink, with traces of wash, 17.4 × 19.5 cm

1858

Birmingham Museums and Art Gallery

Julia Margaret Cameron (1815–1879)

65 *Call I follow, I follow let me die*

Brown carbon print, Autotype Company, 36.3 × 27.5 cm

ca. 1867

The Royal Photographic Society Collection, Bath

From 1863 to 1875 Julia Margaret Cameron took hundreds of photographs, using as models her friends and servants whom she posed as literary and biblical characters. Among her favourite models was Mary Hillier, her parlour-maid, who probably acted as model for the present photograph – an illustration to Tennyson's *Idylls of the King*. It has been observed that the real-life identities of Cameron's models do not matter since they do not impart meaning to images which "find their meaning in the space between idealist fiction and realist

fact".[1] Yet Cameron's photographs, unlike the Pre-Raphaelite paintings which they recall, evoke the real physical presence of the living model far more graphically than the imaginary characters they purport to represent. Indeed, Mary Hillier, who featured as the Madonna in countless photographs, became known locally under her *alter ego*, 'The Island Madonna'.[2]

The present photograph is presented alongside Rossetti's study for *Found*, made from a real life 'Magdalene', Fanny Cornforth, a 'sinner' whose image is sanctified by the intercession of the artist. Both Cameron's and Rossetti's images share an interest in combining intense religiosity with a sensual presence, emphasized by the loose tresses of hair and the pained iconic, profile of the model.

MP

This is among the most poignant studies of Rossetti's model, Fanny Cornforth. Rossetti's "town subject", or *Found*, occupied the artist intermittently for over twenty-five years, although it was never finished. The painting (Delaware Art Museum), begun in 1854, depicts the discovery of a 'fallen' woman by a young drover on his way to market with a calf, who realises that the slumped body of the prostitute is that of his former sweetheart. According to Fanny Cornforth, who had apparently been working as a prostitute (and who also claimed to be a farmer's daughter) the study for *Found* was made by Rossetti when he first took her to his studio, "where he put my head against the wall and drew it for the head in the calf picture".[1] In 1863 Rossetti had Fanny repeat the pose for a photograph taken in his garden, her head this time inclined towards a mirror.[2]

MP

Dante Gabriel Rossetti

67 *Aurelia (Fazio's Mistress)*

Oil on mahogany panel, 43.2 × 36.8 cm
1863
Tate Gallery, London
Purchased with assistance from Sir Arthur
Du Cros Bt and Sir Otto Beit KCMG
through the National Art Collections Fund
1916

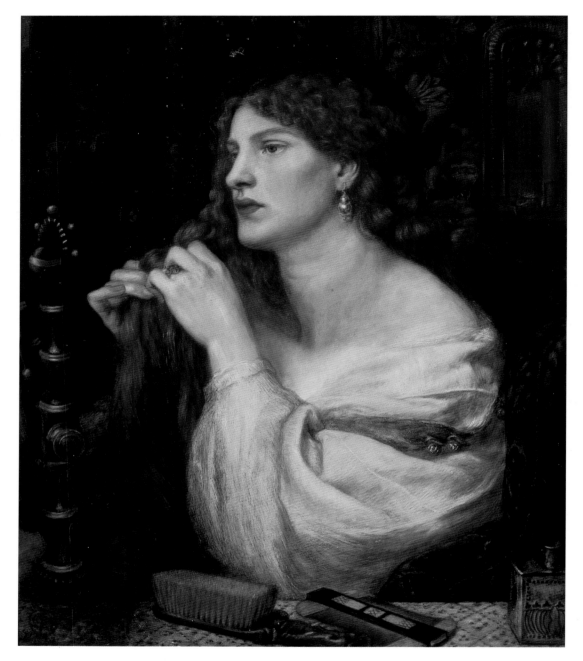

According to the artist William Bell Scott, Rossetti first met Fanny Cornforth in 1858 on the Strand: "She was cracking nuts with her teeth, and throwing the shells about, seeing Rossetti staring at her, she threw some at him. Delighted with this brilliant *naiveté*, he forthwith accosted her, and carried her off to sit for him for her portrait".[1] Fanny's own version of events was rather different. Two years earlier, in 1856, she had been walking with a respectable elderly relative in Surrey Gardens, when Rossetti, accompanied by Burne-Jones and Ford Madox Brown, had deliberately barged into her, and persuaded her to sit to him. Certainly, Fanny's account tallies with Rossetti's usual *modus operandi* in getting young, attractive women to sit to him, "making the acquaintance of one model by running out of a confectioner's with a half-bitten tart in his hand, to stare in her face; of another, 'a simple country girl' who, sitting in a restaurant, felt her hair suddenly seized and untied".[2]

The full story of Fanny's career as prostitute, model and mistress only came to light after her death, not least because Rossetti's family wished to erase her memory.[3] Her real name was Sarah Cox, Cornforth being the name of her first husband's mother.[4] Considered vulgar and charmless by many in his circle, Fanny mesmerized Rossetti through her powerful sexuality, a quality which emerges forcefully in the present work and in other portrayals, notably *Bocca baciata* of 1858,

Boccaccio's libidinous heroine with 'the mouth that has been kissed'. Rossetti probably began an affair with Fanny in 1863, shortly after the death of his wife Elizabeth Siddal, and the year in which he painted *Fazio's Mistress*, an illustration of verses by Fazio degli Uberti (1326–1360) which Rossetti had translated into English in 1861.[5]

Rossetti explained his fascination with Fanny: "Her lips, you see ... are just the red a woman's lips

always should be – not really red at all, but with the bluish pink bloom that you find in a rose petal." Fanny, who was lounging on a nearby couch giggled, "Oh, go along, Rissetty!"[6] Although Fanny remained with Rossetti, by the early 1870s he had come to regard her more as a housekeeper than muse or mistress, distancing himself from her socially, while offering financial support. In 1873 Rossetti partly repainted *Fazio's Mistress*, although he reassured

Fanny, "I am not working at all on the head, which is exactly like the funny old elephant, as like as any I ever did."[7] Fanny remained loyal to Rossetti until his death in 1881, although his family prevented her from attending his funeral. She later remarried and died in 1905.

MP

Sir Edward Burne-Jones (1833–1898)

68 *Study of Mary Cassavetti (Mrs Mary Zambaco)*

Pencil, 32.4 × 36.2 cm
1871
Private collection

The present drawing is among the finest of Mary Zambaco, a beautiful and highly temperamental Greek sculptress, for whom Burne-Jones formed an infatuation in 1868. From that time, her features began to appear increasingly frequently in his subject pictures. By early 1869 Burne-Jones was so captivated by Mary (his "sweet Owl") that he contemplated deserting his wife, Georgiana. When he abandoned the idea, Mary made several very public suicide attempts, including, in 1869, a plunge into the Regent's Canal in Maida Vale. Despite their temporary estrangement Burne-Jones continued to use Mary as his model and muse over the next few years (much to the distress of his wife). He also asked Rossetti to draw her portrait, a scheme which he confessed "excited and exhilarated me".[1] In 1870 Mary modelled for Burne-Jones's highly erotic *Phyllis*

and Demophoön, which, owing to objections on moral grounds, was withdrawn from exhibition at the Old Water Colour Society. The following year, in which the present drawing was made, Burne-Jones, encouraged by friends, finally broke off his relationship with Mary. She suffered a nervous breakdown and fled to Paris. Burne-Jones's last painting to feature Mary's features was *The Beguiling of Merlin*, of 1873, where she was depicted as an enchantress.

Unlike so many of the beautiful young women pursued by the Pre-Raphaelites Mary Zambaco was not poor or dependant on their collective largesse. The granddaughter of a wealthy Greek businessman, Maria had inherited a fortune at the age of fifteen on the death of her father. Although from a solidly middle-class background, she was wholly unconcerned with convention.

MP

William Holman Hunt (1827–1910)

69 *Study of a head (Edith Holman Hunt)*

Oil on panel, 33.5 × 30.7 cm
Signed: *W.H.H. 84. To his old friend Dr. Q... [illegible]/ Painted on Gesso M ... [illegible]*
Manchester City Art Galleries

Edith Holman Hunt (née Waugh; 1846–1931) was the younger sister of Hunt's first wife, Fanny, who died in 1866. According to her granddaughter, Edith fell in love with Hunt at the age of fifteen, although they did not marry until she was twenty-nine, and he was nearly fifty. The couple married in 1875 in Neufchâtel, Switzerland, their union being illegal in England according to the Deceased Wife's Sister Act. Edith, self-consciously middle-class and respectable, was quite the opposite of Hunt's erstwhile working-class model and mistress Annie Miller. Etiquette demanded that while Edith, like the other Waugh sisters, could sit

for their portrait, acting as a model – even for facial features – was not *comme il faut*. As his wife, Edith did, however, serve as a model in a number of Hunt's pictures, notably as the Virgin in *The Triumph of the Innocents*, completed in 1887.

MP

Frederic, Lord Leighton (1830–1896)

70 *Profile study of Dorothy Dene*

Black chalk heightened with white on
buff paper, 29.4 × 20.1 cm
ca. 1885
Signed: *Fred Leighton*
Leighton House Museum, (The Royal
Borough of Kensington and Chelsea),
London

Dorothy Dene (1859–1899) was
Frederic Leighton's most
celebrated model. However, it was
her friendship, quite as much as
her use to him as a model, that he
valued. Dorothy, whose real name
was Ada Alice Pullen, began
modelling to Leighton in 1879. He
used her in *Antigone*, *Viola*, *Clytie*,
The Return of Persephone and
Serenely wandering in a trance of
sober thought – to which the
present drawing appears to be
related.[1] Curiously, he found it
difficult to capture a good likeness
of her, even though her "very
beautiful throat … was
reproduced worthily in many
of his subject-pictures".[2] Soon
Leighton was also employing
Dorothy's younger sisters as
models, spending time with the
whole family: "I go to see them,
when I want to let my back hair
down and get off the stilts."[3]
Leighton encouraged Dorothy in
her ambitions to train as an
actress.[4] Unfortunately, as
Leighton's friend Mrs Barrington
recalled, Dorothy's "very beautiful
face and throat were not seen to
advantage, as they were hardly in
proportion to her figure, which
was short and too stiffly set to
move gracefully on the stage".
Leighton nicknamed her "the little
tee-to-tum", and (when she wore
a hat) "the mushroom".[5] Her lack
of "proportion" may also have
been the reason why Leighton
did not find her especially
accommodating as a figurative
model.

Following the death of their
mother and their father's
desertion, the Pullen sisters were
officially in the care of their
brother Thomas, to whom
Leighton regularly paid large sums
of money. In his will Leighton also
secretly left Dorothy £5,000 and a
Trust of £5,000 administered by
the artist's sisters.[6] Mrs Barrington,
aware of rumours about sexual
liaisons between Leighton and the
Pullen sisters, stated that it was
"almost unnecessary, as it is
distasteful, to mention that this
beautiful paternal attitude
Leighton displayed towards these
orphans was made the subject of
ugly gossip …".[7] There is no
evidence that Leighton had an
affair with Dorothy. He did,
however, father a child by another
woman (also possibly a model),
Louise Wilhelmina Mason, whose
son, Frederick (born 1874),
continued to receive payments
from Leighton into adulthood.

MP

Sir John Everett Millais

71 *A disciple*

Oil on canvas, 124 × 87.6 cm
1895
Tate Gallery, London
Presented by Sir Henry Tate 1894

The model for *A disciple* was Mary
Lloyd, who began to work
professionally for artists following
an introduction to Millais. Her
classical good looks and tall,
graceful physique ensured her
popularity among the most
successful and fashionable artists
of the 1890s. At that time she sat
to Alma-Tadema, Burne-Jones,
Ford Madox Brown, Frank
Dicksee, Holman Hunt, William
Blake Richmond, Thomas Brock
and Lord Leighton.[1] She also sat
to the young figurative painter
Herbert Draper (1864–1920),
who sketched her extensively.
According to Draper, Mary refused
to pose naked as a "figure
model", thus retaining her
respectability.[2]

Mary Lloyd was a particular
favourite of Leighton, who used
her intensively from 1893 to
1895, as the model for
Lachrymae, *Atalanta*, *Twixt hope
and fear*, *The fair Persian* and,
very probably, *Flaming June*. Her
personal history would probably
have remained a mystery had not
a reporter from *The Sunday
Express* come across her during
the 1930s, then aged seventy. She
was apparently the daughter of a
Shropshire squire, forced to seek
employment in London following
her father's bankruptcy. Although
she prospered initially, her
fortunes were clearly tied to the
artists to whom she modelled.
"One by one the artists died. Each
year I grew poorer and poorer,
and moved, as I did so, to
humbler apartments."[3] A serious
illness around 1913 left Mary
without money or friends. By
1933 she was living in a garret in
Kensington eking out a living as a
cleaner and seamstress.

MP

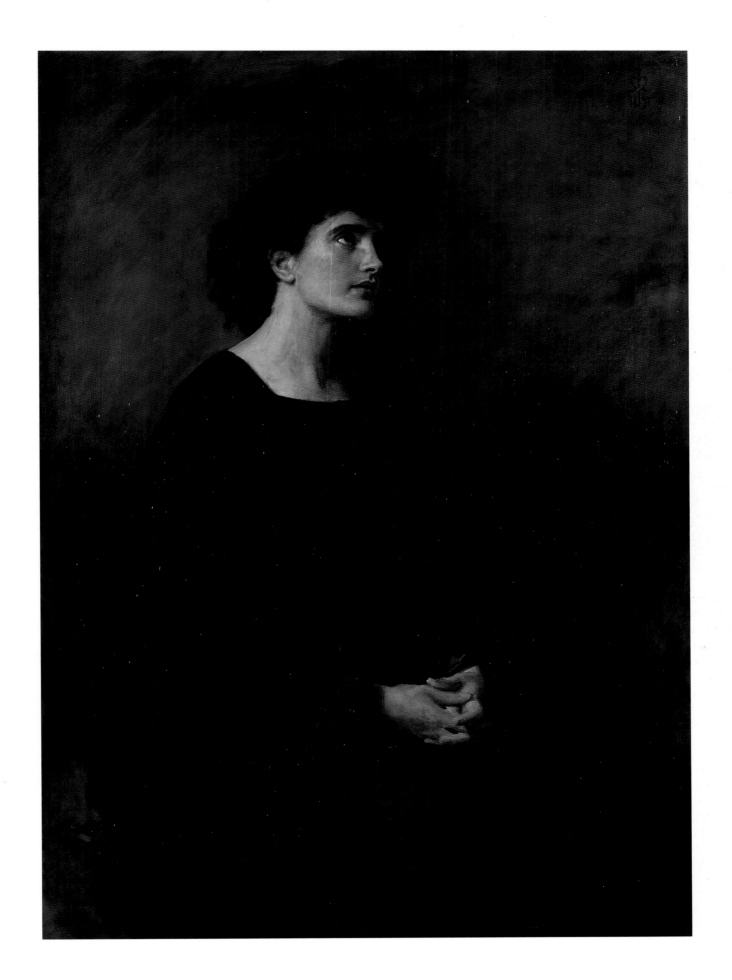

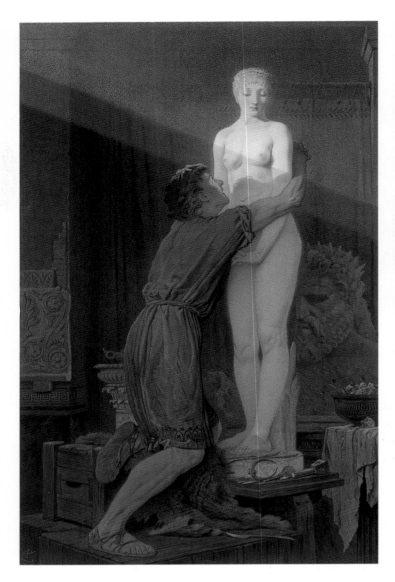

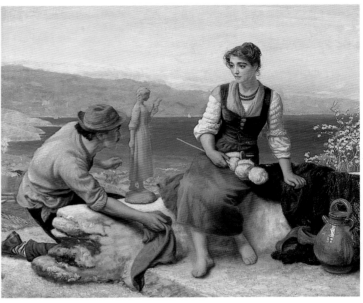

Sir John Tenniel (1820–1914)

72 *Pygmalion and the Statue*

Watercolour, 58.4 × 36 cm

1878

Victoria and Albert Museum, London

Tenniel's *Pygmalion* derived from an early drawing for Clytie in the *Historical Ballads*.[1] He chose to revise it at a time when the Victorian obsession with the story was at its peak, during the 1870s and 1880s. The story of Pygmalion was told in Book X of Ovid's *Metamorphoses*. Revolted "by the many faults which nature has implanted in the female sex", Pygmalion of Paphos shunned the company of women, and instead fashioned an ivory statue with which he fell in love. "Often", says Ovid, "he ran his hands over the work, feeling it to see whether it was flesh or ivory ... kissed the statue ... and embraced it, and thought he felt his fingers sink into the limbs he touched, so that he was afraid lest a bruise appear where he had pressed the flesh."[2] Driven to distraction, Pygmalion prayed to Venus to bring him a wife, "one like the ivory maid". Venus went one better and brought his statue to life.

The potential of the Pygmalion myth as a paradigm for the artist–model relationship was exploited most thoroughly by British artists at a time when questions were being asked about the necessity of the female nude to the creative process, although the fact that Pygmalion was driven to create the ideal woman because of his own misogyny appears to have been ignored. Already, by 1870, the concept of the male artist as a modern Pygmalion had been stimulated by John Gibson's celebrated flesh-coloured nude statue, the *Tinted Venus* (Walker Art Gallery, Liverpool), and his own obsessive reaction towards it: "I said to myself, 'Here is a little nearer approach to life – it is therefore more impressive – yes – yes indeed she seems an ethereal being with her blue eyes fixed upon me!' At moments I forgot that I was gazing at my own production; there I sat before her, long and often. How was I ever to part with her?"[3]

MP

Arthur Hughes (1832–1915)

73 *The potter's courtship*

Oil on canvas, 71.7 × 86.3 cm

1886

Laing Art Gallery, Newcastle upon Tyne (Tyne and Wear Museums)

The potter's courtship may have been an attempt to produce a variation in the vernacular on the popular *Pygmalion* theme. For here, rather than breathing life into an inanimate statue, the humble potter declares his love by making a votive statue of the object of his adoration, a young peasant girl, who acts as his muse. The painting was exhibited at the Royal Academy in 1886, at a time when narratives featuring artists and models were very much in vogue.

MP

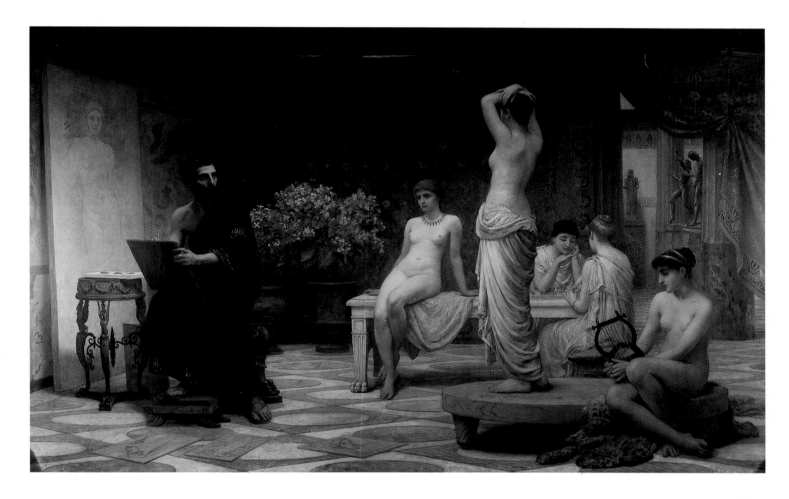

Edwin Long (1829–1891)

74 *The Chosen Five (Zeuxis at Crotona)*

Oil on canvas, 152.4 × 243.8 cm
1885
Russell-Cotes Art Gallery and Museum,
Bournemouth

The Chosen Five illustrates one of the most enduring and celebrated artist–model narratives. Long depicts the dénouement of the story, originally told by Cicero and the elder Pliny, of the ancient Greek painter Zeuxis, who, in an attempt to portray the perfect beauty of Helen of Troy, invited the most beautiful women in the city of Croton to model for him. From these he selected five, taking from each their best physical features to make a composite ideal. Long's pendant to the present picture was a 'prequel' entitled *The Search for Beauty*, in which the artist takes his pick of the available women on offer.

The original narrative of Zeuxis, a pictorial explication of the Platonic ideal Form, continued to appear in medieval illuminated manuscripts, although it was not until the early sixteenth century that the story was given renewed impetus – notably through similar stories relating to the studio practice of Raphael. With the growth of academic art in the eighteenth century it again achieved a didactic prominence, for example in François-André Vincent's *Zeuxis choosing his models* of 1789. The story of Zeuxis underpinned current academic practice. It also provided an incontrovertible justification for the artist having access to as many different models as possible, both in the academy and in the studio.

Although the theme of the painting quite deliberately exploits the erotic potential of the subject matter, Long was praised for his tasteful and restrained approach to what was a 'difficult' subject. *The World* noted that "the academic atmosphere throws, as it were, a veil over those undisguised humanities which should, I think, tend to keep them pure in the mind of Mrs. Boyn from the category of 'hussies'".[1] As Alison Smith has observed, in the context of attitudes towards the female nude model in 1880s England, "Classical myths played a strategic role in dissociating the model from any insinuation of immorality; at the same time they reinforced the idea that the female body provided a perennial source of inspiration for artist and connoisseur alike."[2] In other words, pictures like these were ideal vehicles for legitimizing male fantasy, at the very moment when the female nude as a motif was under attack by moral reformers and the female model was being characterized as a social and moral pariah.

MP

Sir Charles Holroyd
(1861–1917)

75 *Head of an Italian model*

Black chalk on paper, 40 × 21 cm

ca. mid-1880s

Private collection

The young male model appears to be the same youth who poses in the right foreground of Leighton's *Captive Andromache* (*ca.* 1886–88); this is not unlikely, since Holroyd was then working in Leighton's studio. The vogue for young male Italian models increased dramatically in the 1870s, especially in the wake of the Franco-Prussian War when, along with a host of French artists, they fled *en masse* the ateliers and studios of Paris. In 1871, in his inaugural lecture at the Slade School, Poynter assured students that he would make the best Italian models available to them. They were, he claimed, "not only in general build and proportion, and in natural grace and dignity, far superior to our English models; but they have a natural beauty, especially in the extremities which no amount of hard labour seems to spoil".[1] Among the most celebrated Italian models were Alessandro Colorossi, various members of the Mancini family, Sargent's favourite Nicola d'Inverno, and Gaetano Meo, the boon companion of Sir William Blake Richmond.[2] Italians continued to be popular models into the twentieth century, forming the nucleus of the Artist's Model Association founded in the 1920s.[3]

MP

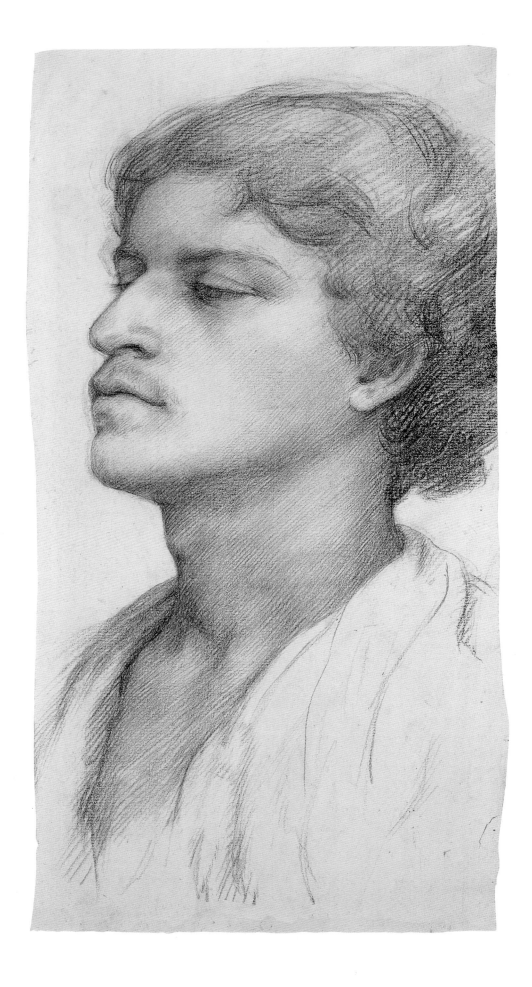

Henry Scott Tuke (1858–1929)

76 *Our Jack*

Oil on canvas, 48.3 × 30.5 cm

1886

Royal Cornwall Polytechnic Society

In 1885 Henry Scott Tuke returned to Falmouth, where he had spent his boyhood. With him he brought a young Cockney model named Walter Shilling, who had also modelled regularly at the Slade. Tiring of Shilling's company (he was apparently rather cheeky), and the monotony of painting the same model over and again, Tuke befriended various local boys, including the sixteen-year-old Jack Rowling. *Our Jack* is Tuke's first painting of Rowling. He poses casually, looking very much as he would have done in everyday life. Although Tuke used a number of boys as models, Jack Rowling was clearly his favourite, thirteen of the twenty paintings Tuke listed in 1887 being modelled on him. In the majority of these works Rowling posed fully clothed; only once stripped to the waist; never naked.

Tuke's studio by this time was a picturesque French brigantine moored near the harbour, where he also lived, often in the company of Rowling, who doubled as cook and bottle-washer. Gradually, as Rowling reached maturity and found work beyond the locality as a deep-sea diver, he reluctantly saw less of Tuke, although in 1890 he wrote from London, pleading to return home.[1] In the event, Jack continued to work as a diver, salvaging cargo from wrecked vessels in dangerous waters around the world. He died aged forty-nine, worn out by the rigours of his job.

MP

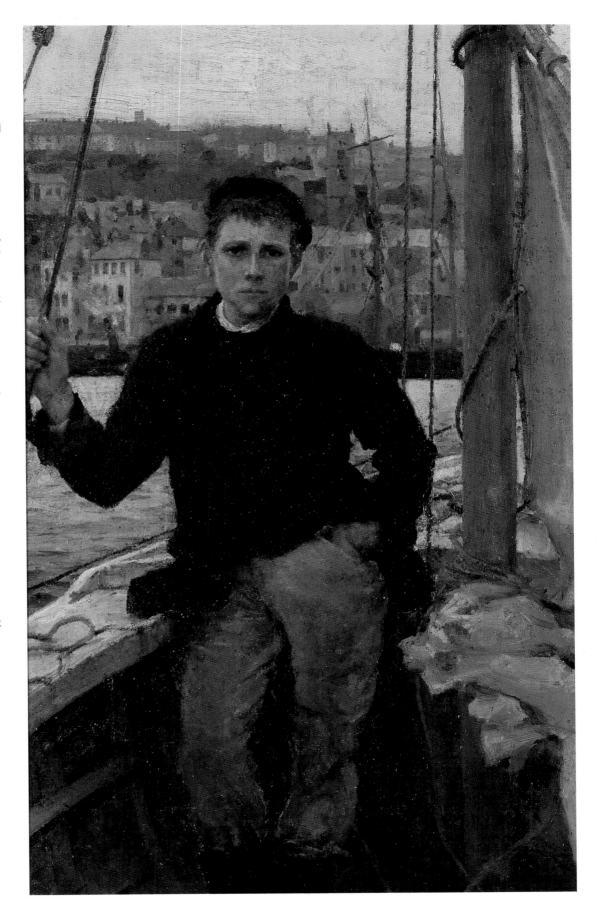

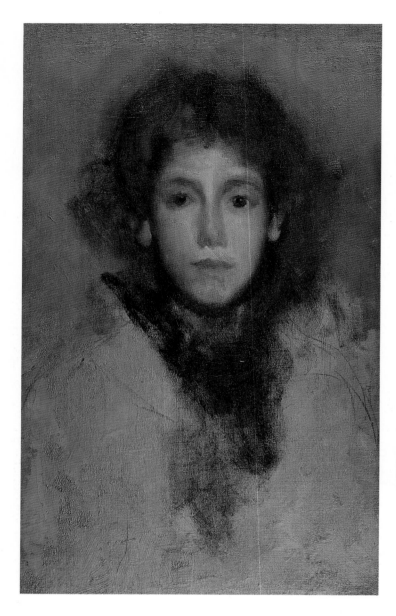

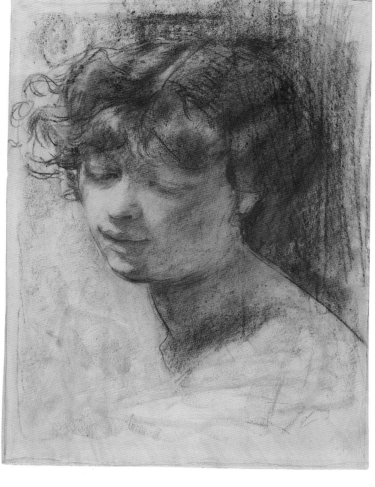

James Abbot McNeill Whistler (1834–1903)

77 *Little Juniper Bud (Lizzie Willis)*

Oil on canvas, 51.6 × 31.4 cm
1896–97
Hunterian Art Gallery, University of Glasgow

During the 1890s, at a time when he was running his own atelier, Whistler returned to making direct studies from the model. He made something of a speciality of portraits of young girls, apparently with the encouragement of his wife. Whistler's interest in child models – which might raise eyebrows today – appears to have been stimulated by a desire to record innocence, particularly that of children from proletarian backgrounds whose as yet unsullied natural beauty formed a 'picturesque' contrast to their ragged attire. The artist was in the habit of touring the poorer districts of London to find suitable models, such as Lillie Pamington, whom he seems to have favoured for her striking red hair.[1]

Whistler did not have to roam the street to find the model for *Little Juniper Bud*, though the circumstances surrounding its inception are as sordid as anything he might have found there. Lizzie

Willis was the eight-year-old daughter of Whistler's house-keeper, and was used by the artist as an occasional model when other young girls were not available.[2] Mrs Willis, who took up her post in 1896, was dismissed by the artist for drunkenness in July 1897. It seems that the whole Willis family, including Lizzie, were addicted to gin. It was this habit that Whistler referred to in the title for this study. He seems to have viewed the drunkenness of Lizzie in a somewhat humerous vein. In a letter to Mrs Birnie Philip in Paris datemarked 16 January 1897 he made a sketch of the little girl with the inscription, "I was drunk once!"[3] Despite what might be seen as his unsympath-etic attitude towards his young model, Whistler's study conveys a poignant observation.

wv

Henry Tonks (1862–1936)

78 *Head of a girl*

Red chalk on paper, 39 × 29.5 cm
ca. 1900
The Trustees of the British Museum, London

This fine character study reveals Tonks's draughtsmanship at its best. The model, although we cannot be certain, bears some resemblance to a young woman named Miss Edwards, who sat to him privately and at the Slade School and who was, according to Tonks, the best model he ever had.[1] Tonks worked extensively from models, notably the Kings, a working-class London family, whom he transported *en masse* from London to his retreat at Betteshanger.[2] Tonks made his model studies in chalks and pastels, and he claimed never to use models while working on

finished pictures, preferring to rely on his sketches. "If you paint from a living person (except perhaps as a study), you will make some idiotic change which will spoil everything. The great thing is to keep the drawings you do and turn to them when you want help."[3]

M P

Augustus John
79 *Study of Gwen John, seated*

Watercolour and chalk on paper,
33.8 × 24.3 cm
ca. 1898
The Trustees of the British Museum, London

Gwen John followed her younger brother Augustus to study at the Slade in 1895. During the three years that they were both at the Slade they shared accommodation. Money was in short supply and Augustus later recalled that they subsisted "like monkeys, on a diet of fruit and nuts".[1] From early 1897 to 1898 they lived at 21 Fitzroy Street, where they were joined for a time by their younger sister Winifred, who had come to London to study the violin.

Augustus made many studies of Gwen during this period. These are frequently quick and informal studies, which contrast with the meticulous figure studies that he was carrying out concurrently in the Life Room of the Slade (cat. 29). This watercolour is unusually elaborate and could almost be a study for a contemporary life subject. While Augustus made frequent use of Gwen as a model, she does not appear to have returned the compliment. She did, however, make drawings and studies of Winifred at the time.

W V

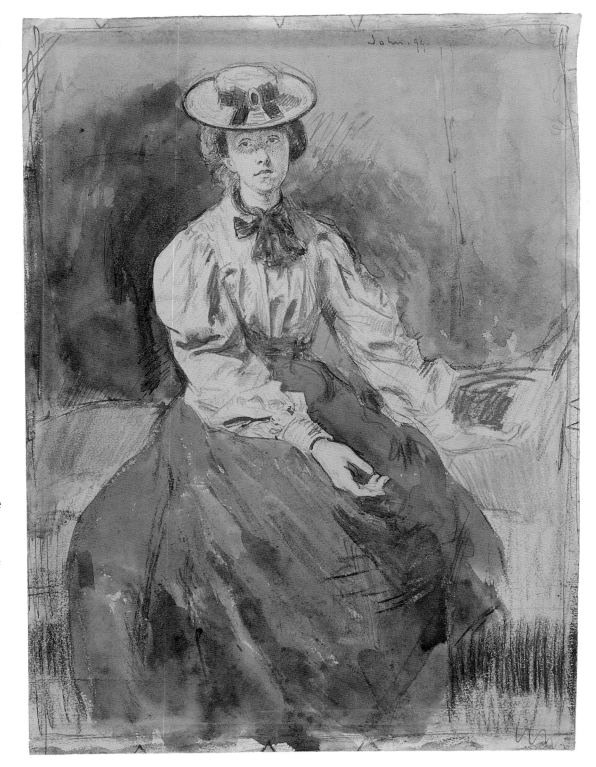

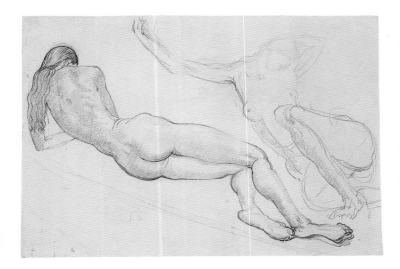

Sir Jacob Epstein (1880–1959)

80 *Two studies of Nan Condron reclining*

Black chalk on paper, 35.4 × 50.6 cm
ca. 1911
Leeds Museums and Galleries (City Art Gallery)

By the time he made these studies of the Gypsy and professional model Nan Condron, Epstein was already a controversial figure in the British art world. Arriving in London in 1905, after three years of study in Paris – where he had gained the approval of Rodin – he was producing work that combined brilliant observational skills with a rich sense of the primitive. His own personal background as the son of Jewish–Polish immigrants in New York encouraged him to develop a strong sense of self-reliance, as well as great sympathy for the social outsider. This interest is reflected in his choice of models. Frequently they came from exotic and oppressed backgrounds. His fascination with Gypsies perhaps began through his acquaintance with Augustus John. John, however, responded to Gypsies as colourful bohemian characters. Epstein was more interested in their position as social outcasts, a persecuted race. No model embodied this more than Nan Condron, with her gaunt yet elegant body and strong

expressive features. Evelyn Silber has described Condron as "in many respects the prototypical 'Epstein model', a loner and outcast who, nevertheless, projected a touching strength and inner composure in the face of the world's hostilities".[1] Unlike many of the more flamboyant models of the period, such as Betty May, Condron was businesslike and

reserved. She made few demands, apart from requiring to be taken to the music hall once a week.

Previously Condron had posed for Orpen and William Rothenstein. She became devoted to Epstein and for a time worked exclusively for him. In later life she came to help out in the Epstein household during a period of domestic crisis in 1953–54.

Epstein made a considerable number of studies of Condron around 1911 and used her for a number of expressive figurative sculptures. Often these contain a marked spiritual element, such as the bronze *Nan the Dreamer*.[2] The studies exhibited here show Condron in a pose related to that of *Nan the Dreamer*, though in a more recumbent position. The sculpture seems to have emphasized the length and angularity of Condron's body, perhaps to enhance its expressiveness.

WV

Sir Jacob Epstein

81 *Recumbent Negress*

Pencil, 42 × 54 cm
ca. 1920
Courtauld Gallery, University of London

Epstein was particularly fond of using non-European models and those from ethnic minorities such as Gypsies. Their exotic character fitted in with his taste for the primitive and the visually exciting, as well as with his sympathy for the social outsider.

WV

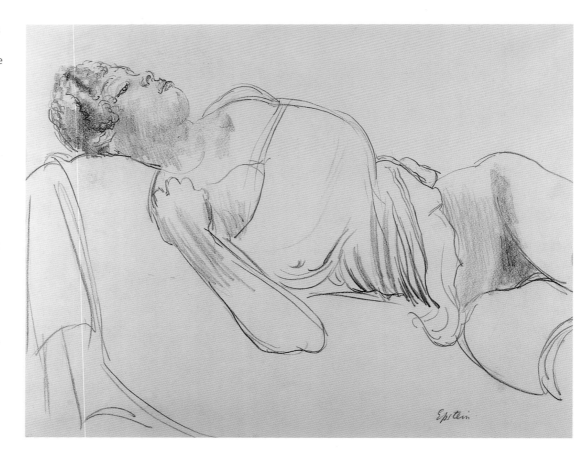

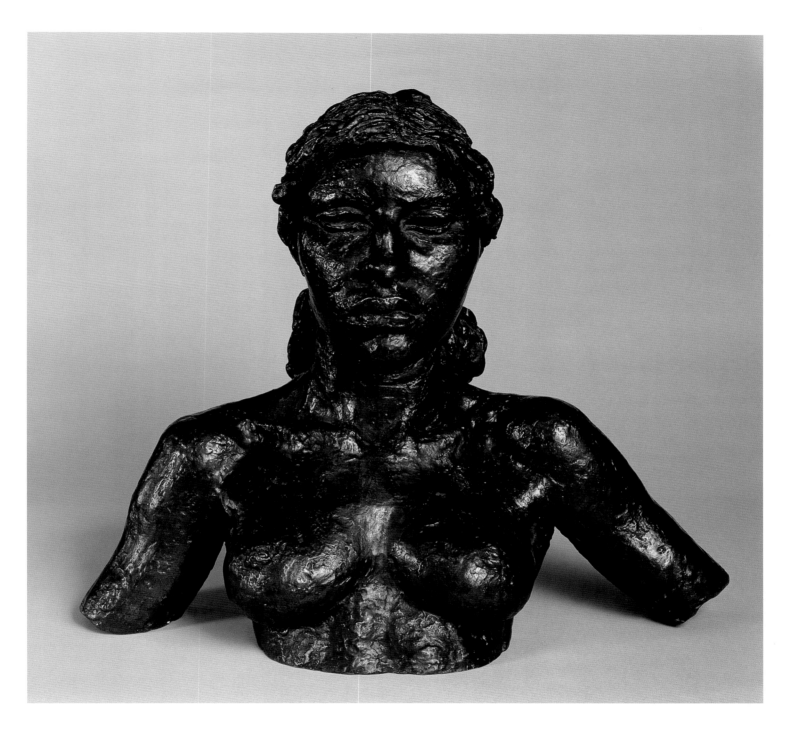

Sir Jacob Epstein

82 *Betty (Esther)*

Bronze, 53.3 × 63.5 × 25.4 cm
1930
Tate Gallery, London
Presented by Howard Bliss, 1945

During the inter-war years
Epstein's practice as a portraitist
continued to grow. While
producing many busts of
celebrated men and women, he
also used favourite models for
more intimate and expressive
kinds of character studies. He
remained fascinated with people –
usually women – from oppressed
and exotic backgrounds. Esther
was a black, half-Jewish nightclub
singer whose sister Rebecca also
posed for the artist. She combined
her nightclub work with that of a
professional artist's model.[1] The
strongly modelled surfaces of this
bronze bust are an example of
the great vitality that Epstein
managed to infuse into his work
at this time, whether modelled
portrait busts or imaginative stone
carvings.

WV

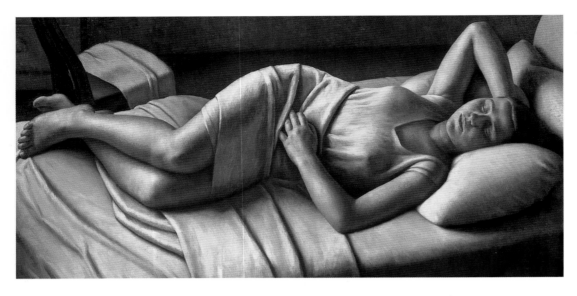

Dod Procter (1892–1972)

83 *Morning*

Oil on canvas, 76.2 × 152.4 cm
1926
Tate Gallery, London
Presented by *The Daily Mail,* 1927

Dod Procter, born Doris Shaw, lived in Newlyn in Cornwall from childhood and was taught at the school set up there by the 'founder' of the Newlyn School, Stanhope Forbes, and his wife. The Newlyn School had been seen in the 1890s to epitomize a form of healthy naturalism to set against the degenerate modernity of France. It remained a haven for artists in the Edwardian period, one of whom, Ernest Procter (see cat. 117) became Dod's husband in 1912. In line with the ethos of Newlyn, Procter chose as her model for this picture Cissie Barnes, the sixteen-year-old daughter of a local fisherman. Admirers of the work appreciated it as an image of a working girl, waking up to a day of healthy employment – the symbol of a natural way of life that seemed to be under threat increasingly in post-war Britain. Although not remarked on at the time, the image also afforded the urban spectator a pleasing degree of voyeurism, displaying a healthy if veiled young form as it stirred in the moments prior to consciousness.

Morning was voted Picture of the Year at the Royal Academy Summer Exhibition of 1927 and bought for the nation by *The Daily Mail* newspaper. Its combination of a faintly modern cubist treatment of form with a sound and appealing traditional theme recommended it to a broad public who wished to embrace the contemporary without encountering the troubling concepts of an avantgarde.

wv

Glyn Philpot (1884–1937)

84 *Male model, with three studies of a head*

Pencil, 41.1 × 27.5 cm
ca. 1930
The Trustees of the British Museum, London

Glyn Philpot made many studies from black models (see cat. 85). This drawing of an almost whole-length black male and three black figure heads is possibly a preparation for his *Negro as Harlequin*.[1]

wv

Glyn Philpot

85 *Seated male nude (Henry Thomas)*

Oil on canvas, 129 × 74.2 cm
1936
Royal Pavilion, Libraries and Museums, Brighton and Hove

Philpot was a successful Academy painter who produced large historical and allegorical works, including a mural for St Stephen's Hall in the Palace of Westminster. His practice as a historical artist necessitated the meticulous study of the figure. However, he brought an unusually strong degree of personal involvement into such work, and this seems to have stimulated him in later life to become increasingly experimental – to the extent that his painting *Great Pan* was rejected by the Royal Academy in 1933. He had a particular fascination with athletic and sometimes somewhat louche characters. A notable example is his obsession with George Bridgeman – "*au fond* an affable layabout, Bridgeman's sensuous good looks and good physique seem to have represented an ideal for Philpot, many of whose most memorable figure compositions of the 1920s portray him".[1]

Philpot also had remarkable feeling for less advantaged characters who he took into his own household to perform the dual roles of servant and model. An early example was the Arab Ali Ben Amor Ben M'rad, whom Philpot met in the early 1920s on a journey to North Africa. M'rad, who was also a "marvellous boxer", developed too much of a taste for the underworld and was eventually deported. A more stable relationship was that with the subject of this picture, the Jamaican Henry Thomas, whom Philpot met in 1929, and who soon settled down into a regular pattern of modelling and household duties.[2] Thomas inspired a remarkable series of pictures, mostly painted around 1936, in which the artist developed a novel and modern technique, using heavy impasto and brilliant colouring. As well as being technically exciting, these pictures suggest a strong sensibility and sympathy for the social outsider that mirrors in many ways that expressed by Epstein in his studies of female models from comparable backgrounds (cat. 80–82) This work was exhibited at the Royal Academy in 1937.

wv

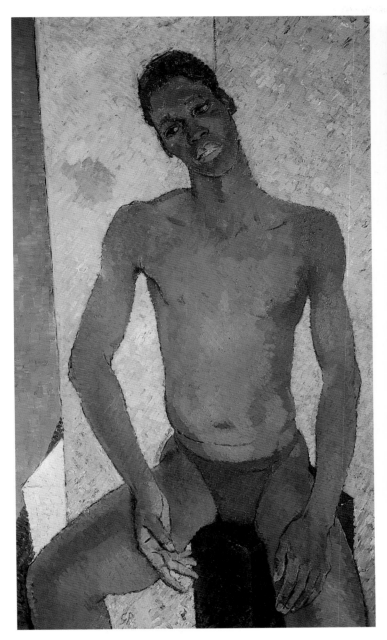

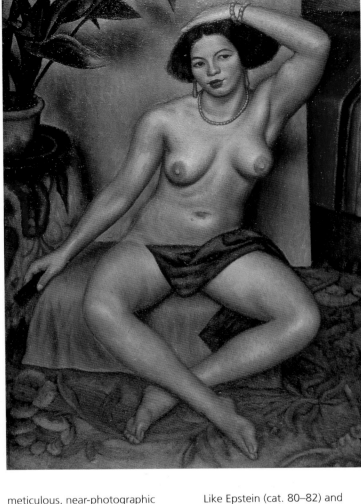

Mark Gertler (1891–1939)

86 *Seated nude (Gypsy at her toilet)*

Oil on canvas, 102 × 71.4 cm

1924

Courtesy of Southampton City Art Gallery

Coming from an Austrian Jewish family, Gertler used his personal experience to bring a striking new dimension into British art, one which forms interesting parallels and reverberations with Expressionist art as it was developing in Central and Eastern Europe. He was particularly concerned to convey a feeling of the primitive, using a powerful, hard-edged manner. The 1920s was the time of Gertler's greatest success, though also the time when his personal vision became increasingly challenged. He was widely talked about as one of Britain's leading painters, and received strong support from Roger Fry and other members of the Bloomsbury Group. He was a strong admirer of Renoir and, like the French artist, he made frequent studies of the nude – though he gave his work a more meticulous, near-photographic finish. His new formalism also accorded with the *rappel à l'ordre* in France of the period, under the influence of which even Picasso had returned to a form of classicism.

Gertler paid special attention to the art of Derain, the former Fauve artist who was also seeking to combine modernism with a sense of tradition. *Gypsy at her toilet* shows interests similar to those of the French artist.

Like Epstein (cat. 80–82) and John (cat. 79), Gertler had a close interest in Gypsies and sympathy for their way of life. But he also used them as a symbol for a sensual and instinctive fom of existence. In this case the subject seems to bear no relationship to any actual aspect of Gypsy life. The model was Miss May Spencer.[1]

wv

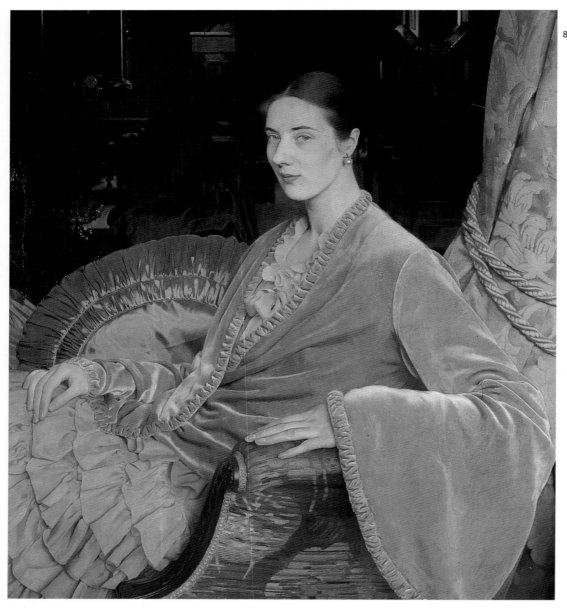

Trained in Paris, after taking a degree at Cambridge, Kelly eventually became one of the most fashionable portraitists in Britain during the early twentieth century. He was a favourite painter of the Royal Family and crowned his career by becoming President of the Royal Academy in 1949.

After an exotic early life – which included an extended stay in Burma – Kelly settled in London. In 1920 he married Lilian Ryan, a young model from a working-class family whom he had met in 1916, when she was posing under the guidance of Sir George Clausen. Kelly painted many portraits of her, exhibiting them under the nickname that he had given her, 'Jane', with the addition of a roman numeral which corresponded with the year of exhibition. *Jane XXX* was exhibited in 1930 and was used as his diploma work following his election to full membership of the Royal Academy in that year. It is commonly regarded as one of his finest achievements in portraiture. The Jane portraits were legendary during the period, and when Queen Mary was introduced to the sitter for them she exclaimed, "Jane, of the many Janes!".[1]

WV

Alan Beeton
87 *Marguerite Kelsey*
Oil on canvas, 132 × 117.5 cm
1936
Private collection

Marguerite Kelsey was one of the models most in demand amongst Academy painters such as Alan Beeton and Meredith Frampton during the 1920s and 1930s. She was valued for her slenderness and elegance and for her ability to hold a pose for an unusually long period. She could pose for as long as four hours at a stretch. Her former training in dancing helped her perform such feats. She had a strong sense of her worth and valued her independence. She preferred to work for older male artists and appears to have enjoyed respectful friendships with them. She had a particular liking for Beeton: "Alan Beeton was my god. I was the only model he ever really used – he painted me for ten years, and educated me at the same time. He taught me how to read and write, took me through the classics, showed me how to use a knife and fork in restaurants. I owe him everything."[1]

WV

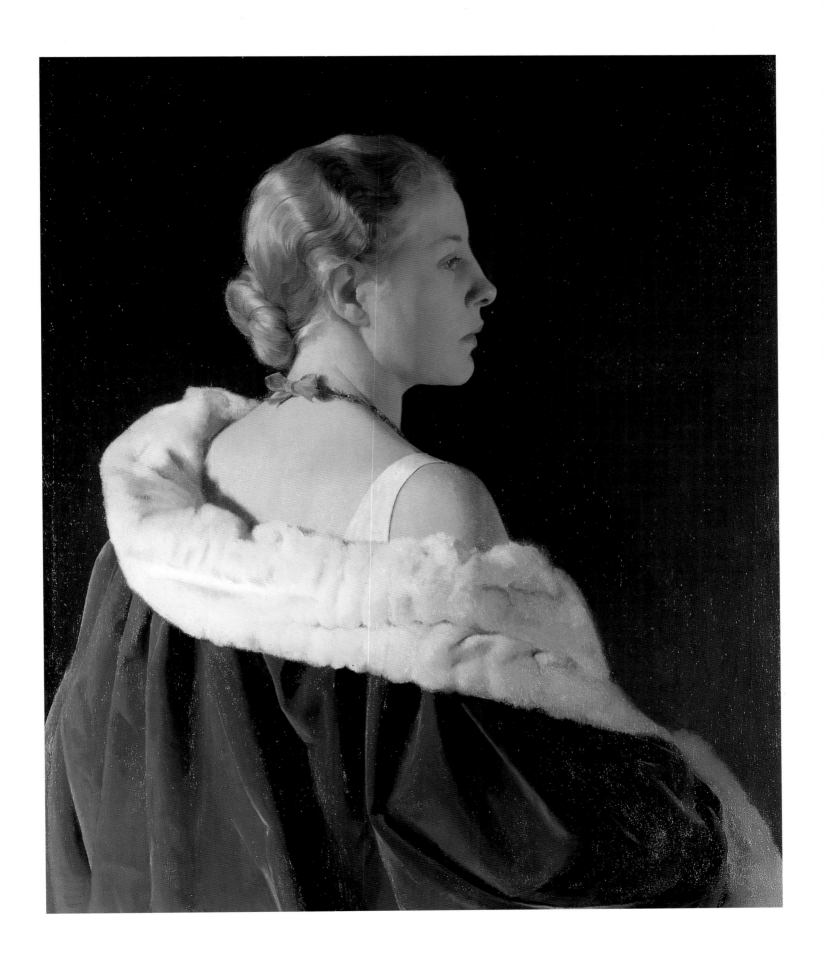

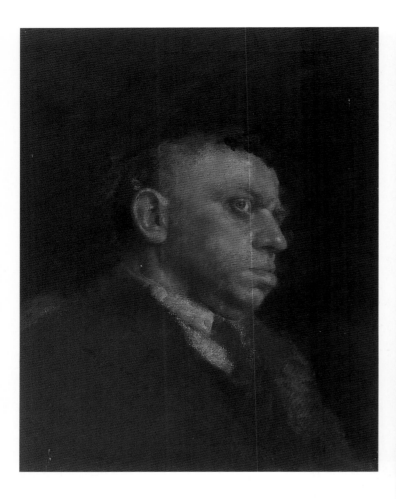

Glyn Jones (*fl.* 1926–1939)
89 *Male head: character study, Slade School*

Oil on canvas, 46 × 36 cm
1926
The College Art Collection, University College London (5100)

Glyn Jones studied at the Slade from 1923 to 1926. He subsequently practised as a landscape and portrait painter, exhibiting at the Royal Academy and elsewhere in London between 1930 and 1939. His skill as a portraitist is suggested by this character study, which won equal first prize for head painting at the Slade in 1926.

WV

Marguerite Evans
90 *Quentin Crisp*

Oil on canvas, 46 × 32.4 cm
ca. 1943
Trustees of the National Portrait Gallery, London

Quentin Crisp began working as a model in art schools during the late 1930s. He later became famous for his autobiography, *The Naked Civil Servant* (1968), in which he recalls his modelling career as well as his experiences as a self-proclaimed and visually explicit homosexual at a time when such people were socially ostracized and ran the danger of prosecution. Himself a writer and artist, Crisp was an excellent model, sympathetic and encouraging to the students and capable of adopting striking poses and holding them perfectly.

Marguerite Evans painted this portrait of him when studying part-time in Willesden Technical College in the class of Maurice de Sausmarez. She recalls: "In portrait classes Quentin was a perfect model, inspiring in his posture, retained remarkably in accurate position over six sittings of 2½ hour sessions. One never had to redraw or repaint one's canvas painting stages, as uncannily he resumed the identical position after each rest period."[1]

While struck and intrigued by Crisp's appearance, Evans had no idea of her sitter's other life: "In those days of innocence, one had not heard the word gay other than as descriptive of merry, lively and bright, the true sense, unlike its meaning today. Though his appearance startled me at first encounter – the bronze-copper mop of hair, rouged cheek bones, painted finger nails and high heeled shoes – I was quite oblivious to the meaning behind all this."[2]

WV

Sir Stanley Spencer
91 *Patricia Preece nude*

Oil on canvas, 76.2 × 50.8 cm
1935
Ferens Art Gallery, Kingston Upon Hull City Museums and Art Galleries

Patricia Preece was an artist who had trained at the Slade and in Paris under André Lhote. She lived with her friend Dorothy Hepworth on the edge of Cookham Moor, close to Spencer's native village, where he retained a residence.

Spencer met her in 1929. He was attracted by her positive personality, and eventually married her on 29 May 1937 after having divorced his first wife, Hilda, on 25 May. The marriage was not a success, and was in fact never consummated. In 1935, during the period of their courtship, Spencer painted two nudes of Patricia Preece – this one, in which she is portrayed seated, and a study of her lying down. In 1936–37 he executed more elaborate double portraits of the two of them (see cat. 120). Unlike the later double portraits – in which his relationship with Patricia is explored questioningly – this work appears to be a genuine attempt at an intimate and erotic portrayal.

Spencer did not like using a professional model and was delighted when Preece offered to pose nude for him. He was keen to study the naked figure as an individual rather than as an anonymous nude: "I want to be able to paint a nude from life and do it as a portrait. I mean not so quickly but taking my time. The No. 1 Nude [this picture] is the best in this respect."[1]

It is possible that Spencer was stimulated into painting such a work by the success of Brockhurst's *Jeunesse dorée* (Walker Art Gallery, Liverpool), exhibited at the Royal Academy in 1934. Brockhurst used a similar pose to celebrate the beauty of his young mistress Kathleen Woodward, whom he eventually married. Spencer may have seen his nude portrait of his own new love as being a stage towards the cementation of a greater degree of intimacy between them. Yet the bored expression on Preece's face and the unflattering realism of the treatment of the body seems to undermine this intention, while resulting in a far more interesting kind of work.

WV

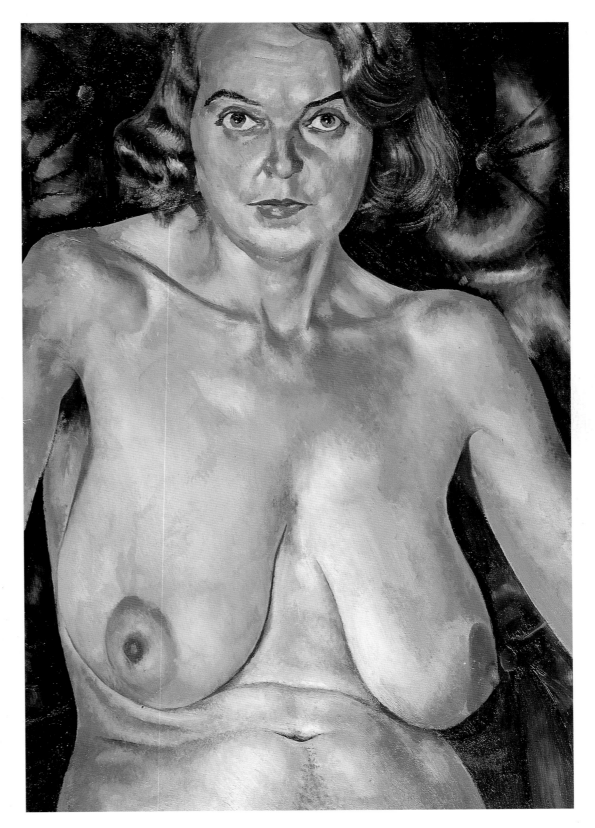

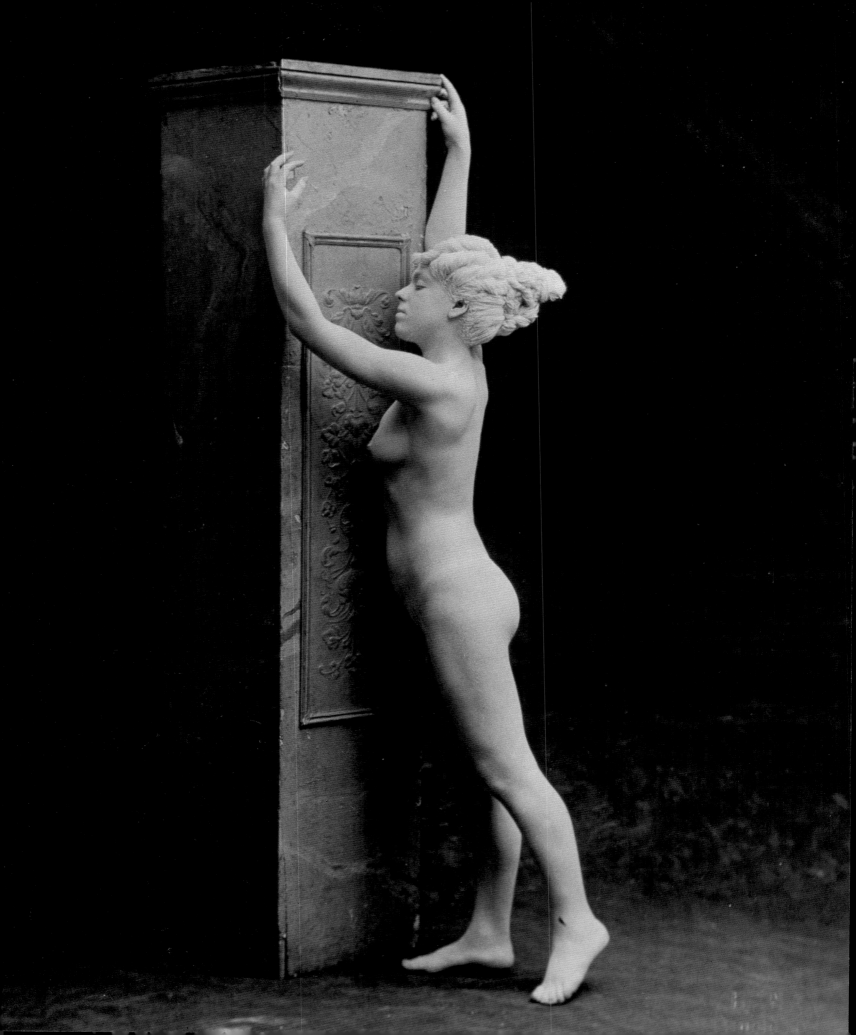

The Naked and the Nude

WILLIAM VAUGHAN

The distinction between the naked figure and the nude might seem to be a specious one, for both are equivalent terms for a body bereft of clothing. Yet over the past century and a half it has been one much insisted upon in Britain. As Sickert complained in his essay on the subject, 'The Naked and the Nude', in 1910, "An inconsistent and prurient puritanism has succeeded in evolving an ideal which it seeks to dignify by calling it the Nude, with a capital N, and placing it in opposition to the naked."[1]

The distinction became the cornerstone of that classic study of the representation of the naked human figure in art, *The Nude* by Sir Kenneth Clark, published in 1956. Like connoisseurs and aesthetes before him, Clark argued that the naked was a body deprived of clothing "huddled and defenceless" while the nude was "clothed" in art, "re-formed rather than deformed, 'balanced, prosperous and confident'".[2] For Clark the nude was the perfect subject for the work of art, "the most complete example of the transformation of matter into form".[3]

There are many reasons why such an assumption should be challenged today. The concept of a higher aesthetic that enables us to look at the portrayal of a naked body without any troubling thoughts of sexuality is surely in itself highly questionable. Similarly, the dominant image of the nude in the Western tradition has to be viewed in the context of the patriarchal values that have prevailed in that society. For the gender relations seemingly neutralized in the classic formulation of the nude in fact operate most powerfully there. It is a male vision of nakedness that has predominated – either to vaunt a heroic masculinity or to satisfy an erotic desire, whether directed towards a woman or towards an Apollonian youth.

Clearly this is a circumstance that we can no longer ignore – and it is no surprise to find that much feminist art and critical practice over the last two decades has focussed upon the re-conception of the body, and in particular the release of the female body from the enslavement of the male gaze.[4] Yet, while bearing this critique in mind when considering the portrayal of the naked figure in Britain in the period covered by this book, we should recognize, too, that very different issues were the focus of debate at the time. It was not so much a question of what kind of gender issues were conveyed in the display of nakedness in art, but rather whether nakedness should be displayed at all. All kinds – male, female, realistic, eroticized or ideal – were viewed with askance by those who claimed to represent the views of the moral majority. Studying the nude was widely thought of as an immoral practice and there were moves in Parliament to have it abolished in publicly funded art schools (see above, Chapter 1). Any depiction of a naked figure was prone to assault by objectors – from Epstein's shockingly modern *Rima* in Hyde Park to Velázquez's demure Rokeby *Venus* in the National Gallery.[5] The distinction between 'nude' and 'naked' was promoted as part of the argument to appease such

objectors. As long as the figure was 'nude' and not 'naked', the argument went, it was 'art'. You were therefore able to enjoy contemplating it as a pure aesthetic experience. There was no connection between what you were doing and the kind of things men in macs got up to in Soho. Kenneth Clark's urbane and reassuring formulation of the issue came in fact at the end of this period of unease, and was in a sense a triumphant assertion of a hard-won position. It also came, ironically, when the battle that had been fought so strenuously no longer seemed to matter as far as contemporary art was concerned. For by the 1950s abstraction seemed to have won the day. Art schools were closing down their life classes not because of the protests of the moral majority, but because staff and students could no longer see the point of doing anything so old-fashioned as studying the human form.

The issue of the depiction of the naked figure had become increasingly controversial during the nineteenth century because of the growing tendency by artists to concentrate on the female. Traditionally it had been the male, not the female figure that had predominated. The principal reason for studying the naked figure had been to prepare artists for the production of history paintings, in which male figures tended to be the protagonists. It was also clear that the male nude had been far more prevalent than the female in the art of ancient Greece, that benchmark for classical values. The Italian and French academies of art that came into being in the sixteenth and seventeenth centuries had excluded the study of the female nude. Only in the later eighteenth century did the situation begin to change. The recently founded Royal Academy in London had been one of the first to introduce the female model – a sign, perhaps, that British artists never had taken the classical as seriously as their Continental counterparts. No painter was more devoted to the female nude in the early nineteenth century than William Etty (cat. 1, 92). His studies in the life class helped him to portray the female nude in his finished pictures with a particular and troubling vividness. As early as the 1820s critics were objecting to the realism of his effects. "Naked figures", wrote *The Times* in 1822, "when painted with the purity of Raphael, may be endured: but nakedness without purity is offensive and indecent, and in Mr. Etty's canvass is mere dirty flesh."[6]

At this time, however, the problem seemed to be a containable one. For the Royal Academy Schools were private and its exhibitions were attended only by people from those educated and privileged sections of society that might be able to take the potentially corrupting effects of Etty's nudes in their stride. When the question of the study and display of the nude in more public arenas arose, then it seemed that steps needed to be taken. As has already been demonstrated (see Chapter 1), study of the nude in the publicly funded government Schools of Design was strongly opposed and for a time altogether prevented.

It is striking that the Pre-Raphaelites – the brotherhood that sought to reform the academic tradition by simultaneously emulating the 'honesty' of medieval art and portraying the contemporary world realistically – should have steered clear of the nude. While they studied unclothed figures – in the academic tradition (cat. 7) – as a preparatory phase in developing their pictures, they did not display nakedness in their finished works. Even Rossetti's 'stunners' – eroticized portraits of contemporary beauties thinly disguised as historical and mythological characters – are clothed (cat. 63, 64). Rossetti finally risked an exposed breast in *Venus Verticordia* of 1864–65,[7] but it was not until 1870, with Millais's *Knight Errant* (fig. 17), that a full frontal nude went on display, precipitating much controversy. Millais had, by this time, long

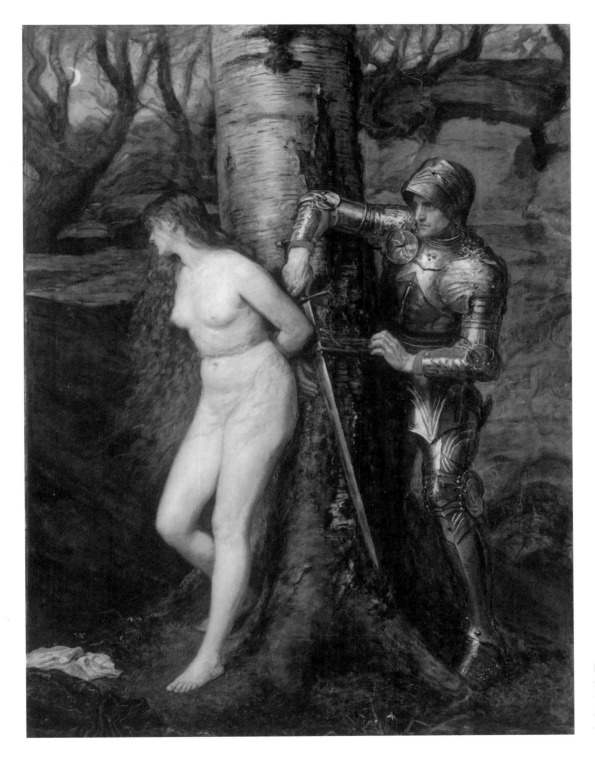

Fig. 17
Sir John Everett Millais
The Knight Errant
Oil on canvas, 1870
Tate Gallery, London

since ceased to be a Pre-Raphaelite. Yet he retained an allegiance to a degree of modernity and realism, and his portrayal of a naked woman was striking for being outside the abstract, classical bounds that usually made such works acceptable as high art. The artist himself had some misgivings about the subject. Originally he had intended the naked woman to be turned towards the spectator and her rescuer. But he reworked the image so that she looked away, presumably in shame at her involuntary immodesty. This was the nearest that the British had come to experiencing a 'modern' nude. Yet it is worth reflecting that by this time such images

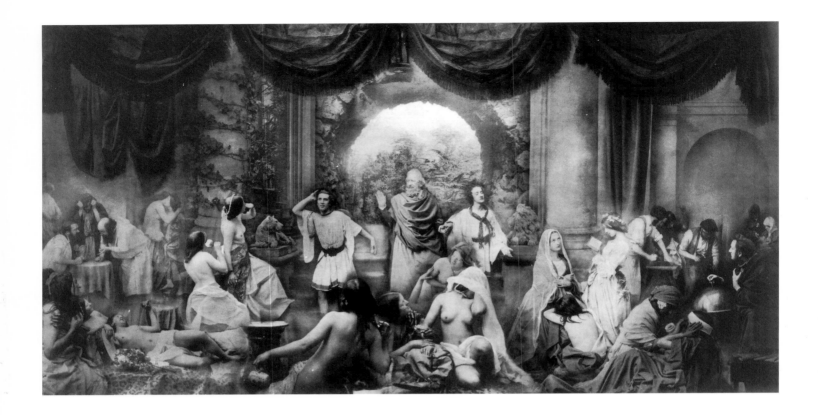

Fig. 18
Oscar G. Rejlander
The Two Ways of Life
Photograph, 1856
Royal Photographic Society, Bath

had become a commonplace in France, where five years earlier Manet's *Olympia* had been a talking point of the Salon.

Millais did not attempt such a subject again. But his *Knight Errant* did herald a return to the frequent treatment of the nude in the hands such classical idealists as Frederick Leighton (cat. 93) and Edward Poynter (cat. 96). Such works could also create scandals – as did Poynter's nude *Diadumenë* when it was shown at the Royal Academy in 1885. This was the year in which "A British Matron" wrote to *The Times* to complain that the prevalence in that year's exhibition of nudity was damaging to public morality and therefore potentially deleterious to national stability.[8] In response to such attacks, Poynter repainted his picture to modify its eroticism. In general, however, the classical nude could be defended on the grounds of its refined and decorous nature.

An important factor behind the acceptance (admittedly limited and grudging) of nudity in such circumstances was the knowledge that such displays took place within the carefully closeted sanctuaries of High Art. Such containment was deemed all the more necessary because of the frightening expansion of the marketplace, where licentiousness of all kinds might be thought to abound. Pornography was far from being a new trade in mid-Victorian Britain, but it was given a new impetus by the growth of double standards promoted by public morality. On a more technical level, the arrival of the photograph offered new possibilities, particularly after the perfection of the wet collodion process which made photographs quicker to take and easier to reproduce. Whatever the debate about proper and improper nakedness might be in the fine arts, the literalness of the photograph seemed to place it irredeemably on the side of the latter. For photographers with a desire to have their practice designated an art, on the other hand, it became a matter of principle that they be given the licence to depict the

nude. The Swedish photographer Rejlander made a bold claim for photography as a high art with his *Two Ways of Life* (fig. 18), in which an elaborate allegory is acted out by both clothed and unclothed figures. The fact that nudity could be legitimated by the intellectual purpose of the work was important to Rejlander. "I dislike a mere nude, if it conveys no idea", he commented.[9] The work became a talking point at the Art Treasure exhibition in Manchester in 1857.[10] Queen Victoria bought a copy of it for Prince Albert.[11] But, despite this, when the work was shown a year later in Scotland it had to be exhibited with the nude parts covered by drapes. Like the fine artists that he was emulating, Rejlander made nude photographic studies for his composition (cat. 94), and by this time there was already a growing practice of using nude photographs to supplement life studies by artists.[12] Despite this, photographs made for artists could still be classed as pornography. A Henry Evans, who specialized in selling studies for artists, including nudes (amongst which were studies by Rejlander), was raided by the police, charged with selling "obscene prints", and fined and sentenced to two years' hard labour despite a petition in his favour signed by artists who used his supplies, including Rossetti and Burne-Jones.[13]

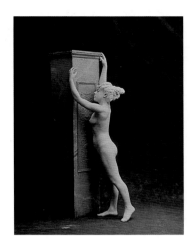

Such action by the police had been made possible as a result of the Obscene Publications Act of 1857. In this 'pornography' and 'obscenity' were given more precise definitions than they had had before. The Act also enshrined the concept that potentially obscene publications and actions could be legitimated if they were done in the name of art – a principle that has been retained to the present day. This also affected the theatre, where *poses plastiques* – tableaux of groups of motionless figures wearing fleshings – were permitted (fig. 19). One of the more amusing outcomes of such definitions was the subsequent permitting of nudity on stage provided the actors and actresses did not move. Motionless, they could enjoy the protection of being works of art. Once in action, they were back in the real world and could be booked for obscenity. Working with such concepts *The Saturday Review* opined in 1858 that it was respectable to pose nude for an artist, but disreputable to do so for a photographer.[14] Clearly Rejlander's 'art' nudes were an argument against this distinction. On the other hand it was true that a huge trade in pornographic photographs had developed. There were frequent reports of photographers getting working women drunk and them persuaded them to let themselves be photographed half-clothed or naked in explicit and provocative positions.[15] The criminalization of nakedness had driven it underground to join the company of prostitution and other forms of sexual exploitation.

By the 1880s the issue of naked display had become the object of a focussed reformist movement. The Social Purity movement had come into being to campaign for the repeal of the Contagious Diseases Acts of the 1860s – Acts that were held to reinforce the double standards of society by laying the blame for sexual immorality on women and not on the men who enticed them. Working on the principle that prevention was better than cure, the movement sought to rid society of the stimuli that caused irresponsible men to have wicked and lustful thoughts in the first place. Nudity in art came under attack, since it was seen as provocative to the male. The links between posing nude and prostitution were emphasized and women who painted and displayed the nude were censured for complicity in male exploitation. Most artists sought to defend the study of the nude. Frith, for example, observed that most women who posed nude at the Academy were highly respectable.[16] But it was grist to the mill of one

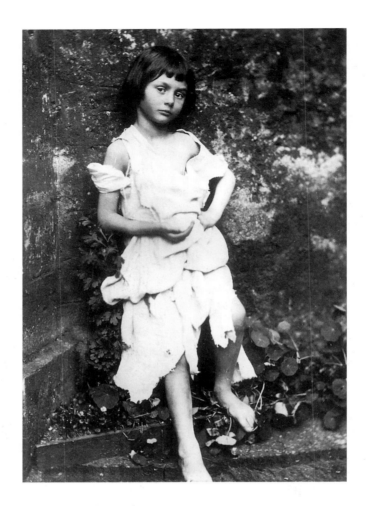

Academician who had long campaigned against the nude on religious grounds. This was John Callcott Horsley – nicknamed 'Clothes-Horsley' by fellow Academicians on account of his obsession. The Social Purity movement gave a new impetus to his campaign. "Is not clothedness a distinct type and feature of our Christian faith?" he bellowed in a lecture to a Church congress. "All art representations of nakedness are out of harmony with it." To which Whistler – not a member of that congregation – later coined the quip, "Horsley *soit qui mal y pense.*"[17]

It seems strange that one area that seems to have evaded the gaze of the Social Purity movement was child nakedness. Despite the fact that prostitutes as young as nine were being hawked in the streets of London, the widespread belief that children were non-sexual beings sanitized the taste for photographing and painting them naked. It could be carried out by Lewis Carroll with impunity. Whatever his feelings for Alice Liddell and other girls were (fig. 20), there is no doubt that the nude and semi-clothed photographs that he took have a heady eroticism about them that is deeply troubling to a more knowing age such as ours. The belief in the 'innocence' of children also encouraged a vogue for representing them naked as signs of this blessed state. The American painter Anna Lea Merritt enjoyed a great success with an image of a naked child in *Love locked out* (cat. 97). Merritt defended nudity in art when this was unconscious. "A model who has from childhood been accustomed to pose is quite unconscious of nudity, but with any *consciousness*, it disgusts me."[18] Whistler was one of those who exploited this vein, making nude studies of pre-pubescent girls with the encouragement of his

wife. Perhaps the most extreme example for us is the depiction of little boys by Henry Tuke (cat. 98). Set in Cornwall, these boys besporting themselves in nature were taken to be signs of innocence and the hope for healthy manhood. Even open-air nude photographs of boys were permitted without too much comment – for instance those taken by Frank Sutcliffe (cat. 99) of local youths in and around Whitby harbour.

Undoubtedly the natural setting helped to render the work of Tuke and Sutcliffe acceptable. Such work could, indeed, be seen as supporting the movement towards healthy living, something playfully alluded to in the epithet for Tuke attributed to John Betjeman, 'The Boucher of the Boy Scouts'. The 1890s was a time when there were growing fears about the emasculation of the population, rendering it incapable of carrying forward the imperialist mission, the 'white man's burden'. It is no coincidence that this is the decade in which the naturist movement came into being. Although the movement did not begin to make an impact on society at large until the 1920s, it was a symptom of a new attitude to the body which dissociated it from sin and exploitation.[19]

The association of nudity with personal liberation can also be found amongst the explorers of pictorial modernism. This was certainly how it was experienced by Nina Hamnett when she first took off her clothes to pose for her friend the sculptor Gaudier-Brzeska and discovered for the first time a pride in her body. The resultant works that Gaudier produced (cat. 111) stand out in his oeuvre for their formal elegance and beauty. Hamnett herself soon took this liberation into her social life, dancing naked to Debussy's 'Golliwog's Cake Walk' at the French painter van Dongen's parties in Montparnasse before the First World War.[20] On a more domestic level the sculptor Eric Gill celebrated nakedness within the family and sometimes made drawings and sculptures of an intimacy that – in view of what is now known about his dubious sex life – can be troubling (cat. 112).

If nudity became rehabilitated in this period, it also was a time of a more positive view of nakedness. This was expressed by Sickert, both in his writing on 'the naked and the nude' and in his art. At a time when modernists were pursuing a new ideal of the nude, he was insisting on the need to place nakedness in a real social context, painting down-at-heel prostitutes and low-life works that were found troubling in their candidness (cat. 105). "Real education in drawing from life", as he put it, was the study of life as lived, not the artificial construct of the studio nude. Although Sickert only painted such nudes for a short time, they have since become one of the best known parts of his work.

Within Sickert's circle there were other artists who addressed the problems he posed – notably Harold Gilman (cat. 106) and Sylvia Gosse (cat. 107). At much the same time Gwen John produced nudes which seem to incorporate the reality of her own experiences as a professional model. Her remarkable nude study of Fenella Lovell (fig. 21) seems to be full of the circumstances of the sitting. John herself complained about the sitter, "I shall be glad when it is finished. It is a great strain doing Fenella." Above all she seems to have objected to the model's constant complaints about a man whom she loved and who did not love her, "as though one has a right to be loved!" Dissatisfaction and disillusion fill the face and seem to empty the body of all eroticism or joy in physicality. As Wyndham Lewis commented of it, "It is a revulsion from her nakedness – an Eve after the Fall."[21] Above all, looking at the work, you feel that Fenella is

naked and she knows it. There is no attempt either by her or by the artist to enter into the pretence of the nude.

Such penetrating nakedness is rarely met with. It is matched two decades later, however, by that produced by Stanley Spencer in his remarkable nude portraits of himself and Patricia Preece (cat. 120). Spencer disliked working from the professional model and was delighted when the woman he was courting offered to pose in the nude for him. Doubtless he hoped the intimacy of these sessions would also promote their growing closeness. In the event they seem to have achieved the opposite – possibly because the images that he created of himself and her are so frank and unflattering. There is almost an involuntary exposure here, as though Spencer's curiosity has over-reached itself and penetrated to the lack of interest that Preece herself was at that time trying to disguise. Before them lies a loveless, unconsummated marriage. Nakedness is revealed to us here in every sense of the word.

The works of Sickert, John and Spencer provided a challenge to later painters who wished to unite a modern sensibility with an exploration of social reality, such as Coldstream and other painters of the Euston Road School (cat. 43). The impact of such thinking can still be found in a later British figurative tradition, notably in the work of Francis Bacon and Lucian Freud, while a theoretical underpinning of such work has been provided by the left-wing critic John Berger, who provided an important reworking of Sickert's position in his own treatment of the nude in *Ways of Seeing*.[22] For Berger, as for Sickert and Coldstream, nakedness had a political charge. It represented a stripping away, a revealing of truth. Perhaps one can see in such frequently painful exposure also the persistence of the British Puritan tradition. Such nakedness, after all, is more about pain and suffering than about the celebration of a state of primal bliss. Like the nudes of Gwen John, those of Bacon and Freud are undoubtedly 'after the Fall'.

1 W.R. Sickert, 'The Naked and the Nude', from *The New Age*, 21 July, 1910, reprinted in *A Free House*, ed. O. Sitwell, London 1947, p. 324.

2 L. Nead, *The Female Nude: Art, Obscenity and Sexuality*, London 1992, p. 14. K. Clark, *The Nude: A Study of Ideal Art*, London 1956, p. 1.

3 Clark, *op. cit.*, note 2, p. 23.

4 Nead, *op. cit.*, note 2, p. 14.

5 The Rokeby *Venus* was damaged in 1914 by Mary Richardson, a militant suffragist. See Nead, *op. cit.*, note 2, pp. 34–43. *Rima* was tarred and feathered by protesters in 1925. See E. Silber, *The Sculptures of Epstein*, 1986, p. 127.

6 *The Times*, 29 January 1822, quoted in Dennis Farr, *William Etty*, London 1958, p. 31.

7 *Venus Verticordia*, oil on canvas, 98 x 69.6 cm, 1864–65, Russell Cotes Museum, Bournemouth.

8 'A Woman's Plea', letter, *The Times*, 20 May 1885, p. 10. See J. Kestner, *Mythology and Misogyny: The Social Discourse of Nineteenth-Century British Classical-Subject Painting*, London 1989, pp. 219–22.

9 O.G. Rejlander 'Stray Thoughts', in *Yearbook of Photography and Photographic News*, 1872, p. 65.

10 Stephanie Spencer, 'O.G. Rejlander: Art Studies', in *British Photography in the Nineteenth Century: The Fine Art Tradition*, Cambridge 1989, pp. 121–32, esp. p. 128.

11 Aaron Scharf, *Art and Photography,* Harmondsworth 1965, repr. 1975, pp. 108–09.

12 *Ibid.*, pp. 119–22.

13 *Photographic News*, XIV, no. 633, 21 Oct. 1870; A. Smith, *The Victorian Nude*, Manchester 1996, p. 56.

14 *Ibidem.*

15 *Ibidem.*

16 William Powell Frith, *My Autobiography and Reminiscences*, 3 vols., London 1887–88, I, p. 40.

17 R. Dorment and M.F. Macdonald, *Whistler*, exhib. cat., London, Tate Gallery, 1994, p. 252.

18 *Ibid.*, pp. 132–33.

19 Adam Clapton and Robin Constable, *As Nature Intended*, London 1982, pp. 21, 32.

20 D. Hooker, *Nina Hamnett*, London 1986, p. 74.

21 Cecily Langdale, *Gwen John*, New Haven and London 1987, p. 139.

22 John Berger, *Ways of Seeing*, Harmondsworth 1972, p. 58.

William Etty

92 *Female nude, standing*

Oil on canvas, 208.3 × 118.7 cm

ca. 1825–30?

Collections, Bradford Art Gallery and Museums

This study of the female academy model is unusual in Etty's oeuvre in terms of its sheer size – on the scale of life – and of the medium used, oil on canvas (most of Etty's nude studies being on millboard, or occasionally paper).[1] The attitude of the model, as was often the practice in the life class, relates to a piece of classical statuary, in this instance the *Venus Pudica*. The present work appears to be a pendant to a life-sized male nude (Bolton Art Gallery), suggesting that both works were either made in the studio, directly from the model (since it would have been impractical to have made them at the Royal Academy), or copied from life studies made at the Academy. In general Etty did not sell his nude studies, although he made these works as a special commission.

MP

Frederic, Lord Leighton

93 *Reclining male nude*

Black chalk on buff paper, 39.5 × 30.9 cm
1850s
Royal Academy of Arts, London

This drawing, which has never previously been exhibited in public, is one of several life drawings presented by Leighton's sisters to the Royal Academy after his death in 1896. Before his arrival in London in 1859, Leighton had studied in the 1840s at the Berlin Academy, at the Accademia di Belle Arte, Florence, and in Frankfurt, where he completed the first phase of his academic training. Following a spell in Italy, Leighton worked in Paris, where he imbibed the various influences of Delacroix, Ingres and Couture. The closely knit hatching and meticulous use of fine line suggest that this drawing was made fairly early in Leighton's career, possibly in Rome or Paris, where in 1849 he drew at an informal life class in the rue Richer.[1] The drawing is an academic study, in that it is clearly an exercise in life drawing rather than a preparation for a composition. The languid, erotic pose of the male model, foreshortened and sprawled upon a bed or couch, lends it an unusual intimacy, although the attitude may have been influenced to some extent by that of the classical Barberini *Faun* (see cat. 102).

MP

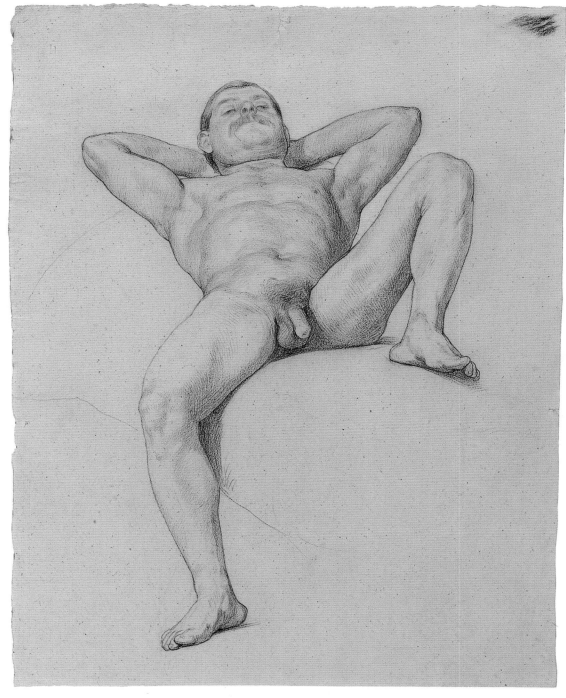

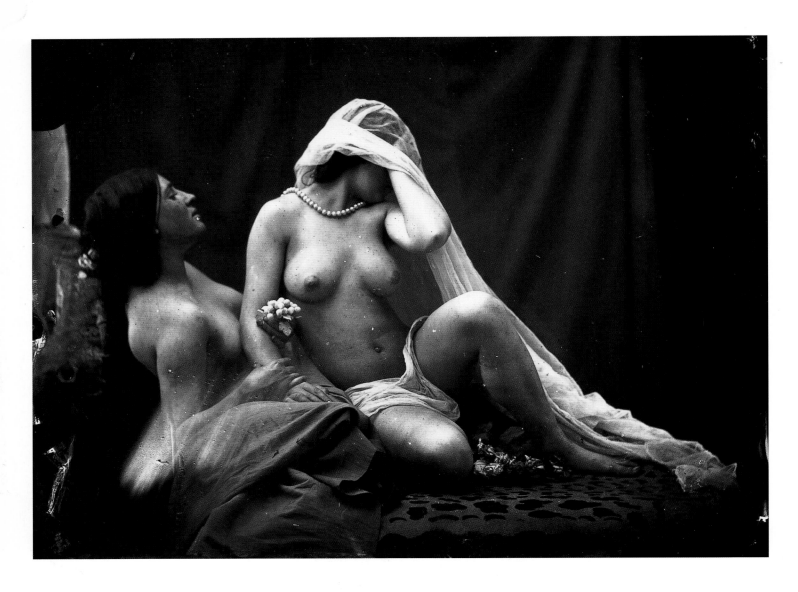

Oscar Gustav Rejlander (1813–1875)

94 Study for *The Two Ways of Life*

Modern print, made from the original
wet collodion negative, 18.1 × 23 cm
ca. 1855–56
Royal Photographic Society Collection,
Bath

Rejlander was a Swedish
photographer who began his
career as a painter. He moved to
England in the early 1840s. In
1846 he settled in
Wolverhampton, where he soon
began to practise photography.
His ambitious *Two Ways of Life*
attracted mixed attention, though
it was admired by Queen Victoria.
A large-scale composition of
clothed and unclothed figures

personifying concepts, it
deliberately set out to claim that
photography was an art as
capable as painting of treating
idealized historical and allegorical
themes. However, it was not so
much this ambition as the display
of photographic nudity that
offended. It was felt that
photography was too realistic a
medium to display naked figures
with propriety. Rejlander defended
his position on the grounds that
photography was capable of
expressing the ideal if correctly
treated. He himself said that he
disliked a nude "if it (apart from
study) conveys no idea".[1]

These studies for the *Two Ways
of Life* show that Rejlander had a
great skill in posing and

photographing nudes to present
ideas and emotions and that he
took particular care with the
formal qualities of his
photographs. He was concerned
that in studies of semi-naked
figures there should be a
harmonious relationship between
the form of the body and the
fabric covering it. He emulated
the effects of Greek sculpture, in
which drapery does not conceal
form. He achieved this effect by
using dampened thin fabric, often
staining it with coffee "to lessen
the colour contrast of flesh and
drapery".[2]

wv

Oscar Gustav Rejlander

95 *Study for a black male as a slave*

Modern print, made from the original wet collodion negative

ca. 1857

Royal Photographic Society Collection, Bath

Rejlander had great difficulty in obtaining models to pose for him naked for his photographic studies. His greatest success was with the vaudeville groups who came to Wolverhampton showing the popular *poses plastiques*. On account of their work (posing still on stage) they were able to hold their poses with absolute stillness – which was a great boon during the long exposures used in photography at that time. These troups of actors also came with black minstrels, and it has been suggested that these might have been used by Rejlander for studies such as the one exhibited here.

WV

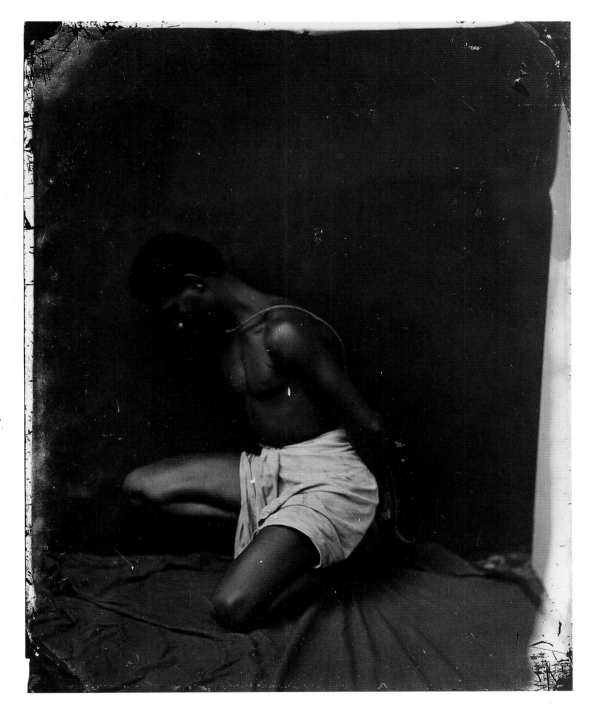

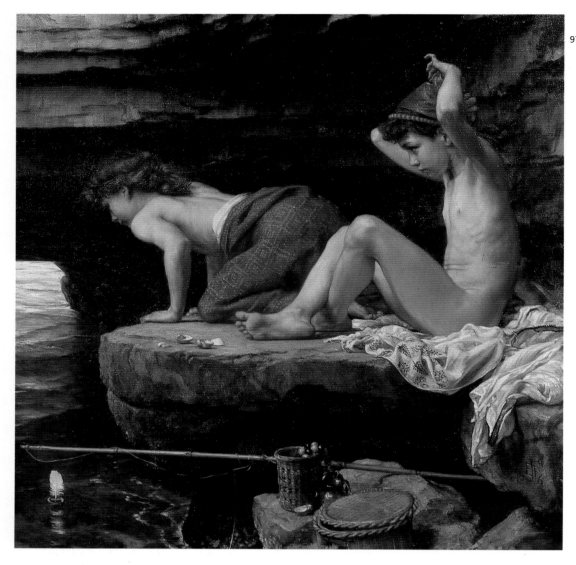

Anna Lea Merritt (1844–1930)

97 *Love locked out*

Oil on canvas, 115.6 × 64.1 cm

1889

Tate Gallery, London

Presented by the Trustees of the Chantrey Bequest 1890

Love locked out was purchased in 1890 by the Chantry Fund for the British National Collection, the first work by a female artist to be purchased for the nation and "one of the most acceptable and gracious allegories now visible in the Tate Gallery".[1] The maudlin subject of the picture, a figure of Cupid vainly trying to enter a mausoleum, was originally devised by Merritt in 1877 as a memorial to her dead husband, "intended for production in bronze relief and to stand between two evergreens at the head of our grave".[2] Unable to afford the cost of a bronze cast, she eventually painted the subject, and exhibited it at the Royal Academy in 1890. Although pleased that it had been bought for the nation, Merritt worried that the private sentiments expressed in the work were being misread in public "as a symbol of forbidden love, while my Love was waiting for the door of death to open and the reunion of the lonely pair".[3]

At a time when visual representation of the naked adult remained a contentious issue the naked child seemed to present a refreshing alternative: innocent, pure and 'natural'. Yet, as Merritt realised, her authorial voice was in danger of being subverted by the image's latent sexuality. Like the photographs of Lewis Carroll and Julia Margaret Cameron, featuring naked, allegorical children, *Love locked out* highlights a paradox elucidated recently by Anne Higonnet: "Children could only become desirable if they were genuinely believed to be innocent. Innocence itself becomes the object of desire. This paradoxical desirability of innocence put an

Sir Edward Poynter (1836–1919)

96 *Outward bound*

Oil on canvas, 49.5 × 49.5 cm

Signed and dated 1886

Tate Gallery, London

Bequeathed by Henry Evans, 1904

Outward bound was painted at the height of the debate on the role of the adult nude in art, and at a time when the nude child was becoming an increasingly popular subject for artists – Anna Lea Merritt's *Love locked out* (cat. 97) had been exhibited at the Royal Academy the previous year. Such pictures also coincided with more radical attempts by artists such as Tuke in England and Eakins in America to paint *plein-air* nudes using young male

models, and with the efforts of photographers such as Gloeden to turn images of naked childhood into an acceptable art form.[1] The subject of Poynter's picture, a young boy and girl, no doubt aimed to promote the concept of childhood innocence. Yet, paradoxically, in an effort to present a timeless, classical idyll, not least through the attitude of the naked boy in the foreground, Poynter's composition highlights the similarities between the nude child model and its adult counterpart. Poynter's further intentions remain elusive. However, given the hostile climate towards painting the adult female nude, it is possible that he wished to divert his interest in the nude

model towards less contentious subject-matter – a decision which may strike the modern viewer as somewhat ironic.

MP

irresolvable tension at the heart of Romantic childhood."[4]

Anna Lea Merritt grew up in Philadelphia, learning to draw the figure by studying anatomy at the Women's Medical College. In Europe she took private art lessons in Dresden, Florence and Paris, and in London took private lessons from Alphonse Legros. "A boy posed. I drew with pencil. The teacher never looked at it. That was the end!"[5] Although she knew of the existence of private drawing schools, including Heatherley's, she never studied in a life class, and it was not until 1881 that she began to study the nude model, using a woman recommended to her by Leighton. The resulting picture, shown at the Royal Academy in 1883, prompted an idiosyncratic request for a nude portrait from an anonymous aristocrat. "I could not accept such an order," recalled Merritt; "I would not even look at her figure, which she much desired. A model who has from childhood been accustomed to pose is quite unconscious of nudity, but with any *consciousness*, it disgusts me."

M P

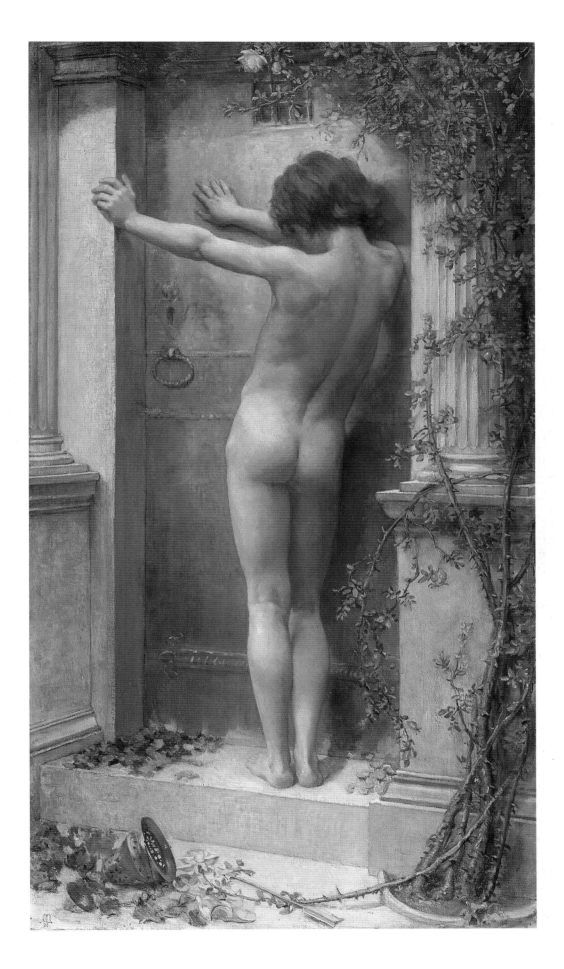

Henry Scott Tuke

98 *July sun*

Oil on canvas, 52 × 42 cm
1913
Royal Academy of Arts, London

July sun was Henry Scott Tuke's diploma work, presented to the Royal Academy in 1913 upon his being elected Royal Academician. He insisted that it should hang in the Life Room. The picture, like the majority of Tuke's nude figure studies, was painted *plein-air* on the Cornish coast. Usually, Tuke's models were youths drawn from the local fishing community, although in this instance he used a professional model, an Italian named Nicola Lucciani. Like a number of Tuke's other models involved in the Great War, Lucciani was shortly to die in the trenches.

Henry Scott ('Harry') Tuke began studying the figure in 1875 under Poynter, and then Legros, at the Slade. In the early 1880s the opportunity to paint the nude outdoors on the Italian coast, and subsequently on the coast of Brittany, gave him the impetus to develop his interest in the genre of the *plein-air* nude. In Cornwall, shortly afterwards, Tuke began once more to paint the male nude figure outdoors. There were some practical problems with the British climate, as Tuke recalled: "When I first began painting nudes out of doors the model sat out till mid-November, and I used to watch him going pink and blue in patches."[1]

The stimulus for Tuke's *plein-air* male nudes came partly from his close association with the New English Art Club, formed in 1886, and its members' desire to demonstrate their affiliation with more avantgarde tendencies in Continental practice: in Tuke's case the *plein-air* figurative work of Bastien-Lepage. However, the first adverse reaction came from Martin Colnaghi, who, having promised to mount the first exhibition of the NEAC at his gallery, withdrew his support on seeing Tuke's *Bathers*.

Tuke's abiding interest in painting young male nudes inevitably raises the issue of his own sexual orientation. He was a life-long bachelor and, like many of his close friends, he was homosexual. However, it would be incautious to impute any ulterior motives beyond painting these boys and generally enjoying their company. At that time it was still commonplace to find youths bathing naked in lakes, rivers and along the coast. It was also an age in which healthy, outdoor male camaraderie was positively encouraged. Even so, there was a potential for misunderstanding and Tuke was careful to gain permission from his young male models' parents before painting them, treating them with due respect as well as kindness. Ironically, the only time Tuke appears to have worried that his actions might be misconstrued was when he introduced a young female model from London, whom he wished to paint as a mermaid: on this occasion, in order to dispel potential gossip, he proclaimed the girl to be the niece of one of his visiting artist-friends.[2]

MP

Frank M. Sutcliffe (1853–1941)

99 *Natives*

Carbon print, 22.5 × 29.2 cm
ca. 1885
Royal Photographic Society Collection, Bath. Gift of the photographer

Frank Sutcliffe was one of the noted art photographers of his day, and a member of the prestigious Brotherhood of the Linked Ring which was founded in 1892 as a secession from the larger Photographic Society and which promoted 'Pictorialism'.[1] He lived for most of his working life in Whitby, and achieved great success with his records of the life of fishermen and other local figures. He achieved his greatest success in 1885 with *Water-rats*, a photograph of young boys disporting themselves naked in Whitby harbour: the boys were truants from school, who were in the habit of taking off their clothes and dashing into the water so that the attendance enforcer could not reach them. Sutcliffe paid the boys one penny each for a day's photography. The work was praised for the naturalness of its effects and the Prince of Wales (the future Edward VII) ordered a copy of it. However, it was also censured for its display of nudity and implicit condolence of juvenile

delinquency. Sutcliffe claimed to have been "excommunicated" by members of the local clergy for displaying the work in his shop window. It also seems that there was resentment amongst those who were trying to building up the local tourist trade, since the habit of local young boys of swimming and playing in the harbour naked was putting off respectable visitors.[2]

Following the success of *Water-rats* Sutcliffe made other studies of local boys naked on the shore, such as the present one. While these emphasize a similar notion of indigenous naturalness, they tend to be more deliberately posed. Many of them bear a striking visual resemblance to the paintings made by Tuke of young boys at around the same time (cat. 98).

W V

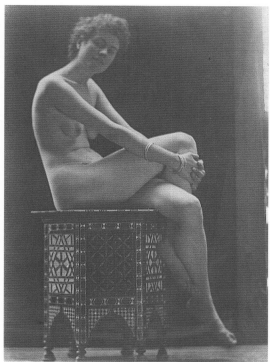

Edward Linley Sambourne

100 **Standing female nude (Miss Hall)**

Cyanotype, 16.5 × 12 cm
3 October 1900
Linley Sambourne House (The Royal Borough of Kensington and Chelsea)

101 *Seated female nude (Mrs King)*

Cyanotype, 16.5 × 12 cm
16 March 1893
Linley Sambourne House (The Royal Borough of Kensington and Chelsea)

These two photographs of nude female models belong to an archive of over 30,000 photographs taken by Edward Linley Sambourne over a period of some twenty years. Collectively, they demonstrate the different ways in which Sambourne employed models, as the basis for his professional magazine illustrations – and for personal pleasure. A born taxonomist, Sambourne carefully annotated his photographs with models' names and dates of sittings, and kept diaries with details of sittings, addresses and brief notes (not always complimentary) on their physical and mental attributes.[1]

Sambourne, who had previously worked as an engineering draughtsman, was taken on as a cartoonist by *Punch* magazine in 1867. Under increasing pressure of work, he used photography in the early 1880s as a quick and convenient means of obtaining studies for his weekly cartoon illustrations, copying or tracing images for incorporation into his final drawings. In 1893, by which time photography had become his overriding passion, he joined the Camera Club, where he took photographs of the naked and clothed models, although he also used his own home, and even, covertly, the streets of Kensington as locations (using his 'detective' camera to photograph local school girls).[2]

Sambourne took the present photograph of Miss Hall at his home at 18 Stafford Terrace on Wednesday 3 October 1900, as one of a series used for the emblematic figure of the Twentieth Century for the *Punch Almanack* of 1901 (see left). As usual, Sambourne went to extraordinary lengths in preparing his composition, making small models of the objects represented as well as numerous photographs of figures, naked and clothed.[3] The photograph of Mrs King was also taken at Sambourne's home, on Monday 16 March 1893, on which occasion she was accompanied by another of Sambourne's models, Miss Derben. (In the index of his diary Sambourne recorded the two models' addresses: Mrs King at 86 Kennington Road, and Miss Derben at 9 Oakenden Street, Kennington, then a solidly working-class neighbourhood.) In this and other photographs in the series, Miss Derben is seated on a Moorish table from Sambourne's morning room. The photographs that resulted from this session, quite unrelated to Sambourne's professional work, were taken almost certainly without his wife's knowledge, while she was staying in Ramsgate. The relationship of these photographs to Sambourne's work as a photographer and his leisure interest in the nude raises questions concerning the boundaries between the photographic nude as a legitimate art form and as a species of pornography.

M P

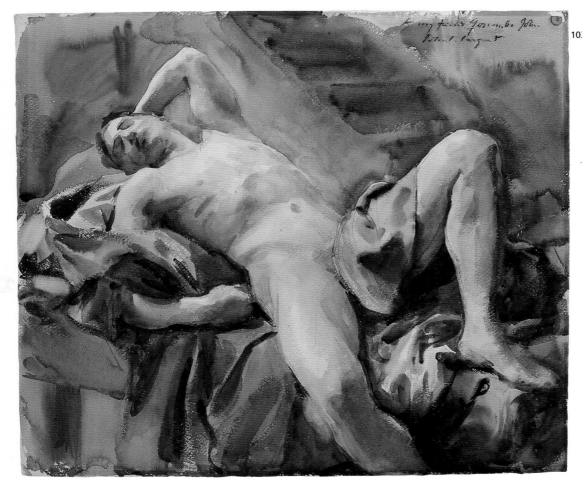

Sir Charles Holmes (1868–1936)
103 *Self-portrait, nude*

Red and black chalk on paper,
45.3 × 28.4 cm
Early 1890s?
The Trustees of the British Museum,
London

Sir Charles Holmes's nude self-portrait emerged out of his idiosyncratic attempts to teach himself life drawing. The son of a clergyman, Holmes was educated at Eton and Brasenose, Oxford. He subsequently followed a career in publishing, at the same time joining an amateur sketching club, the Victoria Drawing Society. In the winter of 1891, conscious of his lack of formal academic training, he spent time independently studying from antique casts at the South Kensington Museum. He made rapid sketches, timed between fifteen minutes and two hours. Holmes was dismissive of the teaching methods at the South Kensington Schools, noting that the "method of most of the students, their timid elaborate modelling with stump and charcoal, seemed an extravagant waste of time".[1] During the early 1890s, Holmes also recalled making life studies from his own body, "the most ambitious being a nude Andromeda, painted from my own bony person with some difficulty and a looking-glass, who showed too many traces of her origin to have tempted even a sea-monster".[2] The present nude self-portait presumably dates from the same period.

The tradition of the artist drawing his or her own naked body stretches back at least to Dürer, although more recent British exponents included Sir David Wilkie, Nina Hamnett, Gwen John and Stanley Spencer. While Spencer regarded nude portraiture as an integral aspect of his personal artistic vision, Holmes, a pragmatist and fitness fanatic, probably took the same attitude as Wilkie, who, when

John Singer Sargent (1856–1925)
102 *Reclining nude male model*

Watercolour, 47 × 54.5 cm
Mid to late 1890s
Inscribed: *to my friend Goscombe John/
John S. Sargent*
National Museums and Galleries of Wales

The present study has been regarded as a "pleasant contrast, in its unstudied naturalism, to those more consciously posed figures" by the artist.[1] However, despite the seemingly relaxed pose, this is not an impromptu studio pose but a deliberate imitation of the celebrated antique statue known as the Barberini *Faun* (see right) and also as *Bacchus*, *The drunken Faun* and *The sleeping Pan* – which may well explain why Sargent dedicated and presented the study to his friend the sculptor William Goscombe John. Sargent, whose draughtsmanship was of the highest order, trained in art schools in Florence, Dresden and Berlin before settling in Paris in the atelier of Emile-Auguste Carolus-Duran. He always enjoyed working from the model, whether in character studies of young girls in Venice and Capri, or drawings made at lightning speed from muscular male nudes. During the early 1890s Sargent began to work intensively from the male nude in his studio at Fairford, many of these studies being related to the murals he painted for Boston Public Library. Among the models who sat to him at that time were several Italians, notably Nicola d'Inverno, who for the next twenty years served Sargent as model and manservant.[2] The model used in the present study was, it has been suggested, Luigi Mancini, whose family were prominent among the Italian modelling community.[3] Certainly, he is identifiable as the thick-set moustached model who features in a number of dynamic charcoal studies by Sargent now in the Fogg Art Museum.[4]

MP

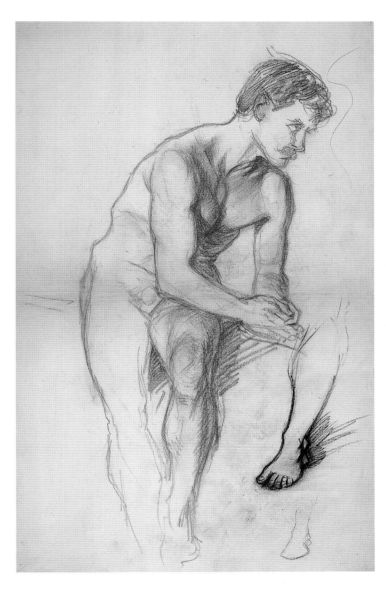

confronted one morning stark-naked in front of the mirror by Benjamin Robert Haydon, simply replied: "It's jest copital practice [*sic*]."[3]

Holmes subsequently abandoned the figure, although he continued to paint for the rest of his life, principally landscapes in the Romantic tradition. In 1903 he was appointed co-editor of the *Burlington Magazine*, and was successively Slade Professor at Oxford, Director of the National Portrait Gallery and Director of the National Gallery.

MP

Gwen John (1876–1939)
104 *Self-portrait nude, sketching*

Pencil, 23.3 × 16.6 cm
1908–09
National Museums and Galleries of Wales

In 1904, after having completed her studies at the Slade, John moved to Paris to continue her career as an artist. Like many other struggling women artists of the period, she supplemented her income by working as a model. She became a model for Rodin on the suggestion of her brother, who commented, "Why not call on Rodin, he loves English young ladies ...".[1] The two became deeply attached to each other, being lovers for several years.

Rodin used her as a model, appropriately enough, for the muse in his monument to her former master Whistler. The monument was never completed, but a cast of the figure remains.

John's experiences as a model for other artists seem to have encouraged her to work for herself in a similar capacity. Perhaps influenced by Rodin's method of rapid sketching, she made many studies of herself in outline. However, the careful line that she uses in these is very different from the ebulient one of the great French sculptor. John scrutinizes herself critically, if tenderly. Her face is omitted, perhaps a sign of modesty. Her exploration of her own body is very different from the admiring self-discovery experienced by Nina Hamnett (cat. 111) later.

This drawing is one of eight almost identical ones in the collection of the National Museum of Wales. It may be connected to those referred to in a letter from Gwen John to Ursula Tyrwhitt (15 February 1909): "I am doing some drawings in my glass, myself & the room & I put white in the colour so it is like painting in oil & quicker. I have begun 5. I first draw in the thing then trace it on to a clean piece of paper by holding it against the window."[2] It is possible that this drawing is such a tracing.

WV

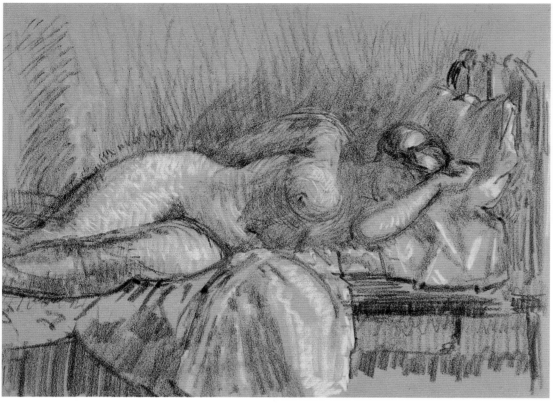

Walter Richard Sickert
(1860–1942)
105 *Female nude*

Chalk and gouache on green paper
24.5 × 32.8 cm
ca. 1905–07
The Trustees of the British Museum,
London

After having absorbed the art
of Whistler and the French
Impressionists, Sickert developed
his own form of realism which
reached a high point during the
period between 1905 and 1913.
In this period – usually referred to
as his 'Camden Town' period – he
developed a new class of subject-
matter representing working-class
subjects in 'real' surroundings.
These include nudes in
claustrophobic bedrooms with
iron bedsteads, most strikingly the
Camden Town Murder, which
deals with the topical murder of
a prostitute. The current study of
a nude woman lying on her side
on a bed, turned towards the
spectator, appears to be related to
the period *ca.* 1905–07 when he
made a series of paintings and
drawings of nudes in similar
positions and situations. These
accorded with his desire,
expressed in 1910 in his essay
'The Naked and the Nude', to
paint figures from 'real life' rather
than to construct conventional
studio nudes.[1]

Sickert would habitually make
use of local cockney models for
these figures. It is typical of his
approach that he felt it important
to have no personal involvement
with his models, so that he could
study them in an objective and
professional manner. He advised
a fellow painter to "find ...
someone whose aspect is
interesting and sympathetic to
you but who is *paid* ...", adding
"Banish your own person, your
life and that means you and your
affections and yourself from your
theatre. During the hours you
paint, by using paid models you
will forget that you are you"[2]

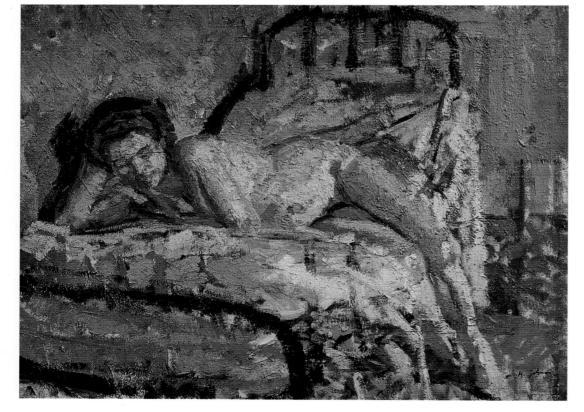

Sickert did not always follow his own advice in this matter. His intention, however, of dismantling the myth of the inspirational model-mistress and replacing it with the idea of a practical, workaday attitude to painting the human figure was an important one both for the probity of his own art and for the encouragement of a modern realist practice in Britain.

WV

Harold Gilman (1876–1919)

106 *The model, reclining nude*

Oil on canvas

ca. 1910–11

Arts Council Collection, Hayward Gallery, London

Like other members of the 'Camden Town' group Gilman was strongly influenced by Sickert's concept of the 'modern' naked figure, which he sought to place in a contemporary and unglamourized setting. At this stage Gilman was also still strongly influenced by Sickert's manner of painting, but he later developed a more monumental style under the impact of Post-impressionism.

WV

Sylvia Gosse (1881–1968)

107 *Female nude looking in a mirror*

Graphite with grey chalk on paper, 60.1 × 44.9 cm

ca. 1914

The Trustees of the British Museum, London

Sylvia Gosse was a close associate of Sickert who treated similar contemporary subjects in a manner related but distinct from his. It was apparently Sickert who persuaded her reluctant father, the essayist Sir Edmund Gosse, to allow his daughter to pursue a professional career as a painter. From 1909, when she first exhibited at the Allied Artist's Association, she made her own

way financially and, while remaining close to Sickert, preserved her own independence.

Gosse did not often deal with the nude as a subject, but when she did so she portrayed this "not in an imaginary setting but in a dreary, north London bedsit".[1] Like Gilman (cat. 106), with whom she sometimes shared a model around 1914, she interpreted the nude very much in the context of Sickert's concept of the 'naked' – the body as perceived in a real situation in the contemporary world.

WV

Sir William Orpen

108 *The draughtsman and his model*

Watercolour, 43.8 × 61.6 cm

1910

Victoria and Albert Museum, London

This picture shows an artist – possibly Orpen himself – at work drawing a model in the open air. Orpen had a fascination with the process of painting the model and returned to the subject many times. This is the only occasion, however, in which he recorded such a study being made in the open air. This watercolour was exhibited at the winter exhibition of the New English Art Club in 1910, where it attracted attention on account of the racy nature of the subject.

The picture was owned by the artist Alfred Rich, a close friend of Orpen's who shared his professional interest in the representation of the female nude. Orpen made a study of Rich at work, painting the model indoors, which is now in the Tate Gallery. It was bequeathed by Rich to the Victoria and Albert Museum in 1929.[1]

WV

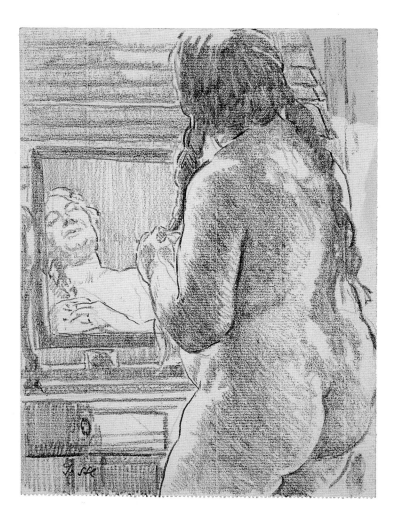

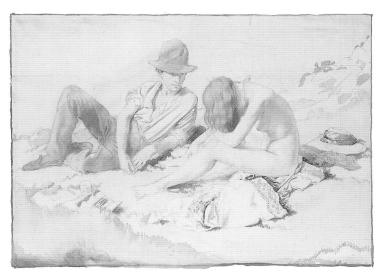

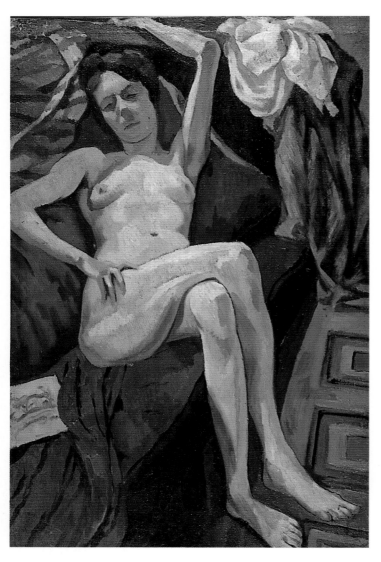

Roger Eliot Fry (1866–1934)

109 Nude on a sofa (Nina Hamnett)

Oil on canvas, 90 × 29.6 cm

1917

By kind permission of Mr Edward
Booth-Clibborn

Roger Fry met Nina Hamnett in
autumn 1913, when he employed
her at the Omega Workshops in
Fitzroy Street. In the summer of
1916 they began an affair, Fry
owning that he was, at fifty,
"a great deal too old ... for such
a *volage* ...".[1] The affair
reinvigorated Fry ("*ton vieux
satyr*", as he signed himself in a
letter to Nina) and stimulated
both artists to produce some of
their finest works – not least Fry's
various portraits of Nina, clothed

and nude. The present picture, in
which Nina's naked form is set
against the bright colours of an
Omega rug, reveals the casual
intimacy of the relationship, and
Fry's admiration for her "queer
satyr-like oddity and grace".[2]
Nina, in turn, made a number of
pencil sketches of Fry naked, very
much in the manner of Henri
Gaudier-Brzeska, whom she had
also sketched naked, and for
whom she had also posed as
model (cat. 111). Nina was very
promiscuous, and ended the affair
with Fry quite suddenly early in
1918, as he told Vanessa Bell: "I
was rather upset when I got back
to find that Nina had picked up
a young man of 18, a drunken
sodomite of pleasant manner and

weak character with whom she
was actually living."[3] Although
Nina remained on friendly terms
with Fry, she ceased to be his lover
and model.

MP

Henri Gaudier-Brzeska

110 *Female nude*

Chalk on paper, 38 × 25.5 cm

ca. 1913

Victoria and Albert Museum, London

In contrast to the rapid outline
sketching method, which Gaudier
made peculiarly his own (see
cat. 36), this drawing shows the
sculptor engaged in a more
systematic exploration of
volumetric form, using bold
diagonal hatching to mark out

areas of recession and shadow.
Even so, the approach is more
spirited and rapid than the
laborious conventional study,
exemplified, for instance, by the
seated male nude of Lowry
(cat. 35).

WV

Henri Gaudier-Brzeska

111 *Torso*

Marble, 25.2 × 98.2 × 7.7 cm
1914
Tate Gallery, London
Transferred from the Victoria and Albert
Museum 1983

The model for this figure was the painter Nina Hamnett (cat. 37). Gaudier, as he wrote to a friend, was attempting" a marble statue of a girl in the natural way, in order to show my accomplishment as a sculptor".[1] In this he succeeds magnificently. The classic beauty of this modern fragment appears to have been inspired by both the work of Rodin and the Greek statues that the artist had been studying at the British Museum. The theme of the female torso had been in his mind for some time. In 1912, when listening to Beethoven's Fifth Symphony in the Albert Hall, he had been put in mind of the form. "I can't describe the Symphony to you," he wrote to his lover, Sophie Brzeska, "but the whole has a suave amplitude, and gives the impression of a very beautiful young woman's torso, firm but soft, seen at first by rarefied lights and then with strong light and shade." In this letter he included a series of sketches of the torso that could almost be first studies for the later work.[2]

Hamnett had befriended Gaudier-Brzeska in 1913. They soon became very close, she being unaware of the true nature of the sculptor's attachment to Sophie. When Gaudier asked her to pose for him, she agreed. In her autobiography *Laughing Torso* she describes how she used the opportunity to show herself off to full advantage, slowly turning round while he made drawings. Gaudier was attracted by the fact that Hamnett was herself a talented artist and did not treat her just as a model. When he had finished drawing, he took off his own clothes, adopted a pose and

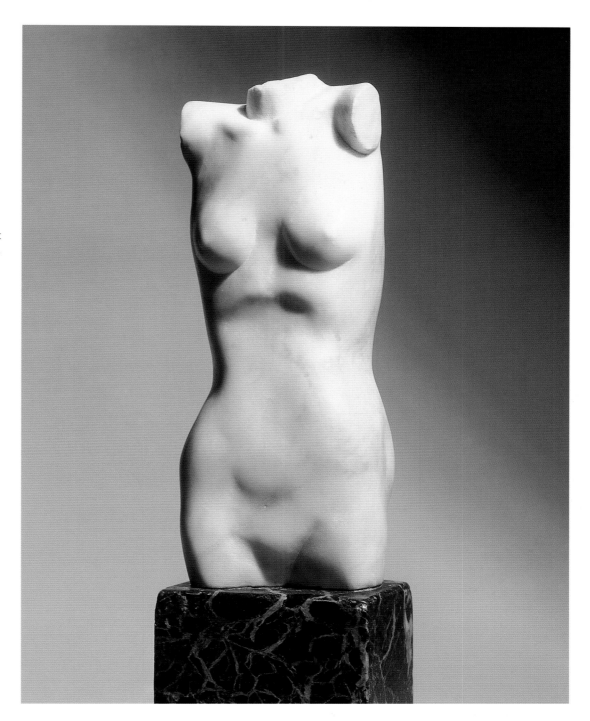

said, "Now it is your turn." Hamnett made some sketches of him before they had tea.[3]

Gaudier's appreciation of Hamnett's elegant and slender body also inspired him to make a sculpture of her as a *Dancer* (Tate Gallery T00762), a work that seems to owe something to the expressive bronzes of Nan Condron that Epstein had recently

made (see. cat. 80).

Hamnett was soon to make full use of her new found awareness of her body, dancing naked at parties in Montmartre. She also remained immensely proud of having been the model for this work, which had early won recognition for its exquisite beauty and which had been acquired by the Victoria and Albert Museum

(from which it was transferred to the Tate in 1983). "Don't forget, I'm a museum piece, darling", she told one admirer. On another occasion she announced, "I'm in the V & A with my left tit off", referring to the slight fracture on the marble's left breast.[4]

wv

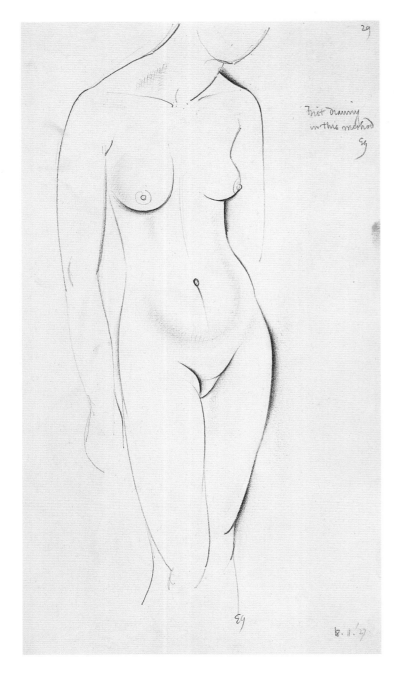

Eric Gill (1882–1940)

112 Sketchbook containing thirty-nine life studies

1927

Victoria and Albert Museum, London

This sketchbook was made when Gill was seeking to re-establish his position as a figurative sculptor after a period of relative seclusion living with his family in a deserted monastery at Capel-y-ffin in Wales. Amongst the works he was sculpting in the autumn of 1927

was a large female torso entitled *Mankind* and a nude statue of *Eve* (both now in the Tate Gallery). These were both exhibited in his major retrospective at the Goupil Gallery in March 1928.[1] Gill believed in carving directly into the stone without making any preparatory studies. However, he felt that he needed to gain a firmer experience of the human figure at this time, hence the present studies.

During the mid-1920s Gill used his daughters extensively as models. This figure may be of Petra, who would have been twenty-one at the time. Gill is notorious for combining a deeply held religious faith with an uninhibited exploration of sexuality. Recent revelations about the extent to which he took the latter – including the practice of incest and the production of pornography – have tarnished the reputation that he formerly held as a bold but essentially healthy and liberating celebrant of the erotic. This has made the appeal of beautiful drawings of the female form such as the ones in this sketchbook especially problematic.

One on page 29, dated 18 November 1927, contains the inscription *First drawing in this method*. The method appears to be one in which curves of the

body are emphasized through a thickening of lines, which gives the figure something of the appearance of a relief sculpture.

WV

Vanessa Bell (1879–1961)

113 *Female nude*

Oil on canvas, 81.3 × 65.4 cm

ca. 1922–23

Tate Gallery, London

Bequeathed by Frank Hindley Smith, 1940

Together with her sister, the novelist Virginia Woolf, Vanessa Bell was a leading figure in the Bloomsbury Group. She developed a deep personal and artistic relationship with Duncan Grant, for whom she also acted as model. She was encouraged by him to experiment with abstraction. Most of her work, however, concerned the depiction of her domestic world, in particular still lifes and portraits of her family.

Nude studies are relatively rare in Bell's work. This one probably comes from the early 1920s, a time when she was returning to serious painting after bringing up her daughter. Bell revisited Paris at this time and was deeply impressed by the monumental, classically inspired nudes that Picasso had recently been painting. There seems to be a response to such work in this nude, particularly in the sense of volume.

WV

Barbara Hepworth (1903–1975)

114 *Female seated nude*

Chalk, pen and ink, 38 × 25.5 cm
Inscribed: *Barbara Hepworth 1928*
Victoria and Albert Museum, London

Although later renowned as a leading abstract sculptor, Hepworth was still working in the figurative tradition in the 1920s. A fellow student of Moore (cat. 115) both at Leeds School of Art and at the Royal College of Art, she shared his interest at this time in primitive art and in using the technique of direct carving in her sculpture. "Carving", she later wrote "… is, in fact, a biological necessity as it is concerned with aspects of living form of which we cannot afford to be deprived."[1]

As also for other sculptors of the period, such as Henry Moore and Barbara Austen Taylor (cat. 116), her study of the naked figure was guided by a concern to observe and record three-dimensional form. For Hepworth and Moore, in particular, there was also a concern when it came to carving a block to bring out the 'natural' form of the material; and indeed to combine the forms of nature with those of the human body. In that sense they had interests very different from those concerns about nakedness and nudity that pre-occupied some painters.

WV

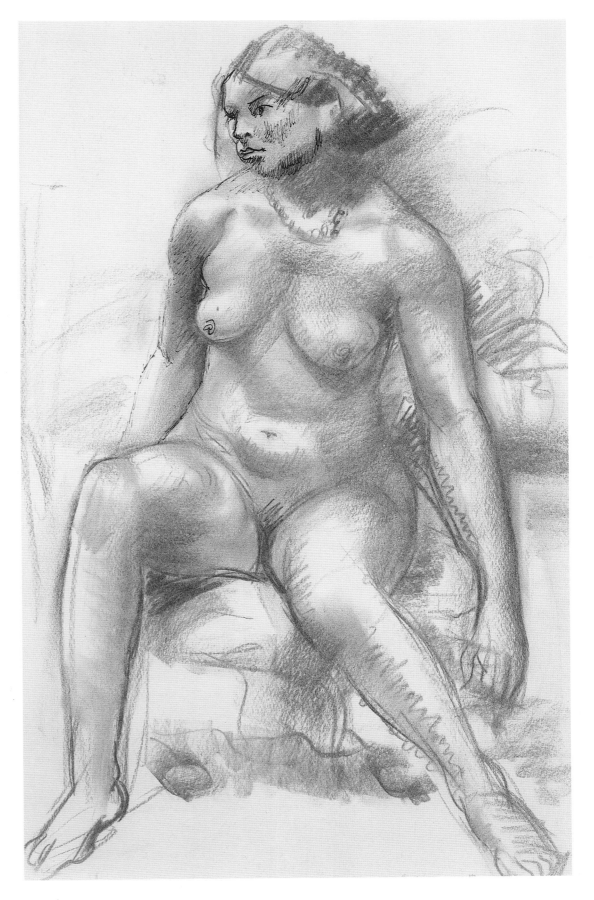

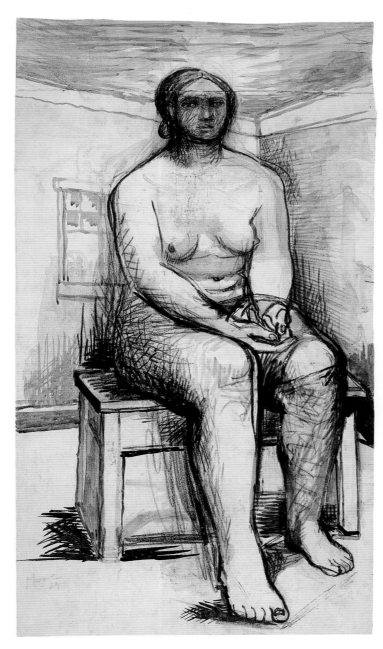

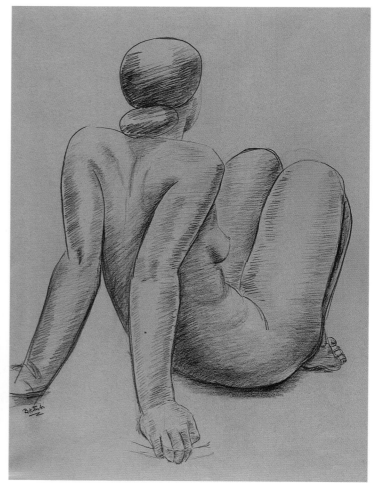

Henry Moore (1898–1986)

115 *Seated female nude*

Chalk and wash on paper, 51.3 × 29 cm

1929

The Trustees of the British Museum, London

In 1929 Moore married Irina Radetsky, a painting student at the Royal College. From this period there are a series of drawings, evidently made in their flat in Hampstead. As an art student Moore had had a thorough training in drawing from the model and held this to be essential for the sculptor's discovery of form. He told Alan Wilkinson, "If you are going to train a sculptor to know about the human figure, make him do more drawing to begin with than modelling."[1]

Despite the fact that he was drawing his young wife, Moore does not explore intimacy or individuality in this work – a strong contrast to the near-contemporary studies by Spencer and Brockhurst (cat. 91, 119, 120)

of women with whom they had a deep personal relationship. Moore's concerns remain more rigorously artistic. He was at that time working on the completion of his relief of the *West Wind* for the Headquarters of the London Underground at St James's Park and was deeply involved in the problems of monumental sculpture. His main concern in this study is the representation of form in a broad and solid manner. Moore continued to draw from the model in the early 1930s, but did so less after that, as his sculpture moved towards abstraction.

wv

Barbara Austin Taylor (died 1951)

116 *Female nude, seated*

Chalk on buff paper, 53.5 × 38.9 cm

1935

Signed: *B.A. Taylor*

Manchester City Art Galleries

Barbara Austin Taylor was a professional portrait sculptor. She studied at the Westminster School of Art, at the Grosvenor School of Art and at Rome. She exhibited at the Royal Academy and elsewhere in London between 1932 and 1947.[1]

wv

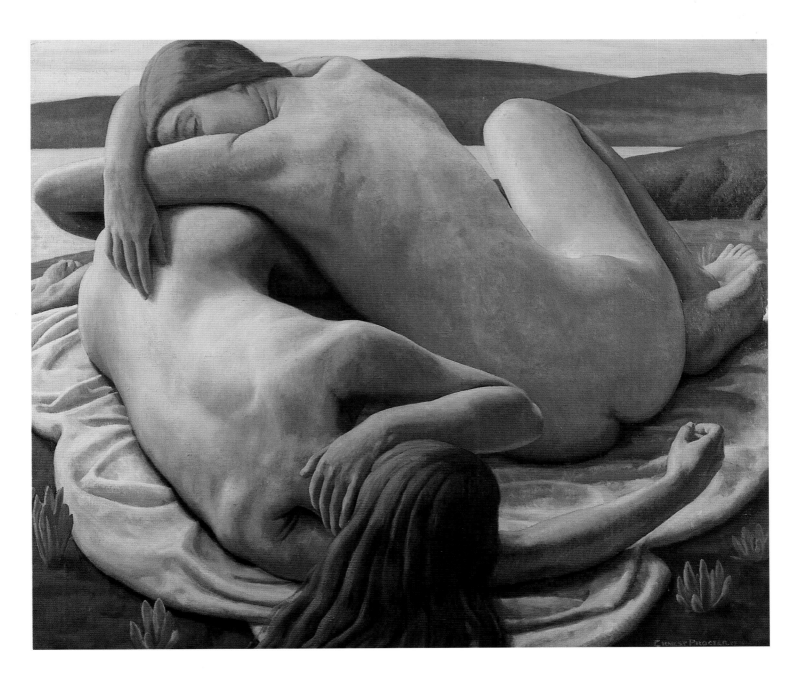

Ernest Procter (1886–1935)

117 *The day's end*

Oil on canvas, 91.6 × 106.5 cm

1927

Leicester City Museums

During the 1920s Ernest Procter built up a reputation for figurative work with allegorical and symbolic themes, in which he combined elements from Italian and Flemish fifteenth-century art with varying degrees of *plein-air* painting. He had studied under Stanhope Forbes at Newlyn. In 1912 he married Dod Procter (cat. 83), a fellow student at Newlyn.

The day's end is simpler and more realistic in treatment than many of his major figure paintings. Perhaps it is intended in some degree to be a response to *Morning* (cat. 83), with which his wife had recently had such success. The model – perhaps for both figures – was Billie Waters, one of his students.[1]

wv

Mark Gertler (1891–1939)

118 *Young Girlhood II*

Oil on canvas, 135 × 64 cm

1925

Visitors of the Ashmolean Museum, Oxford

Since the time that he had been a student at the Slade, Gertler had worked constantly from the model. In his earlier work he had explored his own Jewish background in terms of the new artistic interest in the primitive, using members of his family – and in particular his mother – as models. In the 1920s, however, he tended to move away from such personal involvement and worked increasingly with professional models. *Young Girlhood II* falls within this pattern. The sitter is Alice Edwards, a young girl from the East End of London who was employed regularly at the Slade. Gertler had used Alice as the model for *Young Girlhood I* (1923; private collection) two years earlier, on which occasion his friend Mrs Valentine Dobrée acted as a chaperone. That picture has always attracted attention – and increasingly critical responses in recent years – because it focussed on what Gertler called "the charm of young girlhood",[1] but which can be seen by later commentators as a disturbing combination of pre-pubescence and prescient sexual self-awareness. *Young Girlhood II* is somewhat less problematical, because the self-awareness seems less at odds with the physique and age of the sitter. Gertler used Alice Edwards for several pictures during this period, including *Coster family on Hampstead Heath* (1924; Tel Aviv).

WV

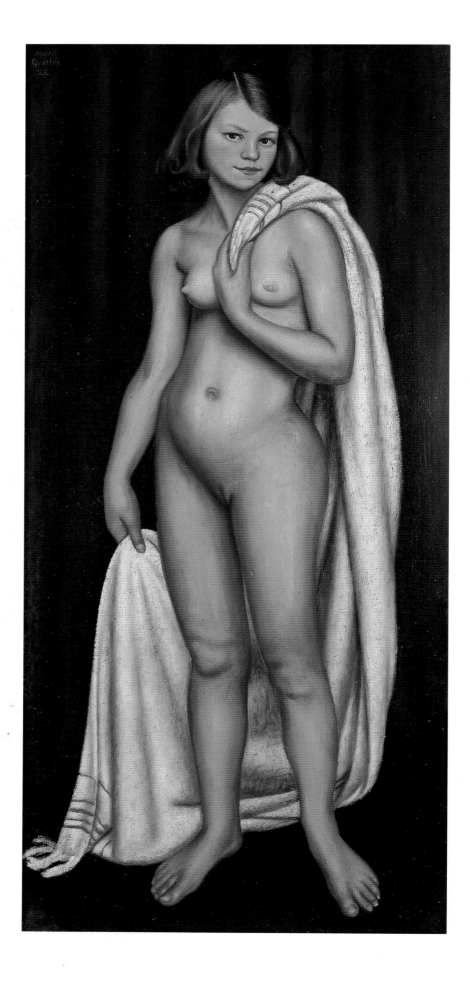

Gerald Leslie Brockhurst
(1890–1978)

119 *Adolescence*

Oil on canvas, 89 × 71 cm

1932

Royal Academy of Arts, London

This is an oil-painting version of a famous etching of the same title by Brockhurst. The model is Kathleen Woodward (his mistress, and later his wife), whom he called Dorette.

Brockhurst was renowned for his brilliant etching technique, and the three studies that he made of 'Dorette' during the early years of their relationship are usually held to be his masterpieces in that medium. Brockhurst normally developed his etchings from a later painting. It had been assumed until recently that in this case the etching was developed from a drawing which is now in the Boston Public Library[1] and that this was the reason for the particular intensity of the etching. In fact A*dolescence* appears also to be based on a painting. Like the etching, the painting is striking in the way in which it suggests an element of self-observation and contemplation on the part of the model. However, this self-observation is far away from the complex and penetrating observation of *Puberty,* Edvard Munch's famous portrayal of a young girl experiencing awakening sexuality.[2] In Brockhurst's treatment of the theme there is more emphasis on vanity – brought out by the toilette items of the dressing table and the discarded slip. There is also more than a hint of voyeurism in the way that the spectator looks over the model's shoulder to observe the model's young body in the mirror. Some of the strangeness comes from the fact that the central mirror is tilted, so that the model can look down at the whole of her body, while the side mirrors are vertical – this gives us a small glimpse of

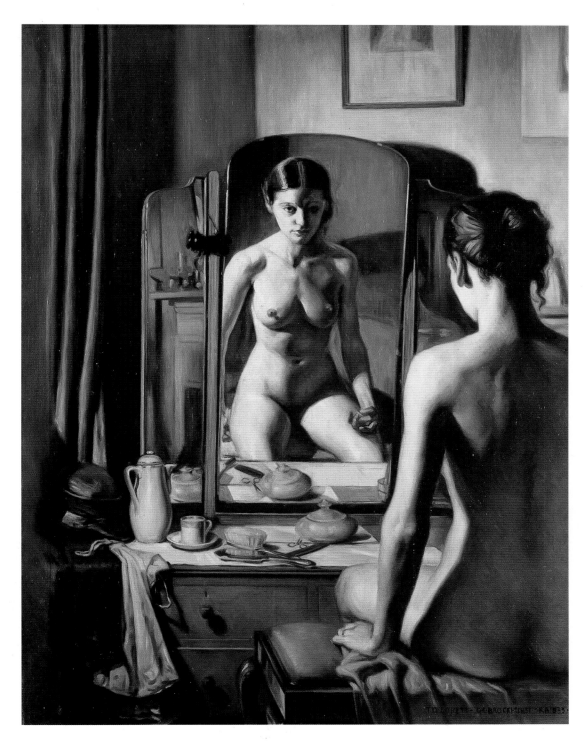

the shoulder and ear of the model at a different angle in the side mirror to the right.

wv

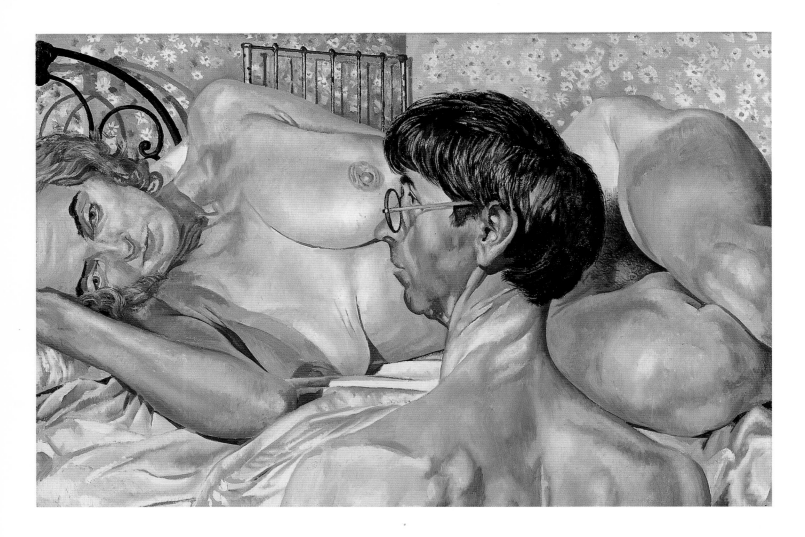

Sir Stanley Spencer

120 *Self-portrait with Patricia*

Oil on canvas, 61 × 91.2 cm

1936–37

Lent by the Syndics of the Fitzwilliam
Museum, Cambridge

This is one of two double portraits
that Spencer made of himself and
Patricia Preece in the period
leading up to their marriage in
May 1937 (see cat. 91). Although
Spencer had made life studies
while at the Slade (cat. 34), he
had an antipathy towards using
professional models. He did,
however, paint naked portraits
of personal acquaintances. Like
Sickert, he believed that the
naked figure only became
meaningful in an actual situation.
Unlike Sickert, however, he used
his own life as the source for such
occasions.

The present work is clearly based
on direct study and is different in
style from the imaginative works
he was producing, which use a
broader manner and bolder spatial
distortion. The composition must,
however, be to some extent
constructed. Spencer has clearly
brought together two separate
images – of Patricia Preece seen
directly and of himself,
presumably observed by means of
double mirrors from the back. He
has also contracted the space
between himself and Patricia, as
though trying to force the two of
them together. This device in fact
emphasizes the psychological gap
between them, something that is
also made clear in the expression
on Preece's face. Her tedium is
further expressed by the fact that
she has ceased to read the book
beside her. The scene is in a

bedroom but the two bedsteads
suggest that they were not
sleeping together, as was indeed
the case.

This exploration of isolation
within intimacy is one of the most
remarkable of all discourses on
the naked and the nude.

Although now regarded as one
of Spencer's finest achievements,
this work caused some
consternation when it was
painted. It was acquired by
Wilfred Evill after a special offer
had been struck by Spencer's
dealer, Dudley Tooth. Tooth
thought that the picture would
be a "very difficult 'seller' " and
therefore waived his normal
commission in order to get the
work off his hands. Evill
bequeathed the work to the
Fitzwilliam Museum in 1963.[1]

WV

Notes to the Catalogue

1

1 Richard and Samuel Redgrave, *A Century of British Painters*, Oxford 1947, pp. 283–84; see also W.H. Hunt, *Pre-Raphaelitism and the Pre-Raphaelite Brotherhood*, London 1905, I, pp. 94–95.
2 F.G. Rose, 'William Etty and the Nude', *Connoisseur*, CIX, January 1942, p. 28.
3 The dealer Richard Colls had a virtual monopoly of the sale of Etty's studies. See Dennis Farr, *William Etty*, London 1958, p. 83.

4

1 W.H. Hunt, *Pre-Raphaelitism and the Pre-Raphaelite Brotherhood*, London 1905, I, pp. 93–94.

5

1 Mary McKerrow, *The Faeds: A Biography*, Edinburgh 1982, p. 87.

6

1 See G.H. Fleming, *John Everett Millais*, London 1998, pp. 14–18; also Malcolm John Warner, 'The Professional Career of John Everett Millais to 1863, with a Catalogue of Works to the Same Date', Ph.D thesis, Courtauld Institute of Art, London, 1985, pp. 26–27, 223; Malcolm Warner, 'Millais as a Draughtsman', in *The Drawings of J.E. Millais*, exhib. cat., Arts Council, 1979.

8

1 Ruth Richardson, *Death, Dissection and the Destitute*, London 1987, p. xv.

9

1 Lindsay Errington, *William McTaggart, 1835–1910*, exhib. cat., Edinburgh, National Gallery of Scotland, 1989, pp. 16ff.
2 Lindsay Errington, *Master Class: Robert Scott Lauder and his Pupils*, exhib. cat., Edinburgh, National Galleries of Scotland, 1983, p. 28.
3 *Ibid.*, p. 31.

11

1 Kathryn Moore Heleniak, *William Mulready*, New Haven and London 1980, pp. 153–54 and 257, note 7.
2 The present drawing is one of a group of 95 life drawings, dating from 1805 to 1862, in the Victoria and Albert Museum. See Anne Rorimer, *Drawings by William Mulready*, exhib. cat., London, Victoria and Albert Museum, 1972.
3 Richard and Samuel Redgrave, *A Century of British Painters*, London 1947, p. 327.
4 Heleniak, *op. cit.*, p. 257, note 3.
5 See Rorimer, *op. cit.*, p. 33.
6 Heleniak, *op. cit.*, p. 258, note 17.

12

1 Lindsay Errington, exhib. cat., Edinburgh, *William McTaggart, 1835–1910*, National Gallery of Scotland, 1989, p. 18.
2 Lindsay Errington, *Master Class: Robert Scott Lauder and his Pupils*, exhib. cat., Edinburgh, National Galleries of Scotland, 1983, p. 27.
3 *Ibid.*, p. 31.

13

1 George Dunlop Leslie, *The Inner Life of the Royal Academy*, London 1914, pp. 28–29.
2 Richard Ormond, 'Art Students through a Teacher's Eyes: The Royal Academy Schools in the 1860s', *Country Life*, 23 May 1968, pp. 1348–49; Richard Ormond, *Early Victorian Portraits in the National Portrait Gallery*, London 1973, I, p. 115 (3182); II, fig. 205.
3 Clause X of 'The Instrument of Foundation of the Royal Academy', in Sydney C. Hutchison, *The History of the Royal Academy, 1768–1986*, London 1986, p. 247.

14

1 *Laws Relating to the Schools, the Library, and the Students*, Royal Academy, 1862.

16

1 Elinor Shaffer, *Erewhons of the Eye: Samuel Butler as Painter, Photographer and Art Critic*, London 1988, p. 17.

17

1 *Letters between Samuel Butler and Miss E.M.A. Savage, 1871–1885*, London 1935, no. 100, p. 134 note.
2 Elinor Shaffer, *Erewhons of the Eye: Samuel Butler as Painter, Photographer and Art Critic*, London 1988, pp. 19–26.
3 For Heatherley's see Christopher Neve, 'London Art School in Search of a Home: Heatherley's, I', *Country Life*, 17 August 1978, pp. 448–50; 'A Question of Survival: Heatherley's School of Art, II', 31 August, 1978, pp. 570–71. See also Jeremy Maas, *The Victorian Art World in Photographs*, London 1984, pp. 35–36.

18

1 Elfrida Manning, *Marble and Bronze: The Art and Life of Hamo Thornycroft*, London 1982, p. 52.
2 *Ibid.*, pp. 109–11.
3 *Ibid.*, p. 49.

19

1 Edward J. Poynter, 'Systems of Art Education', 2 October 1871, in *Lectures on Art*, 4th edn, London 1897, p. 100f.
2 *Ibid.*, p. 133.
3 George Du Maurier, *Trilby*, London 1895, p. 140.

20

1 Sir Edward Poynter, 'The Training of Art Students', a lecture first delivered at the Slade School, 1873, in *Lectures on Art*, 4th edn, London 1897, p. 150.
2 Stuart Macdonald, *The History and Philosophy of Art Education*, London 1970, p. 272.

21

1 Alfred Munnings, *An Artist's Life*, London 1950, p. 156.

2 *Ibid.* For a similar account see Shirley Fox, *An Art Student's Reminiscences of Paris in the Eighties*, London 1909, p. 104.
3 George Moore, *Confessions of a Young Man*, London 1941, p. 82.

22

1 *The Studio*, I, 1893, p. 141.

23

1 The sketchbook is clothbound with the supplier's name and address on the back inside cover: *Fritz Muller. Mal und Zeichnunge Utensillen Munchen. Thoruslanstrasse 75*.
2 On the front cover is a very faint outline, possibly a name and a signature. An examination with infrared photography revealed the letters *K.V. PU.SKI*, which may indicate the surname 'Puleski'. However, it has not be possible to link this name to any known artist of the period.

24

1 Laura Knight, *The Magic of a Line*, London 1965, p. 74.
2 See Harold Knight, *The life class at Nottingham Art School*, charcoal, 55 x 75 cm (sold Sotheby's, 25 October 1994, lot 156).

25

1 Joseph Hone, *The Life of Henry Tonks*, London 1939, pp. 26–27.
2 *Ibid.*, pp. 76–77.
3 C.H. Collins Baker, in *ibid.*, p. 344.
4 *Ibid.*, p. 174; see also pp. 293–94, for his considerate manner towards his own studio models.

27

1 Stuart Macdonald, *The History and Philosophy of Art Education*, London 1970, pp. 103–04.
2 Heather Williams, 'The Lives and Works of Nottingham Artists from 1750 to 1914, with Special Consideration of their Association with the Lace Industry and Society at large',

unpublished Ph.D thesis, University of
Nottingham, 1981, pp. 121ff.

28
1 Arthur Fish, *Henrietta Rae (Mrs Ernest
Normand)*, London 1905, p. 102.

29
1 M. Holroyd, *Augustus John*, 2 vols.,
London 1974–75, I, pp. 38–39.
2 William Rothenstein, *Men and
Memories*, II, London 1934, pp. 22–23.

31
1 *The Slade 1871–1971*, exhib. cat.,
London, Royal Academy of Arts, 1971,
p. 15, no. 25.

34
1 Carolyn Leder, *Stanley Spencer: The
Astor Collection*, London 1976, p. 9.
2 *Ibid.*

35
1 Michael Leber and Judith Sandling,
L.S. Lowry: His Life and Work, exhib.
cat., Salford Art Gallery, Salford, 1983,
p. 3.
2 Mervyn Levy, *The Drawings of L.S.
Lowry*, London 1963, p. 10.

36
1 H.S. Ede, *Savage Messiah*, London
1971, p. 121.

37
1 Marjorie Lilly, *Sickert: The Painter and
his Circle*, London 1971, p. 87.
2 Denise Hooker, *Nina Hamnett: Queen
of Bohemia*, London 1986,
pp. 120–22, 124.

39
1 L. Whistler, *Rex Whistler*, London
1948, p. 15.
2 L. Whistler and R. Fuller, *The Work of
Rex Whistler*, London 1960, p. 1.

40
1 B. Arnold, *Orpen: Mirror to an Age*,
London 1981, p. 46.
2 H.L. Wellington, entry on Orpen in
*Dictionary of National Biography,
1931–1940*, ed. L.G. Wickham Legge,
Oxford 1949, p. 662.

41
1 *Jacob Kramer* exhib. cat., Leeds City
Art Gallery, 1960, p. 7.

43
1 *Paintings of William Coldstream,* exhib.
cat., London, Tate Gallery, 1990,
no. 12.
2 Stephen Spender, Introduction to
Lawrence Gowing, exhib. cat., London,
Serpentine Gallery, 1983, p. 7.

44
1 Alan Bowness and Luigi Lambertini
(intr.), *Victor Pasmore: With Catalogue
Raisonné of the Paintings,
Constructions and Graphics
1926–1979*, London 1980, cat. 23,
p. 289.

46
1 Geoff Hassell, *Camberwell School of
Arts and Crafts: Its Students and
Teachers, 1943–60*, London 1995,
p. 144.
2 Quentin Crisp, ' A Model's Eye View',
ibid., p. 29.
3 *Ibid.*, p. 26.
4 *Ibid.*, p. 27.

47
1 Alastair Gordon, student at
Camberwell 1946–48, in Geoff Hassell,
*Camberwell School of Arts and Crafts:
Its Students and Teachers 1943–1960*,
London 1995, p. 195.

48
1 A similar study of a kneeling female
nude, probably made from the same
model, and dated 22 July 1840, is in
the Ashmolean Museum, Oxford.

49
1 W.P. Frith, *My Autobiography and
Reminiscences*, 2nd edn, London
1887, I, pp. 248–49.
2 *Ibid.*, p. 296; II, p. 3.

50
1 W.P. Frith, *My Autobiography and
Reminiscences*, 2nd edn, London
1887, II, p. 21.

51
1 See *Frederic Leighton 1830–1896*,
exhib. cat., London, Royal Academy of
Arts, 1996, cat. 89–91, pp. 199–201.
2 'Artists and Craftsmen. No. 1: Sir
Frederic Leighton, Bart., P.R.A., as a
Modeller in Clay', *The Studio*, I, 1893,
p. 6; see also Benedict Read, 'Leighton
as a Sculptor: Releasing Sculpture from
Convention', *Apollo*, February 1996,
pp. 65–69.

52
1 Turner Browne and Elaine Partnow,
*Macmillan's Biographical
Encyclopaedia of Photographic Artists
and Innovators*, London 1983, p. 486.

53
1 I am grateful to Shirley Nicholson and
Reena Suleman for their assistance in
preparing the entries on Sambourne.

54
1 See *William Strang RA, 1859–1921:
Painter and Etcher*, exhib. cat.,
Sheffield City Art Galleries, 1981, cat.
53, p. 13 repr.; David Strang, *William
Strang, RA, LLD: Catalogue of his
Etchings and Engravings*, Glasgow
1962, cat. 19 (8), p. 3.
2 David Strang, *op. cit.*, cat. 189 (155),
p. 32.

56
1 Tom Hewlett, *Cadell: A Scottish
Colourist*, London 1988, p. 34.

57
1 *Ibid.*, p. 178.

60
1 See Sally Woodcock, 'Posing,
Reposing, Decomposing: Life-size Lay
Figures, Living Models and Artist's
Colourmen in Nineteenth-Century
London', in Erma Hermens, ed.,
Looking Through Paintings, Cambridge
MA, 1998, p. 456.

61
1 W. Russell Flint, *Models of Propriety:
Occasional Caprices for the Edification
of Ladies and the Delight of
Gentlemen*, London 1951.

62
1 Anatole France, *Thaïs*, trans.
R.B. Douglas, London 1939.

63
1 Jan Marsh, *The Legend of Elizabeth
Siddal*, London 1989, p. 42.
2 *Ibid.*, p. 148f.

64
1 Diana Holman Hunt, *My Grandfather:
His Wives and Loves*, London 1969,
pp. 66–88.
2 Virginia Surtees, *The Diaries of George
Price Boyce*, Norwich 1980, p. 28.
3 Diana Holman Hunt, *op. cit.*, note 1,
pp. 248–49.

65
1 Mike Weaver, *Julia Margaret Cameron
1815–1879*, exhib. cat., John Hansard
Gallery, The University of
Southampton, 1984, p. 26.
2 Helmut Gernsheim, *Julia Margaret
Cameron: Her Life and Photographic
Work*, London 1975, p. 31.

66
1 P. Baum, (ed.), *The Letters of
D.G. Rossetti to Fanny Cornforth*,
Baltimore 1940, p. 4.
2 See Jeremy Maas, *The Victorian Art
World in Photographs*, London 1984,
p. 348.

67
1 W. Minto, (ed.), *Autobiographical
Notes of the Life of William Bell Scott*,
2 vols., London 1892, I, pp. 316–17.
2 Oswald Doughty, *A Victorian
Romantic: Dante Gabriel Rossetti*,
London 1949, p. 252.
3 See Jan Marsh, *The Legend of
Elizabeth Siddal*, London 1989, p. 79f.
4 Fanny married Timothy Hughes, a
"drunken waster", on 11 August
1860. He died in 1872.
5 See A. Wilton, R. Upstone *et al.*, *The
Age of Rossetti, Burne-Jones and
Watts: Symbolism in Britain
1860–1910*, exhib. cat., London, Tate
Gallery, 1997, pp. 98–100.
6 Doughty, *op. cit.*, note 2, p. 316.
7 Wilton *et al.*, *op. cit.*, note 5, p. 100.

68

1 Jan Marsh, *The Pre-Raphaelite Sisterhood*, London 1985, p. 281.

70

1 *Serenely Wandering in a Trance of Sober Thought* was exhibited at the Royal Academy in 1885. See L. and R. Ormond, *Lord Leighton*, New Haven and London 1975, cat. 318a.

2 Mrs Russell Barrington, *The Life, Letters and Work of Frederic Leighton*, 2 vols., London 1906, II, p. 269.

3 *Ibid.*, pp. 272–73.

4 See Ormond, *op. cit.*, note 1, pp. 134ff.

5 Barrington, *op. cit.*, note 2, p. 272.

6 Kate Bailey, 'Leighton – Public and Private Lives: Celebrity and the Gentleman Artist', *Apollo*, February 1996, p. 24.

7 Barrington, *op. cit.*, note 2, p. 273.

71

1 Martin Postle, 'Leighton's Lost Model: The Rediscovery of Mary Lloyd', *Apollo*, February 1996, pp. 27–29.

2 I am grateful for this information to Simon Toll, who is currently writing a catalogue raisonné of Draper.

3 'The Story of Mary Lloyd who had the Face of an Angel but Outlived her Luck', *Sunday Express*, 22 October 1933.

72

1 Rodney Engen, *Alice's White Knight*, London 1991, p. 123.

2 *The Metamorphoses of Ovid*, translated by Mary M. Innes, Harmondsworth 1983, p. 231.

3 Lady Elizabeth Eastlake, (ed.), *Life of John Gibson, R.A.*, London 1870, pp. 211–12.

74

1 Mark Bills, *Edwin Long RA*, London 1998, p. 21.

2 Alison Smith, *The Victorian Nude: Sexuality, Morality and Art*, Manchester 1996, p. 202.

75

1 Edward J. Poynter, *Lectures on Art*, 4th edn, 1897, p. 109.

2 A.M.W. Stirling, *The Richmond Papers*, London 1926, p. 272.

3 For further correspondence and information on the Artist's Model Assocation and on the predominance of male Italian models in the Royal Academy Schools see Royal Academy Archives, Cab. I, Box 27; Cab. E, Box 20.

76

2 David Wainwright and Catherine Dinn, *Henry Scott Tuke 1858–1929: Under Canvas*, London 1989, p. 47.

77

1 R. Anderson and A. Koval, *James McNeill Whistler: Beyond the Myth*, New York 1994, p. 417.

2 Richard Dorment and Margaret F. Macdonald, *James McNeill Whistler*, exhib. cat., London, Tate Gallery, 1994, cat. 209, pp. 280–81.

3 Margaret Macdonald, *James McNeill Whistler: Drawings, Pastels and Watercolours*, New Haven and London 1995, no. 1501, p. 539.

78

1 Joseph Hone, *The Life of Henry Tonks*, London 1939, p. 204.

2 *Ibid.*, pp. 198–99.

3 *Ibid.*, p. 308.

79

1 A. John, *Chiaroscuro: Fragments of an Autobiography*, London 1952, repr. 1962, p. 43.

80

1 E. Silber and T. Friedman, *Jacob Epstein: Sculpture and Drawings*, exhib. cat., Leeds City Art Gallery, 1987, p. 112.

2 E. Silber, *The Sculptures of Epstein*, Oxford 1986, S36.

82

1 E. Silber, *The Sculptures of Epstein*, Oxford 1986, S196, pp. 50, 167.

84

1 Robin Gibson, *Glyn Philpot 1884–1937: Edwardian Aesthete to Thirties Modernist*, exhib. cat., London, National Portait Gallery, 1984–85, p. 23.

85

1 Robin Gibson, *Glyn Philpot 1884–1937: Edwardian Aesthete to Thirties Modernist*, exhib. cat., London, National Portrait Gallery, 1984–85, p. 21.

2 A.C. Sewter, *Glyn Philpot*, London 1951, p. 9.

86

1 John Woodeson, *Mark Gertler: Biography of a Painter, 1891–1939*, London 1972, p. 377.

87

1 Toby Glanville, 'Last of the Red Hot Models', *The Daily Telegraph Magazine*, 18 May, 1991, p. 54.

88

1 D. Hudson, *For Love of Painting: The Life of Sir Gerard Kelly*, London 1975, pp. 40–41.

90

1 Marguerite Evans, 'A Picture of Quentin Crisp', *ca.* 1990, p. 2 (unpublished typescript).

2 *Ibid.*, p.1.

91

1 Keith Bell, *Stanley Spencer: A Complete Catalogue of the Paintings*, London 1992, cat. 165, p. 434.

92

1 Ilaria Bignamini and Martin Postle, *The Artist's Model: Its Role in British Art from Lely to Etty*, exhib. cat., Nottingham Djanogly Gallery, and London, Kenwood, 1991, cat. 1, p. 39.

93

1 See Alison Smith, 'Nature Transformed: Leighton, the Nude and the Model', in Tim Barringer and Elizabeth Prettejohn, (eds.), *Frederic Leighton: Antiquity, Renaissance, Modernity*, New Haven and London 1999, pp. 21–23.

94

1 Stephanie Spencer, 'O.G. Rejlander: Art Studies', in *British Photography in the Nineteenth Century: The Fine Art Tradition*, Cambridge 1989, pp. 121–32; p. 128.

2 A.H. Wall, 'Rejlander's Photographic Art Studies: Their Teachings and Suggestions', in *Photographic News*, no. 29, 31 December 1886, p. 862.

96

1 'The Nude in Photography: With Some Studies taken in the Open Air', *The Studio*, I, 1893, pp. 104–08.

97

1 Frederick Wedmore, *Memories*, London 1912, pp. 90–91.

2 Galina Gorokhoff, (ed.), *Love Locked Out: The Memoirs of Anna Lea Merritt with a Checklist of her Works*, London 1982, p. 115.

3 *Ibid.*, p. 164.

4 Anne Higonnet, *Pictures of Innocence: The History and Crisis of Ideal Childhood*, London 1998, p. 132.

5 Gorokhoff, *op. cit.*, note 2, p. 94.

98

1 David Wainwright and Catherine Dinn, *Henry Scott Tuke, 1858–1929: Under Canvas*, London 1989, p. 34.

2 *Ibid.*, p. 56.

99

1 Margaret Harker, *The Linked Ring: The Secession Movement in Photography in Britain, 1892–1910*, London 1979.

2 Michael Hiley, *Frank Sutcliffe, Photographer of Whitby*, London 1974, p. 43.

100, 101

1 Mary Ann Roberts, 'Edward Linley Sambourne (1844–1910)', *History of Photography*, XVII, no. 2, summer 1993, pp. 208–09.

2 *Ibid.*, p. 212.

3 For Sambourne's painstaking method see M.H. Spielmann, *The History of "Punch"*, London 1895, pp. 534–36.

102

1 James Lomax and Richard Ormond, *John Singer Sargent and the Edwardian Age*, exhib. cat., London, National Portrait Gallery, 1979, p. 111, cat. 102.

2 D'Inverno left an account of his life with Sargent, 'The Real John Singer

Sargent as his Valet Saw him', *Boston Sunday Advertiser*, 26 February 1926.

3 David McKibbin, *Sargent's Boston*, exhib. cat., Boston, Museum of Fine Arts, 1956, p. 111.

4 See Patricia Hills, *John Singer Sargent*, 1986, figs. 214, 237–38, 240–43.

103

1 C.J. Holmes, *Self and Partners (Mostly Self), Being the Reminiscences of C.J. Holmes*, London 1936, p. 132.

2 *Ibid.*, pp. 153–54.

3 Ilaria Bignamini and Martin Postle, *The Artist's Model: Its Role in British Art from Lely to Etty*, exhib. cat., London, Kenwood, *et alibi*, 1991, p. 21 and fig. 5.

104

1 C. Langdale, *Gwen John*, New Haven and London 1987, p. 31.

2 *Ibidem.*

105

1 W.R. Sickert, 'The Naked and the Nude', from *The New Age*, 21 July 1910, reprinted in *A Free House*, ed. O. Sitwell, London 1947, p. 324.

2 Wendy Baron, *Sickert*, London 1973, Appendix, p. 181.

107

1 K. Deepwell, 'Sylvia Gosse', in *A Dictionary of Women Artists*, ed. D. Glaze, London and Chicago 1997, I, p. 603.

108

1 James White, *William Orpen: A Centenary Exhibition*, exhib. cat., Dublin, National Gallery of Ireland, 1978, p. 75.

109

1 Denise Hooker, *Nina Hamnett: Queen of Bohemia,* London 1986, p. 92.

2 *Ibid.*, p. 91.

3 *Ibid.*, p. 111.

111

1 H.S. Ede, *Savage Messiah*, London 1971, p. 151.

2 *Ibid.*, p. 109.

3 Nina Hamnett, *Laughing Torso,* London 1932, p. 39.

4 Denise Hooker, *Nina Hamnett: Queen of Bohemia,* London 1986, p. 236.

112

1 Judith Collins, *Eric Gill: Sculpture*, London 1992, pp. 106–07.

114

1 Barbara Hepworth, *Carvings and Drawings*, London 1952, p. xvii.

115

1 Alan G. Wilkinson, *The Drawings of Henry Moore*, New York and London 1984, p. 19.

116

1 Jane Johnson, *British Artists 1880–1940*, Woodbridge 1976, p. 494.

117

1 *Dod Procter (1892–1972). Ernest Procter (1886–1935),* exhib. cat., Laing Art Gallery, Newcastle upon Tyne, 1990, p. 51.

118

1 John Woodeson, *Mark Gertler: Biography of a Painter, 1891–1939*, London 1972, p. 376.

119

1 *Artist as Model*, exhib. cat., London, Garton & Cooke, 1987, no. 40.

2 *Puberty*, oil on canvas, 150 × 110 cm, Oslo, Nasjonalgalleriet, repr. O. Benesch, *Edvard Munch*, London 1960, p. 12.

120

1 Keith Bell, *Stanley Spencer: A Complete Catalogue of the Paintings*, London 1992, cat. no. 223, p. 448.

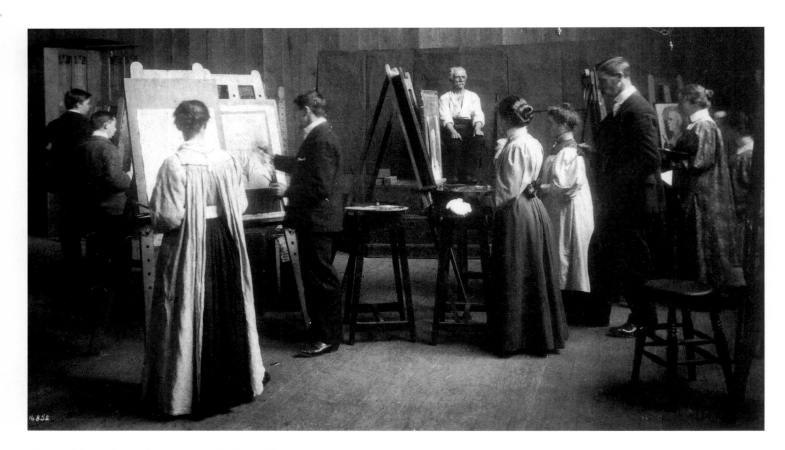

Glasgow School of Art with women painting from old man, photograph, 1906, Glasgow School of Art Archives

Suggested Reading

Anon. 'Artist's Models', *The Artist*, 2 Nov. 1885

Anon., 'Models and Morals', *The Artist*, 2 Nov. 1885

Anon. 'The Nude in Art Education', *The Art Journal*, July 1851

Anon., 'The State of Art Education in Great Britain and the Continent', *The Builder*, 20 November 1869

Marjorie Althorpe-Guyton and John Stevens, *A Happy Eye: A School of Art in Norwich 1845–1982*, Norwich 1982

Quentin Bell, *The Schools of Design*, London 1963

Ilaria Bignamini and Martin Postle, *The Artist's Model: its Role in British Art from Lely to Etty*, Nottingham 1991 (reprinted 1999)

Frances Borzello, *The Artist's Model*, London 1982

Anthea Callan, *Angel in the Studio. Women in the Arts and Crafts Movement 1870–1914*, London 1979

Richard Carline, *Draw they must: A History of the Teaching and Examining of Art,* London 1968

Quentin Crisp, 'The Declining Nude', *Little Reviews Anthology*, 1949

Quentin Crisp, *The Naked Civil Servant*, London 1968

C.P. Darcy, *The Encouragement of the Fine Arts in Lancashire, 1760–1860*, Manchester 1976

Charles Douglas, *Artists Quarter*, London 1941

Nina Hamnett, *Laughing Torso. Reminiscences of Nina Hamnett*, London 1932

Janet Hobhouse, *The Bride Stripped Bare*, London 1988

Sidney C. Hutchison, *The History of the Royal Academy*, London 1986

Ian Jenkins, *Archaeologists and Aesthetes in the Sculpture Galleries of the British Museum 1800–1939*, London 1992

Bruce Laughton, *The Euston Road School. A Study in Objective Painting*, London 1986

George Dunlop Leslie, *The Inner Life of the Royal Academy*, London 1914

Stephen Marcus, *The Other Victorians: A Study of Sexuality and Pornography in Mid-Nineteenth-Century England*, New York 1966

Tessa Mackenzie, ed., *The Art Schools of London*, London 1895

Stuart Macdonald, *The History and Philosophy of Art Education*, London 1970

Stella Margetson, 'Pugnacity and Progress. The London Art Schools', *Country Life*, 14 Nov. 1985, pp. 1546–50

John Milner, *The Studios of Paris: The Capital of Art in the late 19th Century*, New Haven and London 1988

H.C. Morgan, 'The Schools of the Royal Academy', Ph.D thesis Leeds University 1968

Lynda Nead, *Myths of Sexuality: Representations of Women in Victorian Painting*, Oxford 1988

Lynda Nead, *The Female Nude: Art, Obscenity and Sexuality*, London and New York 1992

Christopher Neve, 'London Art School in Search of a Home: Heatherley's School of Art, I', *Country Life*, 17 Aug. 1978, pp. 448–50; 'A Question of Survival: Heatherley's School of Art, II', 31 Aug. 1978, pp. 570–71

Pamela Gerrish Nunn, *Victorian Women Artists*, London 1987

Richard Ormond, 'Art Students through a Teacher's Eyes. The Royal Academy Schools in the 1860s', *Country Life*, 23 May 1968, pp. 1348–49

Clarissa Campbell Orr, ed., *Women in the Victorian Art World*, Manchester 1995

Perriam, Dennis, 'The Carlisle Academy of Fine Art', *Connoisseur*, vol. 189, no. 762, Aug. 1975, pp. 300–05

Nikolaus Pevsner, *Academies of Art, Past and Present*, Cambridge 1940 (reprinted 1973)

Marcia Pointon, *Naked Authority: The Body in Western Painting 1830–1908*, Cambridge 1990

Martin Postle, 'The Foundation of the Slade School of Art: Fifty-nine Letters in the Record Office of University College London', *Walpole Society*, LVII, 1996, pp. 127–230

Samuel Putnam, trans., *Memoirs of Kiki: The Education of a French Model*, intro. Ernest Hemingway, London 1964

Alison Smith, *The Victorian Nude: Sexuality, Morality and Art*, Manchester 1996

Susan Suleiman, ed., *The Female Body in Western Culture*, Cambridge MA 1985

Giles Walkley, *Artists' Houses in London 1764–1914*, Aldershot 1994

Judith Walkowitz, *Prostitution and Victorian Society: Women, Class and the State*, Cambridge 1980

Charlotte J. Weeks, 'Women at Work: The Slade Girls', *Magazine of Art*, vol. 6, 1883

Photographic Credits

While every effort has been made to contact and obtain permission from holders of copyright, if any involuntary infringement of copyright has occurred, sincere apologies are offered

Works of art are reproduced by kind permission of their owners, as indicated beside the illustration. Further acknowledgements and permissions are as follows:

Bonhams, London/Bridgeman Art Library, London, fig. 11
© The British Museum, cat. 14, 15, 19, 20, 28, 29, 37, 48, 78, 79, 84, 103, 105, 107,115
The Syndics of Cambridge University Library, figs. 4, 6, 15
The Courtauld Institute of Art, cat. 41
Curtis Brown Ltd, fig. 12
English Heritage Photographic Library, cat. 45, 46, 47, 54, 62, 75, 76
Glasgow School of Art Archives, fig. 5 and on p. 142
© Courtesy of Mary-Geneste Holliday, cat. 58, 59, 60
James Howe, cat. 74
Richard Littlewood, cat. 92
The Maas Gallery Ltd, fig. 1
The Trustees of the National Museums and Galleries of Northern Ireland, fig. 3
City of Nottingham Musems, Castle Museum and Art Gallery, cat. 24, 27
© The Royal Borough of Kensington and Chelsea, cat. 53, 70, 100, 101
Glen Segal, cat. 4
© St John's College, Cambridge, cat. 16
© Southampton City Art Gallery, Hampshire, UK/Bridgeman Art Library, London, cat. 86
© Tate Gallery, London 1999, figs. 16, 17, 21, cat. 17, 43, 57, 60, 67, 71, 82, 83, 96, 97, 111
V&A Picture Library, cat. 11, 33, 36, 72, 108, 110, 112, 114
Rodney Todd White & Son, fig. 1, cat. 68

Works illustrated are © the artists, their heirs and assigns 1999, and specifically as follows:

Vanessa Bell © Vanessa Bell Estate 1962, cat. 113
William Coldstream © Courtesy of the artist's estate/Bridgeman Art Library, London/ New York, cat. 43
Jacob Epstein © Permission of the Epstein Estate, cat. 80, 81, 82
Gwen John © The Estate of Gwen John. All rights reserved, DACS 1999, cat. 104, fig. 21
© The Estate of Dame Laura Knight, fig. 12
Dermod O'Brien © Courtesy of the artist's family, fig. 3
Stanley Spencer © Estate of Stanley Spencer. All rights reserved, DACS 1999, cat. 34, 91, 120

Index of Artists

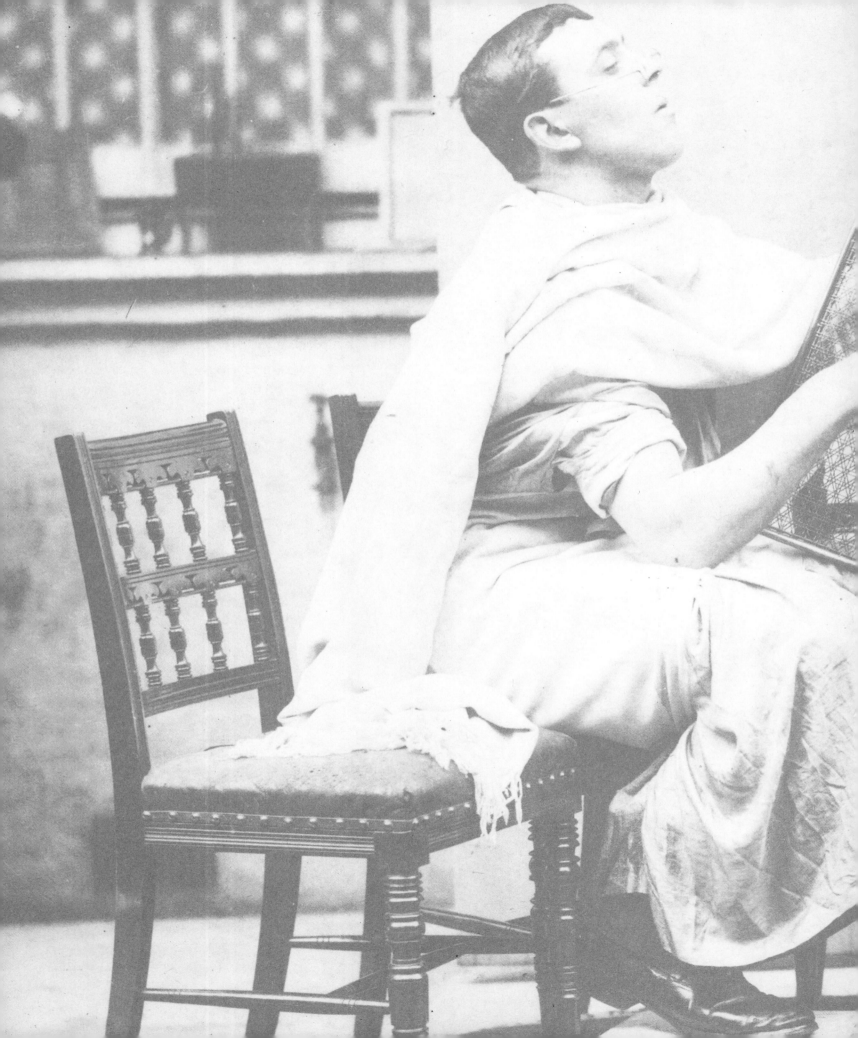